INTO
THE
INFERNO

BOOKS BY STUART PALLEY

Terra Flamma: Wildfires at Night

Into the Inferno: A Photographer's Journey through California's Megafires and Fallout

STUART PALLEY

INTO THE INFERNO

A PHOTOGRAPHER'S JOURNEY THROUGH
CALIFORNIA'S MEGAFIRES AND FALLOUT

**BLACK
STONE**
PUBLISHING

Published in 2022 by Blackstone Publishing
Cover and book design by Kathryn Galloway English
Case wrap: "Dark black background of burnt wood with
red hot embers still burning." photo by Leigh Prather/Shutterstock

Some names and identifying details have been changed
to protect the privacy of individuals.

Printed in the United States of America

First edition: 2022
ISBN 978-1-0941-6369-7
Biography & Autobiography / Artists, Architects, Photographers

Version 2

CIP data for this book is available
from the Library of Congress

Blackstone Publishing
31 Mistletoe Rd.
Ashland, OR 97520

www.BlackstonePublishing.com

CONTENTS

TERRA FLAMMA LOCATIONS
PHOTOGRAPHED 2012-2018

N

★ Terra Flame Wild Fires

CA_Counties

0 50 100 200 Miles

A wall of fire careened toward me from a few hundred yards away. I lay on the hot asphalt, catching my breath and regaining my bearings. The scream of a fire engine rolling down the road jolted me upright. There was white-hot pain in my ankle as I hobbled along to the roadside shoulder. The fire jumped the road behind me, and the winds blew a bellowing column of smoke directly between me and my car. My escape route was cut off, and for all I knew my fancy Land Rover, parked in the dirt next to unburned fuels, was also on fire.

I was moving slowly after running back to my car in surplus combat boots that were two sizes too big, and I tripped face-first again into the asphalt. I was greeted with a mouthful of the Los Angeles County Department of Public Works' finest handiwork.

Standing up, I resolved to run through the dark, horizontal column of smoke leaning over the two-lane road, determined to make it back to my car. I had to start work at a newspaper the next morning and couldn't let my car catch on fire. I had no fire shelter and no radio or way to call for help.

I took a deep breath like I was preparing to blow out a birthday

cake and made a hobbled dash through the smoke. Immediately, ash particles made my eyes sting and squint nearly shut. The smoke in my lungs caused my asthmatic respiratory system to convulse in protest with hacking coughs. The hangover from the photo festival the night before was running strong, and the single-digit humidity and ninety-degree Mojave Desert heat didn't help.

I kept moving forward in the suspended reality, using the edge of the road as my guide to keep moving in a straight line through the smoke as visibility was reduced to zero. Was this it? Would I trip again or pass out and get run over by a fire engine as smoke turned day into night? My mother would kill me even though I'd already be dead.

After what seemed like an eternity but was really only seconds, I emerged on the other side of the smoke to a Los Angeles County Sheriff's deputy parked near my car. He was supervising an emergency roadblock. A dozen civilians looked on at the fire, filming on their iPhones. A large Type 1 heavy helicopter dropping hundreds of gallons of water hovered overhead, the rotor wash blowing my hair. The sheriff held back TV news cameras and a line of frustrated commuters.

The ad hoc crowd looked at me quizzically, silent, as if I were a flaming rabbit running out of sagebrush. The sheriff's deputy leaned on the wide-open driver's side door of his Crown Vic, looking out toward the fire, transfixed and clutching his mobile radio mic. I was covered in ash, dust, and sweat, had a twisted ankle and a broken zoom lens, and had barely made it out of the way of the flaming front of the Power-house Fire.

My heart was still racing as I fumbled for my keys and the push-button ignition with my adrenaline-impaired fine motor skills. I was scared and beginning to realize the gravity of the situation, as helicopter turbines roared above and sirens drove by. The distance running through the smoke was maybe fifty feet but had felt like a mile.

A strange mixture of pain, excitement, fear, and naivety coalesced into a mildly perverse smile. Physically intact but dignity shattered, I laughed as my ankle began to swell.

I liked this.

INTRODUCTION

Into the Inferno is my story of eight years photographing and witnessing fire.

Those first hours at the Powerhouse Fire were a chaotic preview of what lay ahead. Over many summers and falls, triumphs and tragedies, I grew as a wildfire photographer. A young man grew into an adult and saw what he thought was drought become the product of full-blown climate change, human development, and decades of fire suppression.

Throughout *Into the Inferno*, I'll try and show how fire shaped me and how the flames literally tempered my character along the way. Through my near decade-long dance with fire, I'll cover some of California's largest, most destructive, and deadliest fires, which I captured from the front lines between 2012 and 2020. I remember the terrifying scenes at the 2017 Wine Country Fire Siege, the Thomas Fire just months after, and the terror on the beach in Malibu at the Woolsey Fire. As I write this introduction on the precipice of yet another fire season, the forecasts say we're in for a brutal summer and fall, and new fires are already actively burning. There's still snow on the same mountains where fire is consuming the trees, and all of this is largely unprecedented.

At these fires I witnessed first responders and civilians alike engaging

in heroic acts to save lives and property. From one job to the next, I saw wildland firefighters risk their lives and mental health to keep people out of harm's way while trying to save homes. These memories are difficult to share, but they have value because they demonstrate the acute and current effects of climate change in California. These stories also highlight the effects of human encroachment on the Wildland Urban Interface (WUI) and how historic suppression of wildfires has led to unnatural fuel loading.

I humbly ask that you try to put yourself in my boots and place your eye behind the viewfinder of my Nikon and join me in this journey as a wildfire photographer. More importantly, I invite you to feel what it is like to be permanently altered by smoke, heat, and ash. I have seen that fire is duality—beauty and destruction. I search for this tension in the images I capture and the stories I tell.

Some moments and images continue to haunt me, but I wouldn't feel this connection to the earth, to humanity, to fire itself without the lows and the highs. I hope that with these stories, you are encouraged to engage in civic society; to vote for leadership that will take decisive climate action; to educate your friends, neighbors, and families to make smart fact-based decisions; and to realize that there is no more climate normal. There is only a new and volatile climate reality.

If we ignore our worsening fires, we do so at our peril. Like the memories I confront in this book, we must face this reality with courage and the best grace we can, not because we want to, but because we have to. Nothing less than the well-being of the planet and the survival of humankind is at stake. And I believe we can and will overcome the present crisis, but the level of suffering and impacts are up to us and the decisions we make.

THE JOURNEY

I have been on a journey from asthmatic kid in the suburbs to almost getting run over by a fire engine to seasoned wildland fire photographer seeing climate change in my literal backyard. The world was changing,

and I was growing up. It was a strange parallel to see fires worsening yet have the experience help forge me into the person I am today. The experiences tempered me to become a stronger version of myself, physically and emotionally. Ultimately, they allowed me to better tell this story—of how worsening wildfires impact everyday Californians—in a more authentic way, from the heart, real and raw. I hope it does the best service to the stakeholders in fire. That's what it's all about.

As I continued to document fires, I realized it was more than just drought. It was human development into the WUI, climate change, and how we prepared and reacted to the changing wildfire conditions across the state. California wasn't in a vacuum—severe wildfires were happening in Australia, South Africa, the Mediterranean, South American rainforests, and other areas where it was more slash-and-burn agriculture vs. wildland fire. The result was still the same, uncontrolled flame, release of carbon from plants, property destruction, and air pollution.

As I photographed more fires, I gained insight with each blaze. A tip from a firefighter, an observation of their activity, listening to the radio—I began to pick out the subtle details of how a fire is fought. I learned their jargon, radio parlance, body language. The right way to rig an element, tie your boot laces, the local terms, and weather influences. While my work was about the big picture of climate change, I could never get it done without learning the nuances of staying safe and getting to where the images needed to be made. I had to immerse myself to be the best steward of the access and privilege I had been given to document the story. It was the big picture and little picture at once, learning the small details to better understand the entirety of the situation.

After my Powerhouse Fire debacle, I figured that learning how to be safe at wildfires would be necessary to make better pictures, but I didn't realize that dedication to learning would end up becoming a pursuit in and of itself. Fire is its own living and breathing entity, with no two blazes alike. Yes, patterns emerge, and fires can rhyme like history, but on a granular level nothing is *exactly the same*. I learned how a single percentage point drop in relative humidity could cause

a fire to explode, or a puff of wind could complete the fire triangle of heat, fuel, and oxygen. The fire would be asleep one moment, roaring the next. Or the fire would lazily wake up, rather than go nuts. It depended on a host of factors I became familiar with as I photographed more blazes.

During nonwildfire photoshoots in SoCal, I'd warily eye canyons and freeways along dense and overgrown chaparral near massive subdivisions in foothills and rural areas around the megalopolis. To me it began to look like hillsides drenched in gasoline ready for ignition, and the oil-packed brush was just that. Places where fire hadn't burned for decades were tinderboxes, exacerbated by hotter temps and stronger wind events. The drought was the final straw that caused fires to explode around the summer of 2012 when I photographed my first blazes.

While the Powerhouse was a close call personally and destroyed over one hundred homes and burned 30,000 acres, it no longer stands out as a serious wildfire. That's not to say it wasn't serious for those who evacuated and lost everything—it was probably one of the most traumatic weeks of their lives. But the Powerhouse has been superseded by fires burning over ten times the acreage and destroying more than two hundred times the number of homes. The scale of these events has become dramatically worse even within a relatively short amount of time. The Powerhouse Fire may have seemed like a behemoth to a rookie like me. Watching the fire crews following brush engines in the ash to put out embers, I was reminded of images of Russian soldiers following tanks during the Battle of Kursk in WWII, except this was within a few hours' drive of where I grew up. It was scorched earth both ways. But it pales into comparison to fires now. It was but an ominous foreshadowing.

FIRE WALK WITH ME

The pyrocumulus stands as a smoky monolith to the essential nature of a fire. Fire is not a living thing, but it breathes oxygen and exhales

heat and flame. The pyrocumulus, literally translated from Latin as fire cloud, is the smoke and ash that create its own weather.

A pyrocumulus can tell you about wind, temperature, humidity, fire severity, and give you an idea of how the fire may continue to behave considering current and forecasted conditions. As a fire explodes in size or is extinguished, it can also provide an aerial strata of particulates, which can be read as a living record of the fire—before it's swept away by higher altitude breezes. As I drive into a fire, I'm closely watching this fire cloud as an indicator of what the fire is doing. At booming blazes on clear days, smoke can be visible hundreds of miles away, and the pyrocumulus itself fifty miles away or more with a clear view. I'm studying it along the way, stalking the blaze until I can strike with my camera.

In Southern California, fire is on the periphery of everyone's life. Even if you grow up at the beach or in the flatlands of urban Los Angeles, the Santa Ana winds come every fall and eventually you see the smoke column on the horizon.

These themes repeated themselves as the seasons evolved, became longer, more brutal, more destructive. And I saw them beginning as a kid, before I ever picked up a camera.

DREAMS OF FIRE

Turns out I was preconditioned to be drawn to wildfires.

Fire contains elements I'm fascinated by: light, night skies, constantly evolving situations, being outdoors, traveling, and adventure. Today, climate change also plays a major role. There's nothing quite like staring at an incredible force of nature right in front of your eyes. Feeling the rush of wind at your back as the fire sucks in more oxygen, the sounds of the flaming front and torching trees roaring like a steam engine across the plains, and the sun turned orange and sometimes blotted out from the sky. You feel small. You realize your place in the universe. Humankind feels insignificant. Nature, the planet, whatever you want to call it, is showing us who's boss.

How can you see something like that scale of fire and not be drawn to it, and not be changed? I see it in many of the wildland firefighters I've met along the way too. Fire leaves a mark on you.

My own journey into the world of fire began as a young child in the early 1990s when the Laguna Canyon Fire ripped through Laguna Beach, a few miles south of where I grew up in Newport Beach. This area, sometimes called the California Riviera, is a wealthy coastal enclave with multimillion-dollar homes and luxury cars at nearly every intersection. However, the natural forces that shape the beauty in Orange County—wind, erosion, fire, and waves at the coastal plain

of mountains—are the same forces that shape wildfire. Growing up I remember seeing the bent-over column of smoke emanating from Laguna Beach in the fall, the vaguest of memories as a five-year-old not yet even in kindergarten. Wildfire is on the periphery of virtually every resident in California. And sometimes it smashes right into you.

In high school, ash fell on the dance floor for our Halloween Ball. It was late October of 2003, as the Old and Grand Prix Fires ran roughshod over the mountains into San Bernardino. The lights from the DJ booth shot across the dance floor, illuminating the particles of falling ash, and our eyes watered from the particulates. To the south was the Cedar Fire, which destroyed thousands of homes and burned over 270,000 acres. The record-setting Cedar Fire was the largest and most destructive wildfire in California history until it was surpassed by the Tubbs and Thomas Fires in 2017. As of 2020, it's still one of the top-five largest and deadliest wildfires in modern California fire history.

To the northwest in 2003 were the Piru and Simi Fires in Ventura County. Dozens of other smaller, yet still serious fires, peppered the region and overwhelmed exhausted firefighters for weeks. The fall 2003 California wildfire season is the textbook definition of a fire siege that now forms an extensive basis for my understanding of wildfire in the state. With serious asthma, my breathing became so impacted my family and I drove out to Palm Springs, away from the Santa Ana winds sending fire and smoke over the beaches.

Before leaving I remember the scent of smoke embedding itself in our football practice jerseys, and the sweat evaporating off our uniforms before it had the chance to cool us. The sun, the bone-dry air, and the particulate-laden atmosphere conspired to bake anything that dared cross its path. You can feel the dryness in your bones. Each fall would be like that in high school, the practice field aligned with Santa Ana winds on the hillside at the southern end of the Los Angeles Basin. Those afternoons filled with heat exhaustion were my first education in fire weather.

Fire followed me as I grew older. In 2007, the Santiago Fire ripped through the Trabuco Ranger District of the Cleveland National Forest and into the Irvine foothills populated by cookie-cutter subdivisions.

As the fire raged, I flew home to visit family in Orange County, talking my way past a skeptical California Highway Patrol officer at a checkpoint with my university newspaper press pass to photograph. Flying in the night before, on the 737 into Orange County Airport, you could see rings of backing fire in the hills over the Santa Ana mountains. I was mesmerized. Driving down Santiago Canyon in my friend's tiny hatchback, we came across burned trees, a roasted BMW SUV, and miles of fully consumed fuels. It was my first exposure to a wildfire, or at least its aftermath. The palette of grays, ashen earth, and the rust color of burned steel and melted aluminum was a set of visuals I'd never seen. Where that fire burned is visible from my patio today and is still ringed by tens of thousands of upscale homes.

FIRE DRAWS ME CLOSER

During my final college summer studying and photographing in Taos, New Mexico, I watched wildfire smoke from afar that would drift into the valley carved by the Rio Grande, turning sunsets behind the adobe Ranchos de Taos church into a giant fireball. Like Ansel Adams before me, I was taken in by the sensual curves of the historic structure, now accentuated by the all-consuming orange haze of wildfire smoke. As June waned and the smoke grew thicker, I returned to California post-graduation, taking the scenic route north of Los Alamos.

The road took me via Abiquiu, home of Georgia O'Keeffe. At the tiny gas station sandwiched between Highway 84 and the Chama River, I washed my windshield, which was covered in ash drifting off the mesa where a massive pyrocumulus was forcing an evacuation of the town. That was the Las Conchas Fire in 2011, and it would eventually burn over 156,000 acres and destroy more than one hundred structures. It's some sort of weird foreshadowing that I was again on the outskirts of all these major wildfires. But it also speaks to how wildfire affects everyone surrounding it, even if we are not directly impacted or evacuated by the flames.

That fall I started graduate school for photojournalism at the University of Missouri. My first summer into the program I took an unpaid internship at the *Orange County Register*, and a few days before returning to Missouri for my second year, a fire broke out near Temecula in Wildomar that was fast-moving in the August heat. It was arguably out of the newspaper's coverage area, but I convinced the editor to let me borrow fire gear, drive out, and file photos for the newswire and a short story brief. I hauled out on Interstate 15 right before rush hour and got past the roadblocks into the fire.

I arrived and almost immediately encountered a large hillside home in flames. The fire front had already passed through, but the home probably had fallen victim to embers in the attic or vents. The palm trees were like candles dancing in the uphill breeze as rafters over the garage and back patio trellis collapsed to crackle and pops. I watched support timbers collapse in the garage. A Riverside City fire engine crew was saving what items they could from the residence—toolboxes, file boxes placed next to the pool, family photos, a child's pedal Barbie car.

As I recount in my book *Terra Flamma*, furniture was tossed into the pool, like someone had thrown it in a hurry before evacuating. The pool was coated in a layer of ash, its water a paste of ash, home debris, and chlorine. Surrounding the pool were the burning palm trees, their torched fronds drooping from the heat, a few lay on the patio. I knelt down to the edge of the pool low with my camera to make a picture. "This is wild," I thought to myself. I'd never seen anything like it before. Nearby, an inmate fire crew rested after cutting a fire line around the house. It was the first time I'd seen a prison inmate in person.

The summer of 2012 was pivotal because California entered the critical phases of a multi-year, record-setting drought. The burning home in Wildomar underscored the collision between humankind and nature. On one hand, a country home with an amazing view; on the other, prime wildfire habitat with steep hills, uphill winds, and tinder-dry brush. The memories of all the other wildfires on the fringe of my life came rushing in. It was no longer an abstraction, just smoke, or the aftermath.

Wildfire was real.

In the summer of 2013, I returned to California permanently to finish my master's documentary project on the Salton Sea and to try breaking into a full-time career in photojournalism. Within seventy-two hours of arriving home, I found myself en route to the Powerhouse Fire on my first formal wildfire photo assignment with a newswire agency.

Just like air is sucked into the fire, I was now drawn to the flames. I was unwittingly buying a ticket as a passenger on a wild ride for the rest of my life. I drove home from the Powerhouse Fire at 3 a.m., exhausted, with a sprained ankle, and still a little bit embarrassed. In the twenty-four-hour McDonald's drive-through on the way home, I realized I needed to learn fire safety, to think like a wildland firefighter, and to immerse myself in their world if I wanted to stay alive on that ride, and to make the kinds of inroads to see wildfire up close in the future. Between stuffing my face with french fries and chicken nuggets, I made a mental list of training and gear needed. I needed to be ready for the fires that were sure to come during summer.

The first day of my apprenticeship at the *Orange County Register* was starting later that same morning. My suitcases and boxes still weren't unpacked, and my hair smelled like smoke.

After gripping me in its nearly fatally warm embrace, fire had bestowed me with a California homecoming to remember.

TWO

HIGH FIRE HAZARD SEVERITY AREA

My abrupt introduction to extreme wildfire behavior at the Powerhouse Fire was a typical large blaze in the WUI of greater Los Angeles County and Southern California. It was also the first large wildfire I'd photographed. The WUI is where nature meets human development, where fire and forest conspire against the encroaching developments and enclaves of humanity. The WUI can run from a rural subdivision of homes built amidst the mixed pine forests of the Sierra Nevada foothills to suburban housing tracts on the fringes of Los Angeles that abut dense brush, steep hillsides, and national forests. The WUI area is where the majority of destructive wildfires burn, when measured by property damage.

The Powerhouse Fire burned northwest of downtown Los Angeles in the rugged terrain of the Angeles National Forest amidst explosive chaparral fuels. Chaparral is a plant community found in both Mediterranean and Southern Californian climates. Chaparral is drought-tolerant and shaped by hot, dry summers and mild winters. There are various subtypes of chaparral with varying fire regimes (length of time between fires). But, in general, when chaparral fuels are at critically dry levels, they burn hot and fast and destroy everything in their path. Running on the wind, these fires won't stop until they reach the Pacific Ocean.

The night before I arrived at the Powerhouse, dozens of homes were destroyed around Lake Hughes. Low humidity, triple-digit

temperatures, and overnight wind pushed flames into the WUI around Lake Hughes, claiming hundreds of structures.

Twenty-four million people live in the densely populated megalopolis that is Los Angeles, running uninterrupted from the Mexican Border near San Diego to the sprawling mansions of Santa Barbara. While many live within the coastal plains and interior valleys of Los Angeles, San Diego, Orange, Ventura, Santa Barbara, Riverside, San Bernardino, and Kern Counties, the mat of subdivisions and tract homes extends further into the deserts and mountains each year, with hamlets and towns nestled in foothills and higher valleys where retired folks can escape the rat race, where people take refuge from the hustle. Often families seeking the affordability of a single-family home without the traffic and sky-high prices of the LA Basin and coastal California find themselves in the WUI. Places like Moreno Valley, Hesperia, and Santa Clarita have seen explosive population growth since the end of World War II, and they are all in the bull's-eye of major wildfire activity. Similar growth has occurred in the Sierra Nevada foothills and North Bay Area communities of Central and Northern California. Orange County, my home region, is no exception.[1]

The trade-off to suburban and rural living is the prevalence of fuel intermixed with structures in a historic fire corridor. The combination of homes, human life, and fuels creates a complex set of challenges for wildland firefighting and suppression. Trees, brush, grass, pine trees, even native Joshua trees and other yucca plants are all consumable organic materials for a wildfire. They are also intermixed among development, between homes, businesses, medians, and open lots. Vegetative fuel runs like seams through neighborhoods and towns.

This fuel, when combined with oxygen and heat, completes what's known as the "fire triangle" to produce combustion. And when the winds blow, as they often do along the Californian coast, there is no lack of oxygen propelling fire across the landscape. Some of California's deadliest, largest, and most destructive wildfires have occurred in the fall when fuels are critically dry and the Santa Ana winds are at their strongest.

In meteorologic terms, Santa Ana winds are a type of dry katabatic

wind that occurs when high-pressure cold air in the Great Basin spills down toward the coast. Due to compressional heating from the friction of all that air going over the smaller surface area of mountain peaks and through narrow passes, the air becomes bone dry and hot as it blows toward the coast. The Great Basin is a large geographic feature in the Western United States, over 200,000 square miles. This has a significant influence on California's weather patterns. A katabatic wind is one that carries air from a higher elevation down a mountain to a lower point. The winds race the rains, and if the winds win, fire often follows.

This is a simplification of how offshore winds work, but the result is a mass of air that moves downhill from coastal mountains blowing fire-feeding oxygen directly into the path of where homes are densely built in California—the coastal plains and foothills on the ocean-facing side slopes. If there is a fire with a Santa Ana at its back and homes in the front, you have conditions for megafires like the 2018 Woolsey Fire in Malibu. Another example, the 2003 Cedar Fire, was started by a lost novice hunter who started a signal fire under Santa Ana winds that quickly grew out of control. Until the 2017 fire season, the Cedar Fire was the deadliest and most destructive wildfire in modern California history. There is a fatal correlation between the occurrence of Santa Ana winds, Diablo/North winds (the Santa Ana's blustery cousins in Northern California), and major wildfires.

Wildfires also tend to escape initial containment on hotter days when the ignition component of fuels are higher. But they can also occur in the dead of winter under the right conditions. The Probability of Ignition, or PIG metric used by firefighters, means the probability that an ember landing in a fuel, such as grass, will ignite said grass on fire. The index measuring the PIG ranges from 0 to 100. For example, an ignition component of 80 means that an ember landing on dry grass on a hot sunny afternoon in the Los Angeles Basin will have an 80 percent chance of igniting that grass. Likewise, the ignition component will be close to 0 when it's cold and rainy on the Central Coast. When there are thousands of embers landing in front of a fire, it's a foregone conclusion that the fire will continue to spread and spot ahead of itself under wind.

When the winds pick up, fresh oxygen is heaped on the fire in waves, and the wind also physically pushes the flames forward. Canyons around Lake Hughes during the Powerhouse Fire acted like giant wind sieves, funneling flames toward homes and burning them overnight.

We are also seeing wildfires increasingly transitioning into urban firestorms once they jump from the WUI to more densely populated urban areas, as seen in the Tubbs Fire in 2017 and the 2018 Camp Fire in Paradise. The scenario plays out across Northern California and in other Western states and provinces in the US and Canada where wildfires are part of the ecosystem. Once the fire becomes established in the attics of homes, the fuel switches from brush and trees to the house itself, with the residential structure providing a dense and highly combustible combination of processed wood, plastics, and sometimes toxic chemicals that burn for hours. Wildfire behavior experts and climate scientists overwhelmingly agree based on existing evidence that these types of fires will continue to increase in frequency and severity and will occur outside of the traditional fire season (summer and fall).

After my close call at the Powerhouse Fire with flames jumping the road west of Lancaster, California, I stayed at the fire and regained my composure. I took a break to send photos to the newswire service I was freelancing for. As the afternoon waned into dusk, I came upon a reservoir that had uncontrolled fire burning behind it. I always loved photographing at night under the stars for traditional landscapes and had a tripod in the back of my car. As the light faded, the flames began to glow more visibly against a darkening sky. The warm orange hues of the fire contrasted with the blue-and-pink sky, and I was captivated.

I rattled off a few long exposures near the dam and began making my way home toward Orange County, which was a three-hour drive over half a dozen freeways. I was headed east along a county road toward Lancaster and the Antelope Valley Freeway, known as "the 14" in SoCal freeway parlance. I stopped maybe five miles away from the flaming front and set up my tripod to make a few more pictures. Stars and the distant glow of the fire punctuated the sagebrush and scrub of the transition zone to the Mojave Desert, and the images coming

through my camera's LCD screen intrigued me. In one frame were stars, foreground, and fire. Like the hues of dusk earlier that evening, the inky blue of the night sky contrasted with the bold colors of the fire. Fire is ironic. It embodies the beauty of nature on one hand, and the destructive forces of natural disasters and climate change on the other. Beauty and destruction, in one image. How could opposing forces be one and the same?

THE CYCLICAL NATURE OF WILDFIRES

In my 2018 photography book *Terra Flamma: Wildfires at Night*, I described the "Ballad of Santa Ana Canyon." I researched the archived Orange County papers of former forest ranger and amateur historian Jim Sleeper and other historic accounts. I found that wildfires burned in the same areas under similar conditions at alarmingly frequent intervals whether houses and towns were there or not.

Wildfires follow similar patterns and often occur in or near footprints of fires past. At one of the last firestorms I witnessed in 2018, the Woolsey Fire, this exact scenario played out. I had driven and studied the areas around Malibu, LA, and San Diego on road trips, photoshoots, and other errands, always observing the topography, fuels, and assets at risk in a given area. The Woolsey Fire burned through footprints of *forty-five* previous fires recorded between 1897 and 2018.[2] While many of those fires were small, a handful of them were also deadly, destructive, and historic. It's always a matter of when, not if, whether the 101 to Malibu corridor faces another major wildfire. The Saddleridge Fire in 2019 burned in a similar pattern as the earlier Sayre Fire,[3] under similar conditions in Los Angeles County. Both the Woolsey and the Sayre Fires jumped mega freeways, as embers sailed over the concrete into receptive fuels. Two more Santa Ana–fueled fires in 2017 followed similar behavior to the infamous 1888 Santiago Fire.[4] For the 2017 Tubbs Fire in Sonoma and Napa Counties, it followed a hauntingly similar path as the 1964 Hanley Fire.[5]

We wring our hands knowing that building in fire-prone areas places many of our communities in perilous situations. But we build there anyway.

THE MYRIAD CAUSES OF WILDFIRE

Wildfires are a frequent occurrence throughout Southern California. While peak fire season is typically from May to November, wildfires can happen anytime, anywhere, depending on fuel conditions and weather. I've watched Santa Ana wind–driven wildfires burn in January and have stood on the beach in December watching flames in Ventura jump the 101 freeway and burn to the beach. I've seen wildfires rip through the Mojave Desert in April and vegetation fires threaten homes in March in coastal Orange County. Fire season in California is now year-round.

Ninety-five percent of all wildfires in Southern California are human-caused. Fires have been started by accidental or negligent ignitions from downed power lines, weed whackers sparking into brush, dragging chains on trailers, auto fires into the brush, faulty electrical wiring in hot tubs or tennis court lighting systems, and improperly extinguished or illegally placed campfires. Arson does account for a smaller yet statistically significant portion of wildfires, approximately seven percent.[6] Add in dry lightning strikes starting remote fires in the Sierras. A dry lightning strike is a lightning downstrike that contacts the land, trees, or brush, without any associated moisture in the storm. This often causes new fires in hard-to-reach spots. Add the density of California's population recreating in the WUI and dozens of national forests, and you have a recipe for a constant source of wildfire ignitions, ranging from the sinister, to the reckless, to the negligent.

Consider the cause of California's deadliest and most destructive wildfire in modern history as of October 2020: the Camp Fire. The fire was caused by aged and improperly maintained power lines in the Feather River Gorge, owned by Pacific Gas & Electric. The line failed and molten metal fell into tinder-dry brush during high winds after

years of drought. Rubble from the burned homes is still being cleared out at the time of this writing, and I expect the town will never be the same. A comprehensive set of civil suits, court hearings, and legal maneuvering will likely result from homeowners seeking restitution for their lost properties and quality of life. Billions of dollars and dozens of lawsuits are on the line. However the North Complex, which burned in summer and fall 2020 into the Camp Fire burn scar, was started by a natural dry lightning strike, and one of the most expensive pieces of infrastructure at risk was the hydrological system feeding those very power lines.

Although wildfires in California are almost always caused by human factors, most are contained while they are small. Tens of thousands of wildfires happen every year, yet only a small number become large or destructive. Most wildfires you never hear about and are less than the size of a football field, extinguished quickly by the first crews on scene.

The factors that influence how, when, and why a wildfire becomes large and escapes initial containment are varied and include factors such as location, weather, climate (two distinct factors), fuel types, fuel moisture levels, terrain, wind, dead and down fuels, and the ability and effectiveness of initial attack resources to snuff a fire out during the early stages. A fire siege a century ago illustrates when human development, the forest, and critical fire weather combine.

ACCESS TO WILDFIRES, TRAINING, STAYING SAFE

PREPARATION, RESEARCH, AND PREDICTING THE FUTURE

After my journey into wildfire and the mishaps of the Powerhouse Fire in 2013, I decided that if I was going to photograph wildfires, I'd adopt the outlook of a wildland firefighter. I'd get the same safety gear, perspective, and training. And I'd be damn sure to have good fire boots that fit. If I was going to utilize the legal right media has to access fires and other disasters in California, I would be a good steward of that access, and try to turn my lack of experience into an asset for sharing stories with the general public from fires. I vowed not to become a liability. Due to it being the middle of fire season in California, I wasn't able to take any formal training, but I was able to purchase the right safety gear and plan for robust training in the spring.

In the meantime, I'd make use of the law written as California Penal Code 409.5, contained in Subsection D, to access wildfire as credentialed media and learn on the job. Section 409.5 grants certain government agencies authority, "Whenever a menace to the public health or safety is created by a calamity including a flood, storm, fire, earthquake, explosion, accident, or other disaster" to exclude the general public, "where the menace exists." This means police checkpoints,

evacuation zones, and keeping rubberneckers away from first responders and out of a fire zone. Forty-eight states have comparable provisions, which is a tremendous loss for documentation of wildfires, in my view. However, and this is the key legal provision giving media unparalleled access in California, Subsection D says:

> (d) Nothing in this section shall prevent a duly authorized representative of any news service, newspaper, or radio or television station or network from entering the areas closed pursuant to this section.

Bingo! This is why I and other storytellers get such access to wildfires. Without the media access law in California, *Terra Flamma* wouldn't exist, nor would this book. While access is a legal right in California, I view it as a privilege that can always be amended by interests who'd prefer to not have media covering certain aspects of wildfire. Laws can always be changed, and all it would take is a serious incident of media compromising first responder safety for that to happen (and it's happened at individual fires, as we will come to find out). Journalists refer to this access simply as "409.5." It's even printed on the back of the media placards that go on my truck's dashboard window at fires, to clearly identify myself as media. The exceptions are active crime scenes, and where media presence would interfere with fire operations, or safe egress of fire crews. Even if the area is deemed unsafe by first responders for media, they are not allowed to stop the "duly authorized representative."

This is why providing for your own safety and staying out of the way of first responders is critical. Once safety has been provided for, take pictures aggressively. I borrowed this phrase from number ten of the 10 Standard Firefighting Orders, which states "Fight fire aggressively, but provide for safety first."

I have a strong obligation to make smart choices and be safe while covering wildfires. With great independence in disaster zones closed to the public, comes great responsibility. These responsibilities include

wearing the proper personal protective equipment, or PPE, being aware of special fire hazards, listening to scanner radios for updates, understanding fire behavior, and yielding to fire engines and crews. You are there to document the work they are doing and the scene for public benefit. Becoming the story by being unprepared or reckless is an unprofessional *and* unethical outcome and should be avoided. As I learned at the Powerhouse Fire, all it takes is one mistake to put yourself in a bad spot.

Most of the time firefighters and law enforcement work with media for wildfire access in Southern California, and there's an understanding that media will do their reporting while staying out of the way of first responders, and it usually works, albeit with uneasy tension on occasion. There can be access challenges when it comes to law enforcement arbitrarily deciding what laws to enforce (or ignore), and it's not always guaranteed with rare (but increasing) safety exceptions due to media crowding in media-dense regions like Los Angeles. Regardless, at many wildfires I've covered in the better part of the last decade, firefighters are almost universally happy to work with media and have their story shared with the public, provided that safety comes first.

LOGISTICS

Getting past police checkpoints is usually the smallest obstacle when getting to a fire. Hours of prep work are required. To quickly travel to and photograph fires within the first twenty-four-hour period of a large fire, you must adopt the hybrid mindset of a firefighter-journalist and be prepared as both. Coming from a photojournalism background, I was prepared for the second element. To think like a firefighter, I took a page from their professional playbook.

Whenever there is Red Flag fire weather (issued by weather agencies as a Red Flag Warning or RFW), or when I generally suspect we have conditions for large wildfires, I prepare like a firefighter getting called out for a crew with a two-hour response window (or less) to get

to the station. When I spent a few days shadowing a local fire crew on the Cleveland National Forest after my first few seasons chasing fire, we only did trail work and brush clearing, but to me it was a clear view into the logistics and mindset of responding to a fire. That means when you're asked to be in a state of readiness, you are ready to go twenty-four seven. You have a "red bag" packed with fourteen days' worth of clothes, personal items, toiletries, and, if needed, prescription meds. You have all your PPE ready and in good working order. Batteries are charged, memory cards formatted, backup hard drives packed. I keep a red bag in my garage, ready to go for long campaign fires on assignment for the US Forest Service or as media when the blazes last for weeks. That crew I embedded with was the Trabuco Tigers, which are based at the bottom of the mountain range where the 1889 Santiago Fire burned. Fire is always cyclical.

I also learned to keep a smaller go-bag for semilocal fires in SoCal where I might spend a quick overnight or long day at a blaze but am close enough to run home for a night's rest in my own bed. In the Sierras I'm usually camping out or sleeping in my truck, but in SoCal those same freeways that encourage sprawl allow me to get home even at 3:00 a.m. from a fire 150 miles away. It's fairly easy in the dead of night when commuters are sleeping and traffic through the Los Angeles Basin reaches a nadir.

At home I back up all of my images onto a thirteen-drive RAID array and put the best images in the cloud, so even if my pickup truck and cameras are destroyed by fire, the photos are safe. I also have an off-site out-of-state full backup of my archive at a secret location. Everything boils down to readiness to get to a fire quickly and make photos when the action is happening. Sometimes catching the moment comes down to a matter of minutes, or in the case of the Woolsey Fire, a matter of seconds.

On Red Flag days, I keep my fire shirts, Nomex wildland pants, rigger belt, cotton T-shirt, hat, thick wool socks, and liner socks ready to go by my front door. I leave the clothes draped over the armchair in my open living room by the front door, so that if I decide to roll a fire,

I can be dressed and out the door in less than ten minutes. Lacing my fire boots takes the longest. Food, water, cameras, and any other equipment is preloaded into my truck the morning of RFW days. Wildland firefighters usually keep this gear at their stations or in their gear bags, but for me my condo is essentially a wildfire photography station, and my detached garage is the quarters for my truck. I'm not a nerd about this at all!

While wildfires are often in rugged, nasty terrain during hot weather, I'm rather extravagant with consumables. Snacks like Gatorade, RXBARs, trail mix, and sometimes premade sandwiches, if I have time and am feeling fancy, make it to the fire. The goal is to provide twenty-four hours' worth of calories and hydration so if shit really hits the fan I can follow the fire front without having to disengage (and risk losing access back) for a supply run. It took me three years to get the process dialed. I also don't want to go hungry or get dehydrated. Getting heat exhaustion and being cranky/hangry doesn't lend itself to good picture-making or fireground safety awareness.

I also try to maintain a fitness regimen that focuses on leg strength and cardiovascular endurance so I can hike for miles with equipment over the course of a day. Keeping up with crews hiking is important, but so is having an energy reserve to get to a safety zone or away from a shifting fire front. Firefighters take what is called the "pack test" each year for basic physical fitness—walking three miles in forty-five minutes on level terrain with a weighted forty-five-pound pack. It requires moderate physical conditioning, and the actual demands of the job are much more intense, and many elite crews have their own more stringent requirements. Whenever I think I'm in good shape, I see how efficiently hotshot crews move uphill with heavy loads like chainsaws and feel like a sloth. My camera equipment load maxes out at thirty pounds, but a heavily laden firefighter can easily carry fifty pounds or more. Smokejumpers often "pack out" double that when hiking out of a remote fire.

In 2013 I reviewed what gear got used, what worked, and what was a piece of crap. I try to streamline my equipment bag and preparations each

time. Being ready allows me to focus on safety and making pictures. I can handle being hungry and dehydrated, but I've noticed the quality of my photography and reporting is directly correlated to how tired I am. I focus on taking care of the little things so when the big things happen, I can focus on the figurative bigger picture, which improves my literal pictures.

I even sourced a US Forest Service flag and hung it in my garage alongside a California state flag. In postpandemic 2020 America, it's a daily reminder when I work out in the garage to finish my exercise and give it my best. Many firefighters I know are also lifelong students of fire. Yes, it's a job for them, and a hazardous one at that. But they also have passion—for fire, the outdoors, the forest, for understanding the clash of natural forces, humankind, and climate change.

PICKING WHERE TO GO

To operate safely on the fireground, I needed the same training that an entry-level wildland firefighter would get. I combined that with on-the-ground observations, reading every fire book I could get my hands on, and riding in the truck with veteran firefighters telling me stories of past fires and showing me what to look out for as the summer went on.

Understanding fire weather behavior and safety factors lets me pick which fires to cover. Will the predicted heat, winds, or fuel conditions lead to substantial growth that will threaten densely populated areas or remote spots? How can I frame a photo to tell that story? Also, monitoring radio communications on a scanner is important for situational awareness. Listening to firefighter and dispatch communication, in addition to the air tankers and air attack units monitoring the fire from above, allows me to stay aware of what's happening in a specific area. I also learned wildfire jargon to understand fire spread and other tidbits of info that can direct my planning.

Over eight seasons I've developed working relationships with fire crews. It allows for improved access when I see them at the next fire. If I'm a known quantity, crews are more comfortable with my presence,

knowing I'm less of a safety risk or liability. I decided to try and build these relationships after the 2013 season.

THE SMALL WORLD OF FELLOW FIRE PHOTOGRAPHERS

Across the globe, there's a tiny group of fellow photographers that focus on documenting wildfires. You can't get hired full time, the hours are bad, the pay usually low, and the conditions are harsh. But the perks and views make up for it.

Wildfire photographers are a unique niche of photojournalists. There are maybe a dozen of us in the US that focus on wildfires in the summer and seasons where fires occur.[7] We hail from a variety of backgrounds, from firefighters turned photographers to retired cops, to progressive climate change and climate action activists and the occasional thrill-seeker.

At fires it becomes an ad hoc crew. Every fire season the band gets back together on the fire line, coalescing around someone's vehicle while talking about the fire, filing photos, or catching up on life during quieter moments.

Obviously, there is a reason why we're at fires. Each photographer is on assignment for anything ranging from the community newspaper, to a national magazine, to a fire department responding to the fire, to sending images on-spec to a newswire agency in hopes of getting paid after the fact. I've functioned in all of those roles. For newspapers and magazines, you often have deadlines and need to bring your laptop, cellular air card, and hard drives with you into the field. You'll often be sitting at your car at 4:00 a.m., parked with the AC on, in front of a closed Starbucks for Wi-Fi. If you have cell service, you can use your wireless card to connect your laptop. Eventually I got an Iridium portable satellite unit where the data costs six dollars a megabyte for when I'm deep in the forest, or power goes out during a fire siege. Usually, agencies want you to send twelve to twenty images, so you do the math on cost to send just

images. This is why paying for journalism matters. There is a hefty cost in reporting wildfire images from the frontlines each season.

Photographing a fire freelance for a newspaper is usually a poor business decision. Once you factor in the cost of cameras, the specialized fire gear, repairs, boots which run five hundred dollars for a custom pair, radios, insurance, car payments, gas—it's below your cost of doing business. Hopefully you negotiated a decent contract so you retain rights to the images where you can maybe sell the rights to a few editorial clients down the line. It's a gamble that the long tail of images will help put your accounting into the black.

But many of us are not there for the money. My business model now depends on the occasional sale of a fire image to a company after the fact for marketing, or a multi-week US Forest Service assignment to pay the bills. Just don't bank on raising a family or buying a home by being a wildfire photographer. You better have other income, or rich parents. Selling fine art prints also helps.

When I get frustrated with the state of photojournalism, I wonder, "Can you put a price on sitting in the front row to something so awe-inspiring and powerful?" As twentieth-century photojournalist Cliff Edom said, "Being a photographer is a privilege." Contemporary photographer and film director Vincent LaForet says, "I didn't become a photographer to be rich, I did it to have a rich life."

On the downside, some of us eventually are affected by vicarious trauma. It's not the same as primary trauma or PTSD. However, the long-term effects of seeing neighborhoods burn, people get injured, and the fallout from fires take their toll. Those who cover wildfires for many seasons come home changed. It's important to take care of your mental health, and health in general. Fire gives you an appreciation for the quiet days and time with family and friends.

During that first 2013 fire year, as I started fulfilling my personal commitment to learning about the wildfire world and safety post–Powerhouse Fire, reality blew back in my face. I saw how life could be taken away in an instant. Wildfire quickly showed me that it could be a cruel and unforgiving force, a force that consumed all in its path.

GRANITE MOUNTAIN

I checked Twitter during Sunday evening church service. A fire had started near Yarnell, Arizona, earlier in the weekend and exploded in size. The Yarnell Hill Fire threatened the town in Arizona where "the desert breeze meets the mountain air." I'd never been to Yarnell and knew nothing of wildfires in Arizona but had been following the blaze through various accounts I followed that tweeted fire info. As I scrolled and the feed refreshed, the tweets turned frantic as reports came out that firefighters were missing. Then it was an entire crew. Soon came unofficial confirmation and the internet rumor mill that spread faster than the fire itself—nineteen fatalities. The Granite Mountain Hotshots were gone. The entire crew allegedly died during a burnover, save for the lone lookout Brendan McDonough, who barely made it out getting rescued on an ATV.

I sat there in the pew, stunned.

It was barely a month after the baptism of flames at the Powerhouse Fire, and the memory of my panic run back to my car was fresh. How could nineteen firefighters die in 2013? Isn't that why we have radios, helicopters, the 10 Standard Firefighting Orders and the 18 Watch-Out Situations? I almost walked out of the service. My mind disconnected from the sermon and became fixated on my phone, looking for updates, context. Maybe it was a terrible mistake, the crew was just missing, they just needed accounting for.

It was not to be. It seemed like God was taking a day off.

The fire went on to burn into the western Yarnell subdivision of Glen Ilah, where it ultimately destroyed 127 structures in the area. The loss of the Granite Mountain Hotshots remains the deadliest firefighting incident since the 9/11 terror attacks on the World Trade Center. Their loss put the challenges of wildland firefighting front and center across the United States and worldwide. Nineteen hearses coming down the mountain, underneath overpasses topped by mourning red fire engines draped in American flags.

I covered a press conference a few days later in Seal Beach with Los Angeles County Fire Chief Daryl Osby, family friends of the Woyjeck family (one of the Granite Mountain Hotshots who perished). He and some of his battalion chiefs almost broke into tears at the Seal Beach fire station. A couple of the Granite Mountain crew members originally were from Orange County, young men around my age. How many degrees of separation did we have? Did we pass each other in traffic, stand next to each other in a bar at the beach, play against each other in a high school football game? It felt close to home, despite my nascent foray into photographing the wildfire world.

Photographing fire was more than just drought and forests and green engines now. It was personal, and it took me another three years to step into a church again, coincidentally nearly three years to the day, and the same church where Granite Mountain Hotshot Robert Caldwell's funeral was held in Newport Beach. I recounted the memory in my journal:

June 30, 2016:

Remembering 19: Three years ago this evening, the Granite Mountain Hotshots experienced an entrapment at the Yarnell Hill Fire outside of Yarnell, AZ. Nineteen professionals defending a town close to their own home, on their home turf, gone. I distinctly remember being in church in Costa Mesa, CA, that Sunday evening, seeing the news light up on Twitter.

Reading the news out of Yarnell, I felt a pang of fear, then

sorrow. I tried to focus on the sermon but couldn't quite get this feeling out of my mind, as I prayed for the crew to whoever was listening out there in the celestial realm. Details emerged in the coming days—some of those who died in the line of duty had grown up not far from me and were my same age.

Life has a strange way of bringing you into worlds or cycles for reasons we can't fully understand until much later, but I felt compelled to document wildfire and the work that wildland firefighters do.

After three years since stepping into church as an attendee, I returned on another June Sunday a few weeks ago. I had almost forgotten that one of the Granite Mountain crewmember's memorial services was held in the same space. Realizing this during the service, my mind drifted back to the Sunday in 2013.

It's taken three years to fully understand why I'm drawn to this world of wildfires and wildland firefighting. Terra Flamma was conceived not to just post pictures of burning mountains at night, but to get the most impactful, honest, in-your-face images of wildfire and wildland firefighters' work. It also looks at the effects of Western drought (and ultimately climate change) upon the world. I want people to see what the Granite Mountain Hotshots did and sacrificed, and what their counterparts continue to do.

Fire works on its own schedule. It doesn't care about people, plans, development, your Sunday family dinner or Friday night date. Two weeks after the loss of Granite Mountain, as the fire world stumbled its way through grief and shock, came a new blaze that threatened yet another vulnerable mountain town.

No matter the pain, the fire needed fighting, and the stakes were just as high as Yarnell, if not higher in the bigger town and major fire ticking time bomb of Idyllwild.

FIVE

INITIAL ATTACK AT THE MOUNTAIN FIRE

After the Powerhouse Fire and the loss of the Granite Mountain Hotshots, 2013 was shaping up to be a brutal fire year. I arrived in Idyllwild hours after the Mountain Fire started, two hours east of Los Angeles in the San Bernardino National Forest. It was dusk and the sun reflected a glow of cinnabar from the pyrocumulus. It was during the Initial Attack, or IA period of a fire, which generally covers the first twenty-four hours. This is when many fires are extinguished or controlled, but the Mountain Fire was not to be tamed for weeks.

As I drove into a canyon where the fire was actively burning, I turned a corner to see a wall of fire on the hillside and the entire slope aglow with embers. I was mesmerized. I'd never seen anything like it. I was shaking a little from adrenaline and fear, remembering my roadside encounter a few months prior. It looked as if I was peering into the gates of hell, a Dante's *Inferno*.

Down the canyon, I could see the faint flash of sirens and proceeded down the narrow dirt road to where fire engines were protecting intact structures. Another crew hosed down a burning outbuilding while the main house on the property was burning to the ground. By the time I arrived, all the wood timbers on the framing had burned, and low flames danced on the concrete foundation of the home. It was the first time I had seen a structure actively burning at a wildfire.

Up the canyon, there were at least half a dozen structures in similarly burned condition. Smoke hung in a haze around the fireground, and it felt like you were standing on the downwind side of a campfire. The scent of burning wood permeated the air and ash filled the night sky, backlit by the sirens and headlights of fire engines driving the road.

As I hiked around to photograph firefighters protecting the surviving homes, I came upon a group of men curled up against the side of a house, asleep. A small backing fire smoldered twenty feet away in the brush. The men wore orange instead of yellow, and I realized they were Cal Fire prison inmate firefighters. They were curled up resting for a few hours as their non-inmate crew captain told me to be quiet and move along. Apparently, they had been cutting fire line since the fire started and had a moment for a brief rest. It was dark out save for the glow of the fire softly illuminating them.

As I continued to drive around the area where the Mountain Fire was burning, I ran into another brush engine with a crew of four. We were back in a box canyon with only one way in and one way out. Radio communications were sparse and cell service was nonexistent. I'd been in the area for about an hour, and the crew said they'd been there since late afternoon, with no information about what the fire was doing outside the immediate area due to poor radio communications. I filled them in as best I could and thought to myself: *This is what the fog of war must be like.* If this crew of professionals felt isolated, then I—a solo photographer in the middle of a raging wildfire—definitely was.

Making my way out of the canyon back to the main highway, a helicopter flew low overhead with a bright spotlight and a whooping siren. I pulled over and parked, realizing that the helicopter was dropping water *at night.* At other early blazes, I'd seen aircraft fighting fires during the day, but seeing a helicopter fly through virtual darkness amid canyons and tall pine trees to make pinpoint drops was something new. Turns out the helicopter belonged to the San Bernardino National Forest, and that night was the first time the US Forest Service had used night-flying helicopters equipped with night vision since the 1970s.[8] I stood alongside inmate firefighters watching the copter swing

low over burning trees over a home, the siren blaring seconds before a water drop. We were close enough to hear the weight of the water crash into the tree branches.

Back on the main highway at the intersection of California Highways 74 and 371, east of Idyllwild, the parking lot of the Paradise Cafe became a de facto media hub and evacuation center. News vans, fire engines, and evacuees alike camped out watching the fire burning up the mountain and canyon. In the back of a pickup truck sat a woman covered in a blanket, looking shell-shocked and exhausted. She'd likely been evacuated on a moment's notice. I made a quick photograph of her with the fire in the background. In a journalistic misstep I did not ask her name for a caption, a novice mistake I would learn not to repeat. If traumatized civilians were gracious enough on one of the worst days of their lives to give permission to be photographed, I could at least ask for their name. I knew better from journalism school, and I think the adrenaline impacted my ability to think clearly. The moment stuck with me, and in editing the image I could feel her apprehension.

I stayed near the parking lot to make a few more long exposures of the fire underneath the stars and drove home late in the evening with the image of the evacuee seared into my mind.

FIRE ORGANIZATION

It was clear from the beginning: the Mountain Fire would go "extended" or become a complex fire that needed management by an experienced Incident Management Team (IMT). On the second day of the blaze, I could see the pyrocumulus, now sixty air miles away from the beaches in Orange County to the west. The fire was going nuclear.

I returned to the cafe parking lot and, down the highway, a massive Incident Command Post (ICP) had materialized overnight. I drove in as media and parked among hundreds of fire engines, water tenders, and pickup trucks. It was around 7:30 p.m. and at least one hundred

firefighters were lined up in a food line. Dozens of semis were arranged in an orderly fashion, making a trailer and tent city.

This was a Type 1 Incident run in unified command with the US Forest Service and Cal Fire, the state firefighting agency. Type 1 Incidents are typically the most complex and serious fires, which often feature a large wildfire burning near values such as homes or more densely populated areas. "Values" in wildfire parlance refer to anything that would be considered a loss if destroyed or damaged by fire. This could be anything from a house, to commercial timber, to intangible impacts on the quality of life (air quality), and lost income or business due to fire evacuations and related closures. Type 1 fires get a full management team and receive resources from across the country depending on need. ICS is also used during hurricanes and other disasters.

An Incident Management Team (IMT) is comprised of a group of experienced veteran firefighters, administrators, logisticians, public information officers, and other key team members that descend on an evolving wildfire, often with only an hour's notice, for up to fourteen consecutive sixteen-hour-plus days. They may not be pulling the all-nighters that initial attack crews face, but the constant low-level stress of making the decisions that put firefighters in harm's way can place heavy mental and emotional—and potentially legal—burdens on the decision-makers.

An IMT functions from the top with the incident commander (IC) overseeing officers that are in charge of planning, operations, logistics, finance, and other firefighting support. Each of those subgroups then has deputies and assistants. On the fire line the blazes are mapped into divisions. The more letters in a fire's divisions, the bigger it usually is. For example, a small fire may just have two flanks, referred to as "Alpha" and "Bravo" in the NATO Alphabet. Sometimes they will call the second flank "Zulu" to prevent confusion. When you get to megafires and beyond, you will get double letters like Division XX, or Xray Xray. Multiple divisions will be in a branch, where the Branch Superintendent will oversee Division Superintendents, who oversee smaller strike teams and modules within a division. There is

hierarchy all the way down to the individual firefighter, camp cook, and radio technician.

There are air tanker bases, water-dropping helicopters, water tender drivers, washing machines, sleeping trailers, radio programming booths, and equipment caches with hoses, firefighting tools, fuel, and Pulaskis. A Pulaski is a hand-tool that is half ax and half hoe, attached to a piece of sturdy wood that allowed for digging, cutting, and grubbing on a fire line. It's named after Ed Pulaski of 1910 Big Blowup fame. It's commonly used by hotshot and other hand crews in the thick of fire suppression. A giant fire map stapled to a piece of plywood in a field is used for early morning and evening crew briefings. Briefings address weather forecasts, fire behavior, containment objectives, administrative issues, and community updates. A fire camp is its own mini city, as I saw on the second day of the Mountain Fire. The fire had started barely twenty-four hours before, and there was a literal army of firefighters already present.

As I left the Incident Command Post, I ran into the Heaps Peak helitack crew running sling cargo loads across the highway at a makeshift helibase in a ranch field. A slingload is where the items are put into a net, then attached via a heavy-duty strap and literally slung under the helicopter and ferried to a remote location. A helitack crew is a fire module that uses a helicopter for delivering firefighters and supplies to remote fires and can fight the blazes themselves.

The ranching family had loaned the Forest Service use of their property for the fire. As the sun set over Mount San Jacinto to the west, the rays of light were bent and made orange by the smoke coming off the fire. Pallets of Gatorade, water, MREs, gasoline, and other backcountry wildland fire items sat in the meadow as the crew ran a nonstop daytime operation, bringing supplies to hotshot crews in the backcountry. There was even a specialized control tower that was contained inside a semi trailer deployed at the site. The ranch became a self-contained mini airfield.

Between witnessing the fire behavior, homes tragically being destroyed, the fire industrial complex in motion at the ICP, and the helibase operation, I was struck by the scale of the human response to these fires. The impact on area residents was also severe. Before driving to the

ICP on the second day of the blaze, the entire town of Idyllwild had been evacuated. Coming up the highway to the mountain, steady streams of hundreds of cars packed full of belongings came down the hill. I photographed a retired firefighter and his wife pulling valuable art off the walls of their cabin, knowing they may never see their house again. I watched two neighbors cry in each other's arms as one of their wrists bled from trying to pull their panicked cat out from under the couch. I eventually had to put on my thicker brush coat and leather work gloves to help a family load their dog into the car. The dog was having anxiety and nipping at the owners. It also illustrated an ethics decision I had to make.

Fundamentally, I'm a photographer on assignment at a wildfire, but I am also a human. If there's an immediate life threat or someone who needs help, I will help them. My obligation and commitment to other humans' safety supersedes photos. In this case, I felt that helping the family crate their dog was more important than the photos I could've made. There were also no first responders present, or I would've deferred to them for aiding the public. It took two minutes, and I went on my way, and they were able to evacuate safely.

Ultimately, the Mountain Fire's spread was influenced by factors like drought-impacted fuels leading to easier combustion, hot summer temperatures, and low humidities at mountain elevations. The entire town of Idyllwild was evacuated during the fire. The fire burned nearly 28,000 acres and was determined to be caused by faulty electrical wiring on a residential tennis court outside of town. The property owner was sued by the federal government to the tune of twenty-five million dollars to cover the costs of the fire.[9] It's the perfect example of how wildfires can be human caused by accident and without malice, but the end result is still destruction and loss.

HAPPY BIRTHDAY

A few weeks after the Mountain Fire wound down, winds whipped a fast-moving blaze named the Silver Fire in the Banning Pass between

Riverside County and the Palm Springs area. It was just downhill from the fresh Mountain Fire burn scar. The Banning Pass is notorious for wind-driven wildfires and the erratic fire behavior that comes with them. The Silver Fire was eerily close to where the Esperanza Fire burned in 2005, resulting in five firefighter fatalities on a US Forest Service engine.

The Silver Fire burned thousands of acres during the first few hours and forced civilians to shelter in place as the fire burned through. The blaze moved so quickly there wasn't even time to evacuate residences. It was the first time I'd heard about "sheltering in place," a terrifying thing to hear over the radio. The conditions that were killing firefighters and civilians, and causing houses to burn, were happening again. Fire didn't care about what was in front of it.

It also happened to be my birthday, and I was on assignment for my newspaper apprenticeship. I had dinner planned with my family, so I was checkmated into plans the rest of the day. All I wanted to do was chase fire. Eventually, I finished the day's assignments and got to dinner. As the evening dragged on, I decided to just leave after the main course and open cards at a later date. The photo editor for the newswire agency texted me: "Here's an assignment for your birthday!" I left the restaurant to the chagrin of my family, the first of many missed and cut-short events I'd bail on to chase fires.

Arriving in the Banning Pass late that night, I saw the lower side of San Jacinto Mountain covered in glowing embers to the desert floor. I stopped at the hamlet of Haugen-Lehmann off Interstate 10, across the valley floor, to make a wider-angle scene-setter photo. There were no roads with easy access to where the fire was burning. Stars shone overhead, and the field of windmills in the pass were illuminated by light pollution in the foreground. I decided to make three photos and stitch a panorama together to capture the scale of the blaze. A man rode up to me on a child's bicycle as I stood near the freeway exit ramp bracing my camera tripod against the buffeting wind. He braked, and with one foot still on the pedals and the other one on the asphalt, he said, "In summer it's hell here," before pedaling off. Looking out at the scene across the desert, I agreed. It felt like a Coen Brothers movie.

It was only midway through my first season of documenting wildfire and I'd almost gotten hurt, observed the worst wildland firefighting tragedy in twenty years, covered a major Type 1 Incident, and left my own birthday dinner early to chase a breaking fire. It was barely the beginning of August, and there was plenty of summer left in California. I began to wonder: Was this more than drought?

IT'S THE CLIMATE

After photographing major wildfires during the first half of summer 2013 in California, I increasingly became concerned that drought was not the sole factor driving these worsening wildfires in California. Was a warming planet with widening weather extremes a component in these blazes? I'd watch the Powerhouse Fire rip through a community, the Mountain Fire nearly burn down Idyllwild and half a mountain, and the Granite Mountain Hotshots were gone, with half the town of Yarnell burned as well.

What was going on?

Human-caused climate change is making wildfires larger, deadlier, and more destructive. Today, there are more hot days per year that lead to conditions conducive for large fire growth. The globe's warmest year on record was in 2016, with 2020 a close second as of this writing, and possibly exceeding 2016. The ten warmest years on record have occurred since 1998.[10] Record keeping began federally in 1880. This combined with greater swings (climate whiplash) between dry and wet periods in California have led to an increasingly vicious cycle of high fuel loads that dry out, creating tinder for megafires.[11] Combined with development in the WUI since World War II, it's a deadly and alarming scenario increasing in frequency. Add in historic fire suppression and a backlog of prescribed burning, and it's a recipe for wildfire disaster.

In 2020 the parts per million (PPM) of CO_2 in the atmosphere exceeded 410. Using tree ring data for centuries-old oak trees in the Central Valley, and ice cores dating back hundreds of thousands of years,[12] we are able to look further back for California droughts, carbon deposited by wildfires onto polar ice, and CO_2 in the atmosphere.[13] There is a direct correlation between modern ice core samples, instrument measurements, and industrialization of humankind, with a rapid spike after World War II, coinciding with the rise of the automobile, freeways, and the internal combustion engine on a wider scale than before the war.

I spoke with UC Merced professor and codirector of the Center of Climate Communication LeRoy Westerling, coauthor of the influential *California's Fourth Climate Change Assessment*. Westerling and his colleagues have authored some of the most-cited peer-reviewed research discussing the impact of anthropogenic (human-caused) climate change on wildfires.

Westerling writes, "We get these whip lashes of wet season, really wet winters and dry summers." This leads to a broadening of times when smaller wildfires in California can morph into megafires. While wildfire season is year-round in California, Westerling writes, "the combination of more wet years and dry years, together with the more chaotic fire season is going to make for a lot more extreme events."

The most extreme wildfire events in California typically occur in the fall when offshore Santa Ana winds in the south and Diablo Winds in the north howl through the mountain passes into populated areas. Typically, these fires occurred in October and November,[14] but we are increasingly seeing large fires later in the year. Santa Ana winds, for example, happen during the winter and even late-spring months, but typically rains have also occurred so the fuels are not necessarily receptive to carrying fire. However, with precipitation extremes, the windows for Santa Ana winds to ignite fires has grown.

Westerling says, "In those years when you get less precipitation and then the winds, [they] can play an even bigger role than they otherwise might."[15] For example, the 2017 Thomas Fire occurred in December 2017, with two weeks of Red Flag fire weather with offshore Santa

Ana winds. The fire burned until after Christmas, when wetting winter rains had already arrived in California. "Wetting" rains mean it's not just a couple hundredths of an inch of water falling from the sky. It's an amount of precipitation that has meaningful effect on the dryness of fuels, or ends fire season. That's commonly accepted at two inches or more of rain during a storm system. The winter rains came in January and February, fresh on top of the Thomas Fire burn scar, leading to tragedy with mudslides in Montecito. These are events that are typical to California, the fire, the flood, and the winds. However, they are more likely to result in increasingly large and volatile incidents. The scientific body of research supports findings of wildland firefighters on the ground, who are in many ways bearing the brunt of the new wildfire reality.

In 2017, the largest, most destructive, and deadliest wildfires in modern California history occurred.[16] All three of these macabre records were broken again in 2018. By September, 2020 was already the largest fire season on record by acres burned, before the arrival of significant offshore winds across the state.

We are losing the late-spring and early-fall rainstorms in California that act as shoulder season weather, meaning there are more days of dry fuels at critical levels ready to burn in wildfires. Combined with more hot days per year, it is an explosive combination for extreme wildfire behavior.

Former Cal Fire Chief Ken Pimlott, who retired in 2018 shortly after the Camp Fire in Paradise and who oversaw one of the largest fire agencies in the US through dozens of destructive wildfires, says, "We've always had large fires in the state, those conflagrations, what's really changing is duration. It's the length of time of these events . . . There really isn't any downtime anymore."[17] Firefighters on the frontlines see the acute effects of climate change every season.

A PHILOSOPHY ON CLIMATE CHANGE

At this point there is no longer a scientifically feasible or morally sound argument for saying climate change does not exist or for arguing to wait

and see more of the results. The results are in front of us. In burned towns, underwater deltas, and flatted crops. Decades of peer-reviewed evidence and the 2020 fire season can all be tied together. Years of obfuscation on climate science and misinformation campaigns by energy companies like Exxon Mobil also add confusion to the layperson's understanding of the immediacy of our climate crisis.[18]

For California wildfires, climate change is here; it is no longer an abstract concept. Ask the people who lived in Paradise.

Over seventy percent of Americans believe in climate change as a serious issue.[19] Doubting that climate change is driven by humankind is comparable to maintaining the earth is flat in light of overwhelming evidence that it's round.

To limit the most destabilizing and catastrophic climate change impacts, warming needs to be limited to 1.5 degrees Celsius. Because of locked-in cascading effects, that means emissions need to be reduced to *zero* by midcentury.[20] Even more bleak is the fact that national pledges for less aggressive targets haven't been met, and predictions put the actual change between 2.7 and 3.1 degrees Celsius by 2100. This will make portions of the planet virtually unlivable for humans. Our wildfires are just starting to get worse. This is just the beginning.

Paradise. Malibu. Redding. Fort McMurray. Siberia. The list goes on. Different parts of the globe are pretty much on fire nonstop in this new climate reality.

We can live with the WUI and wildfires while working to reduce our carbon emissions. How many more destroyed subdivisions will it take? Broken families who lost loved ones in Paradise. Climate trauma. Firefighter PTSD and shortened life spans due to smoke inhalation. The August 2020 California lightning siege has caused twelve hundred premature deaths and forty-eight hundred excess hospital visits.[21]

Globally, 2020 was the hottest year on record. Heat waves from the SoCal desert, to the Arctic, to the Russian tundra broke records. Temperatures of over one hundred degrees Fahrenheit were recorded in June in Siberia.[22]

This led to massive boreal forest fires in northern latitudes, from

lightning strikes and human starts, leading to the massive burning of important carbon sinks acting as bulwarks against even higher CO_2 in the atmosphere. California's 2020 wildfires released more stored carbon into the atmosphere than a year of emissions in the state.[23] Eventually it will become a brutal loop of worsening consequences: more CO_2 released making the atmosphere hotter, leading to more fires. Scientists refer to these occurrences as "tipping points." The more fires there are, the more CO_2 sequestered in biomass is incinerated into the atmosphere, the hotter the weather becomes, and the more likely fires become. It's a vicious cycle.

These worsening wildfire loops, without an immediate and significant plan to reduce CO_2 emissions over time, will impact more people as fires become larger, more frequent, and occur in places less likely to have them. There will be more fires, more evacuations, and worsening air quality. At-risk populations with impaired lung function, asthma, or other pulmonary issues are at especially higher risk, as are seniors with limited mobility, those without the luxury of owning a car, etc.

In Paradise, California, post–Camp Fire, there was a twenty-five percent housing loss in Butte County over a matter of hours. The groundwater was contaminated with benzene, costing an estimated three hundred million dollars to fix.[24] Add in the immediate deaths, mental health effects, loss of jobs, and quality of life, you have a cascade of effects.

California wildfires are worsening at different rates in the state, depending on the ecosystem. Chaparral is being impacted at a different rate than pine forests or the desert. But the net result is increased wildfire activity across the board.

Add in another event, like a global pandemic, and the effects compound even more. During summer and fall 2020, the United States federal government's failed response to the COVID-19 pandemic resulted in a quarter million Americans dying alone and afraid and tens of thousands being evacuated under shelter-in-place or restricted-movement health orders. Parking lots and playgrounds became evacuation centers. Some people had nowhere to go. For those

in poverty or without emergency funds, having to evacuate without money for a hotel, a real evacuation shelter, or friends or family to stay with means forced houselessness. The American Red Cross and other disaster aid organizations prepared for this, so the end reality was that some shelters were open with health protocols and socially distanced sleeping areas, mercifully. As of this writing, there haven't been reports of evacuation center outbreaks. However, multiple news reports have been published during and after wildfires about people living in their cars with nowhere else to go.

Does this sound like how we want to live? Are we great yet? Reduction in quality of life, you say? How about no life for the nearly ninety people who died in Paradise? Or a quality of life eliminated, because over ninety percent of the town burned down. For many, there was and is little quality of life left to enjoy.

And it's happening again and again.

It's alarming, and we should be alarmist about it. We only can blame ourselves for not listening and taking action at a national policy level. Lives are at stake.

A PERSONAL PERSPECTIVE

Meteorologist and climate champion Eric Holthaus pointed out the average age of humans on the planet is thirty years old. As I began writing this book after the brutal 2018 fire season, I had just turned thirty myself. My lifetime hasn't seen a single normal temperature month. A total of 415 months since the late 1980s have consecutively been above baseline pre-industrial temperatures.[25] And while 2020 is on track for a record heat year, July 2019 was the warmest month on record. Records that stood for decades fall in less than a year, both with temperatures and wildfire acreage, property destruction, and lives lost. While correlation does not always equal causation, the rise in global temperature and the increase in wildfire-related losses are increasingly linked.[26]

Climate change was a new reality I was born into, forged by the

decisions of generations past and the ignorance of those who put mate-
rial gains over long-term health. My generation and the ones that come
after it will inherit a heated planet. People of color, including Black,
Indigenous, Hispanic, and other traditionally marginalized groups
in America, or those who are economically disadvantaged, stand to
lose the most due to environmental racism in America. Pundits often
refer to climate change effects as the "new normal," but there's nothing
normal about the destabilization of world climate systems. It's a new
reality, to put it kindly.

Generally, lightly regulated capitalistic nations don't have a great
record of consuming resources responsibly. Ecosystems are ravaged
without robust environmental protections. Since the end of World War
II, federal efforts like the creation of the Environmental Protection
Agency and ensuing Superfund program have helped to stem this tide,
but only to an extent.

Shortly after entering the White House in early 2017, the Trump
administration gutted enforcement at the EPA, which removed teeth
from the agency to enforce environmental laws. The health effects on
Americans will last for generations both from increased pollutants
and relaxed fuel standards.[27] The former Trump administration bears
responsibility for the ensuing deleterious effect on our right to clean air
and water. The former president and his administrative quislings are
literally complicit in crimes against humanity.

Combine this with the president's inaccurate and simplistic rhet-
oric on "raking the forests" and blaming state politicians in the wake
of California's 2018 fires. Trump also denied wildfire aid to California
in 2020, before a large public outcry pressured his administration to
reverse it. That's a clear track record of the administration playing with
American's well-being and the climate. To fact-check, over fifty percent
of forests in California are federally managed.[28]

I have an obligation based on what I've seen, experienced, felt,
and learned to share the story of wildfires and climate change. To be
clear, it's egotistical to think I've got some sort of mandate to share
these stories—I do not. I simply maintain a strong conviction that fate

and life have come together in such a way where I can be one of many voices helping to share the message.

In addition to sharing the work of wildland firefighters and affected civilians, it's one of my driving factors chasing fires. This really is about human rights, humanity, and doing what's best for *everyone*.

As Dr. Seuss wrote, "I am the Lorax. I speak for the trees. I speak for the trees, for the trees have no tongues." And those trees that have no tongues do a lot for us—they moderate heat, absorb CO_2, and respirate oxygen. Climate-worsened wildfires take those trees away and release the carbon they sequester instead. We must fight for the trees and forests and ecosystems as if they were our future, for their fate is intertwined with future generations of humans. They *are* our future.

Failure to act is tantamount to a death sentence of untold humans, animals, and plants. And if we don't act soon enough, perhaps the dark fate of our own making will come to fruition. I hope not.

I'm just one person and don't profess to speak for anyone but myself. We all need to be the Lorax. It's the climate.

SEVEN

MEGAFIRE

As the summer of 2013 slogged on, I had a growing feeling of unease that these fires in my backyard and beyond were more than the fleeting effects of drought. Existing scholarship said it was climate change, but to me it was simply an academic abstraction, and the connection wasn't yet present. I believed in climate change, but it seemed like a far-off issue that we'd reckon with decades down the line. I also felt that the possible climate-change issues would be less severe than worst-case scenarios projected. It was still too soon for major impacts on wildfires.

I was wrong.

The Rim Fire was the first "megafire" I photographed, and it confirmed to me that human-caused climate change was a significant factor in worsening wildfires. To this day only a handful of fires I've seen match the size, destruction, and ferocity with which the Rim Fire burned. For my inaugural year of wildfire photography, it was a monster. There's no other way to describe it.

At the time it was the third largest blaze in history at over 257,000 acres. It burned for months in Yosemite National Park and the Stanislaus National Forest, clogging the tourist mecca with smoke at the height of summer. This was also my introduction to wildfire in the Sierra Nevada mountains and my first time actually in Yosemite

National Park. I faced access challenges and problems with my PPE, but those experiences forced me to learn quickly in the field.

The Sierra Nevada mountains run north–south over much of California, forming the eastern edge of the Central Valley and points farther north. The western slope is sometimes called the Sierra Front, and the foothills and mountains above the valley floor are an epicenter of climate change impacts. The steep, rugged terrain is a mix of pine, chaparral and, at lower elevations, oak and grasses. As temperatures warm, the treeline for mixed pines increases in elevation. A volatile mix of chaparral brush takes its place. In the zones where they intermix, it provides ladder fuels for fire to transition into crown fires, making them more destructive.

While roads and towns dot the Sierra Front, it is much less densely populated than many of the urbanized areas in the Los Angeles Basin that are in vulnerable WUI. However, WUI still exists on the edges of towns, in forests, and around cabins and rural developments in the Sierras, with the added challenge of steep terrain and access. The Sierras can also have wind, rain, snow, and fire all in the same day. Drought and the ensuing bark beetle infestations led to newly dead trees that were susceptible to large fire. The first two years after mortality, affected pine trees are the most flammable, before their desiccated needles fall off. Afterward trees are still flammable, but less so.[29]

Steep terrain, difficult access, and dense overgrown forests from fire suppression all led to explosive fuel conditions that made fighting the blaze difficult. The Rim Fire was years, even decades, in the making. Add in Yosemite National Park, the height of summer tourist season, a major reservoir that provides drinking water to the Bay Area, and it's the definition of a climate change–fueled disaster.

The Rim Fire was burning for some time before I headed north. I was working full time as an apprentice at the *Orange County Register*, and I had the commitment of daily assignments in Southern California. As the fire continued to rage for days, I eventually convinced my editor to let me cover the fire since the Orange County Fire Authority (OCFA) had sent a "strike team" of five brush-specialized engines to

the fire. An FBAN, or fire behavior analyst, was also part of the IMT from OCFA. That meant that Orange County firefighters would both be in the field on the front lines and helping make important decisions at the command level.

It was an eight-hour drive to the fire through Los Angeles and into the Central Valley, a drive I'd eventually make dozens of more times. It was my first time going that far north on Interstate 5 since attending summer camp as a kid, just south of the Rim Fire. It was a different world now. Everything en route was a yellowed brown, beaten down by the relentless sun. You could see the pyrocumulus, or smoke column, from one hundred miles away, and the drift smoke from even farther out. I stopped in Merced and changed too early into my yellow Nomex fire jacket and pants when it was over one hundred degrees.

I was nervous, excited, a little scared, and definitely sweating.

I had my brand-new White's Smokejumper boots, improperly laced and not broken in. My feet ached every step I took, and they swelled by the end of each day in the summer heat and thick wool socks. Traditional wildland fire boots are based on logger styles from a century ago and haven't changed much. They are made to order by hand, with rebuildable soles and a high arch and heel to help with traction in steep terrain. They now have heavy Vibram soles that are both stitched and screwed in, so even if the sole melts, it won't fall off. It takes a lot to best good fire boots, and they offer reliable protection on hot ash. That also means breaking them in takes weeks and miles of walking and wear.

Finally, up in the mountains in the late afternoon near the town of Groveland, where the highway leads into Yosemite, I thought I'd try my luck accessing the fire with my press credentials. I'd heard rumblings from other photographers and reporters that media access had been shut off. The incident command team and law enforcement were claiming an exception to 409.5d for safety, but was abusing the spirit of the law, and the letter, which provides for safety closures only as long as necessary. It was a total closure of unescorted access for days. There was also complex jurisdiction on the state, Forest Service, and national park

land. Law enforcement also ticketed at least one photographer for being on forest land for simply doing their job taking photos. Safety came first, but it was clear this was an overreach of the 409.5d exception.

I was greeted by two fancy new US Forest Service police SUVs blocking most of the highway, one parked halfway into the lane for oncoming traffic. The officers sat there, doors open, like they were running a checkpoint in Berlin after WWII. When they saw me pulling up, they flagged me down and curtly told me to get lost. I attempted to discuss access and they cut me off. They had guns and badges, I just had a camera and a press credential. I hadn't yet developed the chutzpah to push back more. So I turned tail and went to the ICP.

Fortunately, I had already set up a tour of a quieter part of the fire the next morning with the fire behavior analyst from Orange County and decided to cut my losses. I introduced myself to the PIO trailer and was able to start negotiating fire line access with the Orange County crew for another day.

DAY 1

I met the fire behavior analyst that morning at briefing, and we drove out to Crane Flat Helibase while he took weather readings. He used a handheld digital fire meter, taking notes of the relative humidity, wind, temperature, and other metrics used to help model fire behavior and make fire resource deployment decisions.

On the way in, entire stands of trees were burned to the trunk. Leaves and branches gone. The soil seemed burned too. I'd later find out the fire burned so hot it even killed the bacteria in the soil. There was no sign of life. It went on like this for miles, the sinuous curves of the highway through the mountains revealing another totally immolated stand of trees at every bend.

The helibase at the top of the ridge is where both the Yosemite Helitack crew and the Crane Valley Hotshots have their home base. The area, Crane Flat, had a tower and helicopter landing zone. The base

was busy with copter traffic working the fire and delivering supplies, and the hotshot crew was downhill conducting a firing operation to protect the area. A firing operation is when fire crews strategically burn pieces of fire line near a fire under somewhat controlled conditions, so that when the main body of fire hits the area, it loses fuel and steam. It can be a risky move and backfire, but it can also be a powerful tool to save buildings and other values when cutting fire line and air tankers alone cannot stop the blaze.

The hotshot crew was firing out low-level ground fuels in a grove of pine downhill from their base. It was the first firing operation I'd seen and coincidentally the first photo of me working at a fire was taken there. I was captivated by their choreographed movements, a dance of fuel and fire into the grass as droplets of molten heat dripped onto the ground. These were pros in their element.

Looking back at that photo, I laugh at my three-sizes-too-big yellow Nomex clothes in the forest, my old-style fire shelter I had no training on, and fire boots laced improperly and not broken in. I was still a total newbie, but at least I was trying. Maybe I was fortunate media had no unescorted access that day. We headed back to camp, and without a firefighter escort, I was on my own and out of the fire zone again.

I decided I'd drive to the eastern edge of the fire and see what I could photograph from the Yosemite Valley. It's fitting that my first time in Yosemite was at a fire. I knew of the legendary national park but had never been there. Driving along the Merced River into the open portion of the park, I saw the monolith of Half Dome under a smoky shroud. Earlier in the day I'd seen the normally crowded park gates at Groveland closed, devoid of cars, and partially burned. Coming from SoCal and with the Mountain Fire as my closest comparison, it was a totally different scale. The Mountain Fire was a major incident with a Type 1 team, and the Rim Fire ultimately was 800 percent larger. The scale is challenging to replicate even in writing or in photos.

Being there was truly humbling.

Seeing tourists in the main part of Yosemite after coming from

the fire zone earlier in the day was surreal. You could see smoke from El Portal and Glacier Point, but tourists whipped out their huge video cameras like it was a normal day. The fire was too far away to make any meaningful images.

It was getting late on my drive back to Groveland to prep for the firefighter ride-along the next morning. I had started listening to some new folksy music. It brought a very real sense of place, both in the music itself and the lyrics.

California, Oklahoma
And all of the places I ain't ever been to but
Down in the valley with whiskey rivers
These are the places you will find me hidin'

To me the song was playing at just the right time. I was in a place I'd never been, down in the fabled Yosemite Valley, carving highway corners down from Glacier Point onto the valley floor. Just me hiding out and taking pictures at night.

On the way back I could see four heads of fire from Highway 49 looking miles to the north. It took me four hours to drive end-to-end of the fire. You could see it from the Yosemite Valley, and westward from Groveland and Mariposa. The scale in a new place to me was unreal. The scale and beauty of its geography and forests was contrasted by the destructiveness of the blaze. To me the Rim Fire always conjures up memories of confusion, and maybe frustration. How could such an amazing place get destroyed like this, when we surely had the technology and science to suppress it?

At the end of the first day, I was frustrated with access, dehydrated, and exhausted after the long drive up the day before, and now this long drive from Yosemite along Highway 49 through Mariposa and on to Groveland. Off to my right, I saw the glow of the Rim Fire and stopped at a pullout, grabbing my camera, tripod, and an 85 mm lens. Hiking up a short hill on the public right of way revealed a scene of megafire.

For what seemed to be ten miles across, the fire burned across the land-scape. Being far away, I used that 85 mm telephoto lens to bring the perspective closer. I made a few short exposures of a few seconds, then another at two minutes. The final image shocked me, as it created a dramatic contrast between the warmth of the fire and the cool hues of night. The motion of the earth with a telephoto lens exaggerated the motion of the stars, adding a strange feeling to the scene. Despite my frustration with media access that day, this was proof that you could still create storytelling images from afar, with enough effort to find the right spots. I made a mental note to scout these vistas during the daytime at future fires or fire-prone areas.

I remained optimistic that the incident PIO could help provide access to the fire. I was to report for morning briefing at 7:00 a.m. the next day.

DAY 2

I awoke in the predawn gray of the motel as fire rig engines started up, leaving for camp before me. I walked bleary-eyed into the fire camp to the PIO trailer where I linked up with the PIO and went to the OCFA battalion chief for morning briefing. After getting dialed into the fire, we grabbed sack lunches and I met the crew. We would be following their strike team of massive Type 3 brush engines deep into a dozer line on a division of the fire with no active flame, but still under threat.

As we drove deeper into the forest, the trees grew wider and taller, the smoke thicker. The road went from two-lane highway, to narrow paved road, to gravel, to dirt, then steep bulldozed earth in the trees. Somewhere out there was the fire itself, taking cover behind the hills and understory of the Stanislaus National Forest. The dozers cut fire line eight blades wide, meaning it was the width of eight bulldozer blades. It was easily fifty feet deep. It was one of the largest hastily cut fire breaks I've seen, and still is. The PIO turned to me and said, "It will take years to rehab these scars." The soil drawn up by dropping trees

and shredding brush was loose in composition, no longer held down by roots. Walking through it was like stepping into a sand dune, your feet sinking every step. Fine particles of dust arose. Firefighters on that division called it, "moon dust."

An inmate fire crew argued and swore at each other as they cut down hazard trees near the fire line. It appeared they'd been out cutting fire line for days. The PIO's truck bobbled and swayed over the rock-sand moon dust, the engine whining in 4 Low as we trailed behind the Type 3 brush engine, swaying even more on the ad hoc road. The fire itself was nowhere to be seen.

A Type 3 brush engine is the destroyer of wildland firefighting apparatus and is optimized for reaching off-road and difficult terrain where wildfires like to nestle themselves. Compared to a traditional fire engine, they have higher ground clearance, a shorter wheelbase, and oversized tires. Wildland firefighters call Type 1s "pavement queens," and they will make appearances at wildfires in communities with good road access for defending homes. There are Type 2s, which are a hybrid. And there are also smaller Type 5 and Type 6 trucks, pickups on heavy duty or dual rear-wheel chassis that carry much less water but can get down even tighter roads faster than the Type 3s.

The crew was patrolling the fire line, and outside of their meetings and observation, there wasn't much action for them. However, this is still a representative part of the story. Fire can mean long periods of boredom and slow fire activity on a division until it's punctuated by a weather shift or change in fire behavior.

On the fire line, visibility was greatly reduced by the smoky inversion layer, and it felt somewhat like a horror movie. An inversion layer is when smoke gets trapped in valleys and lower elevations overnight and into the morning as temperatures cool and humidity goes up. Like a fog, the inversion layer settled in the valley, floating among thickets of trees, creating a pallor that hung ominously over the fireground. Somewhere out there was the fire itself, hiding furtively in the forest. It was getting into the afternoon. I'd made all the photos I could, and it was time to file for next day's print deadline. Only problem, there was no

cell reception to send the images. Time to leave the fire line in a hurry to get back to service.

Taking the same rock-filled road back out, the truck underbody hit a rock and got stuck on the bulldozer line. In a cloud of moon dust, the PIO and I both swore as we realized the truck was high-centered. We were still a couple miles away from the paved road and cell reception. I began to worry the deadline would pass. We lucked out. There was a utility truck nearby that towed us out. But the truck was damaged, and the transmission was revving and limited us to a low speed. After all that effort and good fortune, I worried that I was still going to miss the deadline.

Plodding along the dirt and finally onto a gravel road, we got back to cell reception with ten minutes to spare. I sat working on the shitty newspaper-issued laptop with a dying battery and one bar of reception, nerves frazzled from lack of sleep and anxiety. I got a dozen images in moments before the deadline. A sigh of relief. Success. I did it! The images would run on the front page the next morning.

It was September 1, Labor Day. I felt proud that I was out there laboring! After filing, it was time to start the long trip home. I ended up spending the night in Fresno before driving back into the fray of the Los Angeles Basin.

After covering the Rim Fire, I was still somewhat terrified of fire—and mystified by my experiences. But I was on to something and was ready for more. I thought about wildfire and covering it for half the day. My mind focused on weather reports, climate science articles, firefighter Instagram accounts, thinking of how to improve my images and get better views. How to get better access, the right PPE, how to properly lace my fire boots so they didn't hurt.

By the time rains came in the fall, the blaze had cost nearly 124 million dollars to fight and at its peak had over five thousand firefighting personnel assigned. The fire moved so quickly early on that the incident command post was evacuated and relocated. 112 structures were destroyed. The Hetch Hetchy reservoir, supplying much of the Bay Area with drinking water, would be impacted by debris flows from runoff during the winter.

As the winds of fall began, I'd made it through my first summer of photographing wildfires, a little wiser and with a pair of fire boots that sort of fit but still weren't broken in.

My break during winter to regroup and prepare for the next season would prove to be short-lived. My hard-learned lessons would be applied quickly.

EIGHT

A CHANCE ENCOUNTER

I first met Gino at the Butts Fire in July 2014 in Pope Valley, Napa County, near the hilly hamlet of Angwin. It was the first fire I'd rolled in the Northern California wine country and it presaged blazes to come. In the meantime, the Butts Fire burned fast and hard, destroying homes; but, mercifully, it was smaller.

I was midworkout at a gym in downtown Los Angeles when my fire-dispatch group text lit up. I checked Twitter about a new fire outside of Napa. The Butts Fire was tearing through the Pope Valley and forcing shelter-in-place orders, with immediate life safety threats. It appeared as if homes were going to be overrun. The radio traffic was nonstop and professional, but you could still hear the stress in the voices over the online fire radio scanner. I cut the workout short and ran downstairs and out of the gym back over the 110 freeway to my apartment. I showered, grabbed my fire gear, food, and drove eight hours straight to Northern California to photograph the blaze. I didn't arrive until 10:00 p.m., exhausted and strung out from the five-hundred-mile drive, but ready to make pictures into the night. While I didn't make the best images for the *Terra Flamma* project, I would meet a person who would make the trip worthwhile.

On the second day, as the heat rose and the morning boiled over into afternoon, the conflagration started to pick up as I was driving my

old Land Rover around a field where I saw a new, smaller column of smoke up on the hill. There was a large field with a bulldozer parked in the middle, a safety zone and safe spot to ride out the fire if things got bad. I figured it would be a good place to park to observe the fire behavior and maybe chat with one of the firefighters. No sooner did I park than a battered Chevy pickup pulled up in a cloud of dust in the freshly bulldozed field. The truck looked like someone had pulled the reserve truck in the fire department parking lot and took this hooptie out for a joyride. Maybe it was a volunteer?

The driver gingerly stepped out and was wearing a yellow onesie, a Cal Fire single-piece Nomex jumpsuit that I'd never seen before. It appeared to be an old style uniform, phased out in favor of more recent and modular two-piece interface coats and pants. *This dude looks pretty salty*, I thought.

"Hi, how can I help you?" he asked. Later, the firefighter would recount our first meeting: "Here's a photographer wearing all the PPE, and you were playing by the rules, standing at the edge of the public property. And I remember engaging you and saying, 'Hey! I can get you closer to that dip site.'"

We got to talking and within a minute he'd pulled out a large fire map printed that morning at base camp, with all the divisions of the fire marked in topographic relief with supply points (drop points) and dip spots (where helicopters go for water).

As he was showing me the map, I was struck by how willing and eager this busy firefighter was to help me and provide context for the fire and its behavior. He then asked if I wanted to go with him to get closer to the fire line where a K-MAX helicopter was bucket-filling from a small pond. The K-MAX has contra-rotating rotors on the same shaft (two rotors spinning in opposite directions) that make a unique sound and whoosh against the bright sunlight. Once you hear it, you can't miss it at future fires.

He introduced himself as Captain Gino DeGraffenreid, in charge of a team of bulldozers with Cal Fire battling the blaze. This was his home unit—the Cal Fire Lake Napa Unit, whose station was just down

the hill in the Napa Valley. This fire was his terrain, his own back-yard. We saddled up in the beaten Chevy, emblazoned with the unit identifier, "U1450," which is how other firefighters would call him on the radio. Otherwise, they'd call him Division Alpha, for the division superintendent, for example. In this case, he was the dozer strike team leader, helping to supervise all the bulldozers on that particular division tasked with cutting fire line into the hillside.

We rattled up the valley and stopped at a small pond at the treeline of scrub oak, a mile away from the safety of the bulldozed field and much closer to active fire. The pond had a little dock, some sort of fish-ing or stock pond. Gino motioned to me to look up as the K-MAX came down right on top of us with a long-line bucket and scooped hundreds of gallons of water from the pond. We pressed our hands down on top of our helmets to stop them from blowing away. We both raised our arms in a quick wave to the K-MAX pilot. The pilot was looking out the side of the helicopter to fill up the bucket and gave what I thought was a nod of acknowledgment. He then swooped off to drop more water on the blaze. *This is awesome!* I thought.

After this close encounter with rotor wash, Gino proceeded to answer all my questions about the fire, the topography, fuels, and fire behavior at the Butts Fire. I felt a combination of gratitude for his time and sharing of expertise, and the curiosity and awe I used to feel when making my first pictures of fire aftermath years earlier in Orange County. A new world was opening up to my lens.

Gino also introduced me to some of the crew members he often worked with, after the helicopter flew over. We sat on a rough dirt road on a ridgeline overlooking the fire, watching the K-MAX and a Cal Fire helicopter run water. One of his colleagues told a story about a helicop-ter dipping in a pond so shallow the intake nozzle became clogged with young frogs, "pollywogs" as we called them. The firefighters were from units all over the state, but mostly with Cal Fire. I was struck by their collegial banter and closeness. Over the years, they'd worked dozens of fires. "It's the same core group of people that end up traveling the circuit of fires," Gino told me. The band was back together, and I had

a backstage pass. It was the first time I'd been able to ride along with a wildland firefighter at an active fire.

This was a fascinating glimpse into the mentality of firefighters and the ebb and flow between intense action and periods of watching. I got to see their humanity and humor behind the veneer of the invincible public servant. It brought me back to the Granite Mountain tragedy a year earlier—each firefighter a story, a life, more than just a uniform. I knew these women and men were putting themselves out to the same kind of risk, and it humbled me.

We came down the hill back to the bulldozers parked in the field. I exchanged contact information with Gino, thinking it might be helpful in the future to have a connection to such an ambassador of his profession, who was willing to teach this budding photographer a thing or two about fire behavior. I spent six hours photographing the fire and sixteen getting there and back, driving twelve hundred miles in two days. The photos ultimately didn't make the cut into my first fire book or even on social media, but that introduction to Gino and the friendship it would grow into made the trip worthwhile. Much of narrative photography is building trust, relationships, and access that isn't readily available at first glance.

Gino mirrors this sentiment with his firefighter colleagues, "The relationships are so important . . . there's a little bit of that excitement when you get those people back together, and the challenge of a new firefight." Little did I know how pivotal my working relationship, and eventual friendship, with Gino would become, and how accurate his words were and still are.

NIGHT RIDE

The fire became more active that afternoon after the embed with Gino, but I decided to head back to Los Angeles since it seemed like containment was going to increase and the imminent threat from the day prior had diminished. Leaving at 5:00 p.m. would put me into Los Angeles at

2:00 am, but I'd skip all the hellacious traffic. "Screw it," I told myself. I'd make the drive. Caffeine and rock music made the miles go by fast running south through the Interstate 5 corridor in the Central Valley. Stars in the sky, hot air of the night, passing semis on the right and giving way to speeders on the left, doing the dance between lanes on a four-lane interstate through rural California.

It was a drive I'd grow to loathe while chasing fires, often deciding to take CA 99 farther to the east in the future, both for the more frequent six-lane width, and the lack of morons trying to set world speed records between Los Angeles and San Francisco. I'd exposed myself to enough risks at fires and fatigued driving afterward.

The late-night drive was peaceful, though. I called my then girl-friend a few times to catch up and keep me awake, blasting music with the sunroof open and the stars overhead. I smelled like smoke, I was dirty, my car was a mess, but I felt like I was on the cusp of breaking into a world that I'd been fascinated by for some time. Seeing the Butts Fire up close and getting to know Gino and some of the other firefight-ers, was a step in the right direction.

I got back into downtown Los Angeles after 2:00 a.m., to see unhoused people on the sidewalk needing obvious mental healthcare and shelter. It was a strange contrast to the scenes I'd seen earlier in the day. It was like California was multiple worlds fused into one political state. The brush of Northern California seemed a far cry from the lack of affordable housing and adequate healthcare in Los Angeles. But as the 2014 fire season slogged on, I saw how another human crisis was unfolding in the brush and woods of the state.

REALITY CHECK

NO PORTAL AT THE EL PORTAL

After the early season fire bursts in San Diego and Los Angeles, the Southern and Central Sierras also picked up with fire activity. My photographer friend Jeff and I drove up to the El Portal Fire burning at the south entrance of Yosemite National Park, a few weeks after my chance meeting with Gino. The Rim Fire media access issues were a fresh memory, but I figured it was a small enough fire that I'd be able to negotiate some sort of escorted access, especially since I had safety gear, very basic fire training, and a few new connections within the fire world. I'd been sponsored to audit a US Forest Service–led basic wildland fire class during spring of 2014 and spent a week learning alongside rookie wildland firefighters.

In El Portal, I attended the evening briefing at the rustic station in the mountain hamlet. Around one hundred firefighters and command staff gathered to listen to the incident commander and meteorologists describe the fire and weather. "Humidity recovery will be poor," said the IMET, or Incident Meteorologist, typically staffed by the National Weather Service.

Poor humidity recovery meant that it would be dry in the higher, mixed-pine elevations and the fire would burn actively overnight. I

said to Jeff we'd be able to make powerful storytelling images if we got access closer to the fire. The drama of engines and firefighters looked small compared to centuries-old pines in the rugged topography of Yosemite.

After the briefing I started hitting up important-looking firefighters, a.k.a. the old ones with the biggest moustaches. We "tied in" with or met with the PIO and received a promise of possible access the next day. I was optimistic we'd finally get access to a fire in Yosemite! As we waited that night, Jeff and I decided to try our luck at the roadblock directly. It never hurts to ask, I mused. I drove up in my Nomex to the National Park Service police checkpoint but was met with an immediate order to turn around and leave. Foiled again.

We headed up Glacier Point Road to see the fire from across the valley. I surmised we might be able to make pictures from one of the switchbacks leading higher, since they faced in the general direction of active fire. A few miles away, smoke wafted over hundreds of smoldering and slowly burning acres on the opposing hillside. Waiting it out until dark, and punching in with a longer zoom lens, the long exposure I made showed hundreds of spots of fire, from burning bushes and trees, to smoldering roots, all compressed into one frame.

It was a scene where the long-exposure abilities of modern digital cameras could create a lengthier light and visual recording compared to light the human eye can gather. My favorite image from the fire was four minutes long, so the camera captured over one-hundred-times more light than my eye did. It is like magic gathering all that light into one image. Nikon had just come out with the D810, a high-resolution camera with incredible low-light capabilities. The right lenses, technique, and creative experimentation paid off.

We called it an early night (at least by wildfire standards) around 11:00 p.m. and snuck into the parking lot of the Badger Pass Ski Area, where the incident command was mobilizing an actual base camp. Overnight, it was starting to look like the base camp at the Mountain Fire, with trailers full of supplies arriving in the wee hours of the alpine night.

We parked next to some trees at the top of the lot by the rows of porta-potties, stuck our helmets and Nomex on the dashboard, and passed out. Nobody was going to bother us amid the chaos, especially with our fire helmets on the dashboards. Just another anonymous fire-support person in the scurry of the initial attack period.

As dawn broke, we furtively dressed and drove out of base camp before drawing too much attention. It wasn't against the rules to be there, but we wanted to be incognito. We drove down to El Portal to get cell reception. Part of the problem with getting escorted access at remote and restricted wildfires is that you can't simply call public information officers. There's just no cell reception. It's also illegal and unsafe to call them on a two-way radio when you're not officially assigned to a wildfire incident.

On the way down to look for the information officer, we saw him escorting a national TV crew into the fire. We stopped and asked if we could caravan in, and he threw his hands up saying "Sorry, there's nothing I can do!" Jeff and I were pissed. We'd been dangled access and been tossed aside. Whining right then and there wasn't going to make for better pictures, so I decided to take the loss on this one and give up. We decided to leave the fire area, satisfied with our images from the evening prior.

Leaving the fire zone along the main highway, we made pictures of the large, Type 1, heavy helicopters dipping in the Merced River, their snorkel nozzles banging on rocks as they drafted in the shallow, drought-stricken river. Through the smoky haze of the lifting inversion layers in the mountain valleys, it was a contrast between the low water levels due to summer and drought, and the acute effect of it—fire. To me, these slower moments say as much as fire itself, albeit in a quieter and subtler way.

While I was frustrated with the access issues in the National Park, I would eventually learn how to navigate the special considerations in federally managed areas that weren't US Forest Service land. A day would come where I'd get fire access to Yosemite, I pledged to myself.

The end images were an example of how wildfire can be approached

from different angles, and in this case, put into geographic context. The long shot from across the valley showed the steep terrain, density of fuels, and size of the fire. The long exposure capturing air attack overhead added to the sense of scale. Like some of the earlier Santa Ana fires and the night shot at the Rim Fire from twenty miles away, it reinforced the idea that wildfire photography needn't always be extremely up close.

As we left Yosemite and headed down the hill, we saw another pyrocumulus on the horizon. It was too far to be part of the El Portal Fire. Another fire had started.

CHASING THE FRENCH FIRE

Coming down Highway 41 into Oakhurst, the southern gateway to Yosemite, we realized the new fire was farther away than it looked. Narrow canyons and winding roads made travel distances deceptively long. With limited data and communications, we made an educated guess on the map and picked a road. We got to a roadblock, and there were no police, just a lone firefighter and his Forest Service–issued truck. He was also ordering resources for the fire as it exploded in size behind him. This was initial as initial attack gets. Local engines from the district did what they could, but mostly they had to sit back and watch. Their priority was not getting burned over by hundreds of acres of timber torching, crowning, and exhibiting plume-dominated fire behavior.

We were so close to the fire we could hear the preheating and explosions of individual trees having their sap heated to a boiling point, then exploding into combustion. Branches fell in the distance, crashing into other branches on their way down, a cacophony of big sticks breaking into little sticks and hitting the ground with a thud.

We convinced the firefighter to escort us in for photos. Jeff and I followed behind him. We made a handful of photos and decided to bail. This fire was dangerous, and with the scant resources, we were a burden on this firefighter going out of his way to give us access. I'll be

back, I thought. We were trashed from the night before and the long drive up to the Sierras, so we decided to head back to the LA Basin.

REALITY CHECK

A few days later, I revisited the French Fire on assignment for a news-wire service. It was the first blaze in the Sierras I photographed up close at night, under the Milky Way. I requested and received access with a firefighter escort. It was pretty nice! It was also the first time I'd watched an inversion layer settle in. I gained an appreciation for how mountains, mixed conifer forest, and steep terrain cause different wildfire behavior compared to lower elevations among chaparral.

As we came around the bend on the smoky and narrow road within the French Fire perimeter, we stopped at a viewpoint looking toward the flames. The fire front had passed, but trees and ground fuels were still smoldering. Overhead, the Milky Way was visible with minimal light pollution. I started making pictures quickly, as the firefighter who drove me out mentioned the inversion layer would settle in quickly. There are thermal dynamics in the atmosphere that are influenced by local weather factors and terrain. Inversion layers often moderate fire behavior, but they create notoriously poor air quality for those on the surface underneath them.

Ten minutes later, cold air descended over the backcountry in a dance of smoke, stars, and smoldering stumps. With a very wide-angle lens, I photographed on the tripod as the fire tucked itself into bed for the night, insulated in a hazy blanket of smoke. Soon the trees were obscured in the canyon. It was like watching nature put its child into bed for the night.

That night we got closer to *very* active fire and ran into a lost water-tender driver, driving thousands of gallons of water aimlessly in the fog of the burning forest at night. We got back to the command post late, and I made it to sleep around 3:00 a.m. I didn't realize it, because I was so tired, but I was spiking out in the main parking lot of

the ICP, which is kind of a no-no. Crews usually have designated sleeping areas. Lesson learned.

That night I was tossing and turning as trucks came in and out, their diesel engines and heavy-duty tires squeaking, rumbling, and clattering up and down the rough dirt road into camp. The smoky inversion layer was making it tough to breathe comfortably. My sinuses became congested from smoke. Ultimately, I got four hours of sleep, and I left that morning straight from the parking lot back to Los Angeles. I still hadn't recovered my sleep debt from the long trip with Jeff to Yosemite a few days prior, and I was backtracking another three hundred miles back to Los Angeles less than twenty-four hours after doing the drive up. I was burning the candle at both ends.

Coming down the switchbacks into Oakhurst and eventually Highway 99 in the Central Valley and on to the 5 south into LA, I was fighting drowsiness. But I hit a wall in the mountainous portion of the interstate coming into Santa Clarita. There were no exits to pull off to rest. I was battling my eyelids drooping, heavy despite the daylight and heat.

Then it happened.

I dozed off for a second and jolted awake as my six thousand pound SUV hit the rumble strip on the far right lane of the Interstate. Below me was a four-hundred-foot near-vertical drop into a canyon below the roadbed. A fraction of a second longer and I would've been dead. I rolled down all my windows, cranked the AC, and beelined for the next exit that was, luckily, only a few miles away. The gambling with my limits and endurance had been pushed too far.

I made it to a CVS parking lot and immediately passed out for thirty minutes, but it was enough to get me back on the road. I realized the driving to and from fires was just as dangerous as the fire itself.

Giving myself a critical self-review after, I had to squelch my ego and admit that I pushed my luck driving. Running up to the El Portal and initial attack at the French Fires was too much without adequate rest. Staying at fires late into the night and rushing home the next day tired was reckless. I needed to pace myself in order to safely drive the

hundreds of miles up and down the state. There was no glory in being a drowsy driver. "You always have time to rest," I repeated to myself.

Vehicle-related accidents are one of the most common fatality and injury incidents with wildland firefighters, alongside entrapments and burn injuries.[30] I saw that firsthand. Fatigue, long drives, crappy roads, smoke, dense forests, and hundreds of large fire engines and trucks all contribute to an increased likelihood of road accidents. I realized that compromising my safety on the road by driving exhausted was tantamount to walking into a firing operation without fire boots or a helmet.

I arrived back in Los Angeles barely able to stay awake for Saturday night in the city. I showered, sank into bed, and slept like the dead for hours.

TAKING A CHANCE

The rest of the 2014 season mellowed in Southern California after an intense start, but I wasn't ready to give up on photographing fire in Yosemite. In September, I got my chance when the Meadow Fire exploded in size. It had started as a lightning-strike ignition back in July and had been left to burn as a managed or monitored blaze. But now heat, weather, and fuel conditions propelled the spread of flames as hikers were making their ascent on the popular climbing route to the top of its ragged granite face.

The path to the peak went through a forested portion on a lower hill, cutting off their egress route. While the hikers were being rescued by helicopter, I was sitting in traffic on my way to the LAX departures terminal, where I was dropping off a friend. I pulled up the Yosemite Conservancy webcam pointed at Half Dome, and it was lit up with afternoon smoke from a fire burning hundreds of new acres. The Meadow Fire had been a monitored blaze, which was in accordance with the park policy of allowing natural ignition fires to take their course to keep the forest healthy. Most of the time this policy worked

to benefit the park and ecosystem, but sometimes it impacted visitors when weather shifted.

"Shit! I should go up there?" I'd gotten a good night's sleep, had dinner ready at home, and was looking forward to a productive Monday morning catching up in the studio. I pulled up the weather and radar. Intermittent thunderstorms were hitting the western side of the Sierra Crest at elevation near the fire. Would the drive north be worth it after striking out twice in two years in Yosemite? I vacillated, then decided to hit the road direct from LAX. I couldn't be sitting in my office when there was the chance, however slim, of capturing Half Dome ablaze.

I realized that the shot of Half Dome at night, gilded with fire, would potentially be the defining image for the *Terra Flamma* project. After visiting Glacier Point in 2013 during the Rim Fire, I knew the vista potential existed. The image might capture the contrast between places we love and the good fire that burns them, and that collision amid climate change.

I pinged Jeff and told him to get his ass on the road—I wanted him to see it too.

I drove through thunderstorms, a mostly full moon, clouds obscuring the fire, and arrived around 11:00 p.m. "I drove up here for nothing!" Seven hours hauling up to the fire and there was minimal glow to be seen. I'd struck out.

Jeff and I decided to set up our cameras and wait it out overnight at Glacier Point. We weren't allowed to camp there, but since we were posted up with our cameras actively working, we were in the clear.[31] I dozed on and off throughout the night, waking up around 5:00 a.m. to see what the morning light would bring.

The fire was still quiet, having moderated overnight. As blue light came up over the eastern horizon, the fire picked up a bit in the predawn breeze, and low clouds reflected the warm glow of flames above Half Dome. For two minutes, it was visual perfection—sublime and magnificent.

All the access bullshit of the summer, the long drives, the missing activities with friends and family, it was all worth it for this moment.

The scale of Half Dome, the smoke, the wind, the fire, the sunrise. Right then and there. Presence, in full flow with the fury of nature.

"This is why I do what I do," I whispered to myself.

An hour after sunrise, more intermittent thunderstorms swept through, and a downpour doused much of the Meadow Fire. The sun backlit rain and smoke over the Yosemite Valley produced another dramatic display. It showed how quickly light and weather conditions change in the mountains. Even if I hadn't taken a single photo of the fire, I would've been content just to sit there and watch the morning storm move over the smoke. It is a feeling and memory that will always bring a smile to my face.

The Meadow Fire made me realize, just like the El Portal and Rim Fires, that it was usually worth taking a chance to make landscape pictures despite difficult close-up access. Sometimes you drive five hundred miles and eight hours for absolutely nothing. Other times you wonder why you don't take more risks when you're looking at the back of your camera screen and see an image that you're proud to share.

That fall we were spared the Santa Ana fires that happened earlier in the year, and I planned to use fall and winter to prepare for what 2015 had coming. Long-range weather predictions said winter would be drier than normal. There was no end in sight for the drought and fuel conditions across the state were getting worse.

I needed time to prepare, but the gods of fire had one last surprise.

THE CAMPAIGN FIRES
OF LAKE COUNTY

The drought in California during the winter of 2014–2015 continued to worsen with significantly below-average rainfall. As a result, the King Fire ripped through 40,000 acres in the Tahoe and El Dorado National Forests in a matter of hours. We were in a water debt with major reservoirs running dangerously low, water restrictions in place, and Central Valley farmers drilling deep wells to try and extract what they could from aquifers.[32] While fuels dried out in the WUI and forest, the valley floor of the Central Valley actually sank, and continues to do so, from aquifer depletion. The California USGS calls it, "subsidence." While the ground where two-thirds of America's fruits and vegetables come from was sinking,[33] the forest was wilting.

In parts of California, NOAA recorded the second hottest summer on record.[34] San Francisco, for example, had experienced its hottest year on record in 2014, the year prior. While not all cities experienced record heat, 2015 was the fourth warmest year for Los Angeles, and the hottest ever in Ely, Nevada, in the heart of the Great Basin. The overall trend was not good. Drought and heat served to damage vegetation from bark beetle infestations and more, priming forests for wildfire.

The bark beetle, more specifically the western pine beetle, reproduces by burrowing into the bark and phloem of trees where it tunnels and lays its offspring. The young larvae then eat the tree for nourishment,

and later fly off to infest another tree. However, trees have a natural defense against bark beetles—sap. The sap leaches into the boreholes to entrap and suffocate the beetle, neutralizing the threat. However, sap needs water, so during drought a tree is unable to uptake enough water in its root system to effectively produce sap. As bark beetles find a vulnerable tree to attack, they emit pheromones that signal to other beetles that the tree is susceptible. Pretty soon beetles swarm a tree, and without adequate defenses, it's overwhelmed and killed.

If you look at pieces of firewood in the Sierras, you can see the bark-beetle patterns in the trunks of dead trees and bark scattered on the ground. At many fires in the Sierras, the trees that sawyers drop on the fire line and alongside roads have thousands of boreholes etched into them. Under normal conditions, the trees and the bark beetles find the delicate dance in nature known as homeostasis. However, drought and warmer temperatures put the balance in the bark beetles' favor, decimating trees already stressed from drought.

Virtually the entire Sierra Front from Kernville up to Paradise and beyond is affected by the bark beetle. In 2016 alone, sixty-two million trees died in the Sierra Nevada mountains. The tree mortality map published by the US Forest Service looks like a sea of red dots indicating devastation. Hundreds of trees per acre are affected.[35] For the first year or two, the trees are dead, the pine needles do not fall off, and thus provide incredibly dry kindling for wildfires. Oddly enough, studies suggest that after the dead pine needles fall off, the dried hulks of trees and branches present less of a threat. Of course, that does not change the acute, short-term fire impacts when large swaths of forests are hit by the beetle.[36] A fire starting in "major bug kill" forests along the Sierras indicates potential for extreme fire behavior. The King Fire at the end of 2014 exemplified that threat.

As bark beetle kill combines with dry ground and ladder fuels, in addition to warmer temperatures, the conditions for major wildfire in the Sierras were primed for 2015. It would continue the legacy of 2014 with an early start and late finish.

Another effect of warmer temperatures, aside from the daytime

highs that get press coverage, are the overnight lows that don't bottom out like they used to. Combined with poor humidity recovery, higher temperatures overnight allow fires to remain more active. It gives one- and ten-hour fuels like grasses and shrubs less time to absorb ambient moisture from the air. These fuels will become highly flammable within that period. It becomes a self-sustaining factor of plants baking more and more, increasing the probability of ignition and lowering the live fuel moisture.

WRAGG BLOWUP

Gino's scuffed pickup, somehow still running, rattled and bounced down the dozer line in the hills above Fairfield. I was again at another fire in Northern California. His two mobile radios broadcast nonstop radio traffic across the fire as units struggled to contain fire jumping the line. Gino picked up the radio mic every few seconds, ordering units around to keep the fire line from being lost. Fire raged outside my passenger window as the flames licked the side mirror and door. Gino told me to buckle up, hold on, and lean away from the window. In my Nomex, I could feel the heat on my skin like an oven being opened.

A spot fire was cresting the ridge and jumping the bulldozer line and the fire was getting away from the army of firefighters on the hill. Flames ten feet high reached over the top of the cab as we sped through, clunking and creaking over the uneven, rocky terrain. Tagging along with Gino as the division supervisor, I was literally riding along in the hot seat. At least the view was nice.

Hand crews and bulldozers worked below, and a four-engine propeller aircraft dropped flame retardant from above. The numbers of fire engines and crews were written on Gino's driver's side window, keeping track of people on "his piece of line." Containment refers to the percentage of fire line around active flames, and it can go down if a fire jumps the line. Containment is an indicator of progress but is not a guarantee of fire dying down. A fire can have significant containment

yet still experience spot fires or other issues that allow the blaze to spread. It's not uncommon, as seen during the Wragg Fire.

A crew of bulldozers was downhill cutting more fire line around clusters of burning brush. A Cal Fire hand crew and the El Dorado Hotshots from the US Forest Service were also hacking away on the steep hillside to try and corral the flames. I was grateful I'd met Gino the year before and stayed in touch. There was no way I'd have this access and perspective just as media. My Subaru Outback wouldn't have made it down the dozer line, and I'd be impeding fire operations due to limited access. An embed was the only way.

The Cal Fire crew asked Gino for more bulldozers to reinforce fire line they were worried would reignite. As the crew captain left, Gino turned to me and said, "Playboy of the year." The Cal Fire crew captain was being extra careful (fair!) about his hand crew cutting line. It was barely two years after the death of the Granite Mountain Hotshots and, with the explosive fuels, crews were on edge. The captain was also set to retire later that year, explaining his caution. He didn't have a speck of dust on him, though, and looked way too clean to be in the middle of an active fire line. After a stressful day, I laughed out loud at the collegial jab. It was nice to smile for a second.

As the fray died down and I stepped out of the truck, I was immediately stung on the wrist by big, obsidian-black bugs the size of large houseflies. There were thousands of them swarming the sky, flying into the side of my face, under my Nomex collar, into the front of my camera lens. They were congregating on the stumps of burned manzanita bushes; it looked like a frenzy. A firefighter turned to me and said, "Stump fuckers!" as I recoiled from another one stinging my hand. It wasn't serious like a bee sting, and it wasn't exactly a cloud of locusts, but their pecks and swarm got the apocalyptic feeling across clearly enough.

I'd later research these bugs, commonly known as black fire beetles, and they actually have infrared sensors that attract them to the heat of a wildfire immediately after it burns through. The bugs reproduce in the hot ashes of the chaparral, adapted to lay their eggs in the freshly burned wood to provide food for their offspring. A 2012 study claims,

black fire beetles' infrared-sensing cells are actually more sensitive than the best available infrared sensors on the civilian market.[37] Where there was death, life immediately followed, even if it was a swarm of stinging bugs. The ecosystem had already optimized recovery from the violence of fire. These little annoying bugs I was swatting away were actually niche specialists with the superpower to feel heat from miles away.

After observing the bugs, the spot fires died down and two hours later the fire looked better. Gino took a breath and handed me an ice-cold Red Bull from a massive cooler as battered as his truck. It was coated in fire line dust, but I chugged it. As we took a breather on the ridge and looked at the horizon, another large pyrocumulus loomed fifty air miles away. I asked Gino, "That's not the Wragg Fire, is it?" He replied matter-of-factly, "No, I don't think so, Stu."

INITIAL ATTACK AT THE ROCKY FIRE

The tiny beetles and massive pyrocumulus reaching 20,000 feet into the heavens put me in my place and my human existence in perspective. Between the fire and the phyla, we were just a small part of this place we call earth.

I said goodbye to Gino and drove downhill toward Fairfield for cell service and ran into my friend Loren who was interning as a photographer at the *San Francisco Chronicle*. We caravanned north where we learned the fire was in Lake County. I'd never even set foot in the county before, let alone that far north.

Speeding north on two-lane country roads through the narrow ridge valleys that separate the North Bay and wine country from Lake County, we came into the Clearlake basin. As the sun set, a giant wall of smoke glowed pink in the waning minutes of the day. The smoke column rose behind a McDonald's, and I snapped a quick photo while sitting in traffic. It was a contrast between modern American capitalism and the ripple effects of climate change.

Driving from Lower Lake toward that same glowing column of

smoke, I stopped to make a picture on the main street. A man was leaning against his truck looking down the road, with a furrowed brow, looking worried about the fire. It encapsulated the impact to this county with an eighteen percent poverty rate.[38] We then headed into the fire and were waved through the one roadblock. It was very different from the access issues of the Rim Fire in 2014, or some of the other major fire sieges of the past two seasons. This was the volatile initial attack period. The fire was winning, exploding in size, and resources were scrambling to fight fire and law enforcement to manage evacuations. We got into the fire and drove down a dirt trail off of Morgan Valley Road, an east–west route where the fire was burning among sparsely spaced homes.

As we walked along the dirt road taking photos of the fire and talking to an ambulance crew, puffs of wind blew embers downhill, worrying me. Thirty seconds later another stronger gust ignited a spot fire in tall grass among oak trees. The fire was downhill from us, moving slowly, but still a threat. I called out, "Spot fire!" around the same time the ambulance crew spotted the flames. I turned and told Loren we needed to book it back to the cars to get back on the road for safety. We ran the quarter mile back to the vehicles.

We probably would have been fine, but given the fire behavior I'd seen all day, I wasn't taking chances. As we reached the cars, we heard the roar of turboprop engines and a Cal Fire S2 air tanker flying over us at four hundred feet. I saw the pink mist of Phos-Chek flame retardant streaming out from under the bomb bay doors, dropping directly over our heads. I yelled for Loren to duck and take cover behind his car. Tanker drops can be deadly and crush vehicles if it's a direct impact.

Luckily the drop landed long past the road, and my car took an indirect hit from the slimy flame retardant. Loren's company car took a direct hit with the windows down. His gray sedan was now pink. He had to use half his windshield wiper fluid just to see out the window. My helmet GoPro camera was filming at the time and the dash back to the vehicles and air tanker drop was caught on film. Every so often I watch the footage and crack up laughing at how we panicked. I also realize we did the right thing by bailing ASAP. *This is why situational*

awareness is important, I thought. We retreated off the dirt track back onto Morgan Valley Road, watching the fire front move downhill toward our former position.

AFTERNOON DRAGS ON

After the Cal Fire S2 dropped on top of us, the cutoff time for air tankers hit and the planes disappeared from the sky as dusk fell. The smoke column turned from pink and orange to ever deeper hues of purple until you could see light from the base of the fire itself. I took a few minutes to reset—uploading and filing images to the newswire, getting my headlamp ready, having a quick snack, and chugging water. I would be up pretty late in this ongoing firefight. I polished off the leftover Red Bull that Gino gave me earlier in the day.

Loren and I were parked in a field near a home, and in the hills a half mile away, flames jumped from the trees as the fire flank moved closer to the property—a house, a barn, animals, and a garage. The Arrowhead Hotshots, another hotshot fire crew, were starting a firing operation around the perimeter of the house to save the property. They were burning tall grass to deprive the main body of fire from being able to reach the house. I watched the grass ignite while two firefighters carried a bench in the field to safety. Next to the home, a larger Type 1 city fire engine crew was pulling hose line to prepare for saving the home. The house looked to be in good shape and had enough firefighters to save it, but the residents had yet to evacuate.

The homeowner was panicking in the middle of a traumatic emergency situation and was running around the property speaking incoherently. By staying on the property, they created a safety issue for firefighters trying to protect the home, and for themselves by staying in the way. The homeowner almost tripped over firehose and kept approaching the firefighters asking over and over again: "Oh my god, will my house be okay?"

This situation exemplifies what *not* to do in the middle of a

fast-moving wildfire. First off, evacuate when you're asked to. Mandatory evacuations are triggered for a reason—when your home and life are in danger. Staying behind, especially if you are not prepared or experienced in this type of situation, can cause panic. Eventually, a friend came to the property to calm down the homeowner and drive them out of the area. After they left, the structure engines completed another firing operation around the house, and the home was standing the next morning.

After the structure was saved, Loren called it a night and headed back to San Francisco in his Phos-Chek-covered car, and I ran into photographer Kent Porter again. We'd briefly met at the Wragg Fire a few days prior, but finally had a chance to chat as we both set up our tripods looking into a canyon awash in flames and embers. I quickly saw how experienced Kent was, how he read the wind, fire activity, and was intimately familiar with the region. He's a lifelong resident of the North Bay, and this was a major news story in his community's backyard.

The scene we both photographed reminded me of the Mountain Fire two years prior in SoCal. I was peering into the gates of hell itself, again. But now I was more confident, focused, and experienced. We made frames till late evening, exhausted from the driving, the Wragg Fire blowup, running from the spot fire, and the drama of the home being saved. I drove into Lower Lake and was able to grab a motel room and crash for the night. It was the wee hours of the morning, and the weather forecast for day two was not letting up with heat and low relative humidity.

ROCKY FIRE DAY TWO

I stirred late in the morning on August 1, but the Rocky Fire was already awake. More precisely, it never fell asleep. Heading back out onto Morgan Valley Road, I descended straight back into total chaos. There were more fire engines this time and relief crews were in place from those on initial attack, but now the fire was all over the road and

moving east. There was a fire front in the hills, backing fire on the road, firing operations to save structures. The situation was changing by the minute, and I was balancing making pictures while ensuring my little Subaru Outback didn't get burned up.

Two firefighters were "dragging fire" with their McClouds—a rake/shovel-looking tool with sharpened teeth that can be used to clear low brush or hack it away. They had jammed fusees onto the end of the McCloud and lit them, using the tool to drag fire along the grass. They were trying to save a structure while the fire was approaching. Fusees are similar to road flares, but larger, and burn at over two thousand degrees. They are often used by wildland firefighters to ignite back-fires, and in the absence of drip torches can be used in smaller pieces of brush to protect buildings. The firefighters saved the outbuildings and the shed, and I moved on.

A few miles down Morgan Valley Road on the north side, backing fire was moving through grass toward a ranch structure with a home and pen, still full of horses. The horses were running in circles in the corral, perhaps half an acre, when a caretaker showed up with a bale of hay to feed them. She was in her sixties in an older pickup with blue Levi's and a red-pink plaid shirt. On any other day it would just be another summer day in the country, except the background was punctuated by fire.

Firefighters hustled the owner out of the area, and the fire intensified on a small ridge heading toward the property. The brush was golden-brown; no moisture in sight. A dead oak tree remained skeletally north of the property, a relic of where water once was. As the wind picked up, a fleet of crows took to the air. Horses running, birds flying, and fire encroaching. It was a much quieter moment than many of the photos I made at the Rocky Fire, but to me it summed up the small traumas and losses that happen. The tree, the horses, the owner, not knowing whether their stock and home would be standing when they came back after evacuation orders went in. It was like a quiet movie scene before the nuclear bomb hits, except this was reality. It was energy being released in the form of fuel and brush instead of splitting an atom. The charred end result was much the same.

As the second afternoon dragged on, it was wildfire on repeat. A spot fire erupted south of Morgan Valley Road, and within thirty minutes a second column of smoke, thousands of feet high was burning across the road from the main body of fire. There were now two fires as the spot fire exploded. An already dangerous fire had become even more so. At this point the blaze was zero percent contained, totally out of control. Firefighters were simply trying to save homes and make sure everyone was evacuated, including animals.

I found a pullout near where Kent and I had photographed the blaze the night before, with the flames now a few miles uphill at the spot fire. I pulled up behind a Ford Super Duty with a large radar dome on the back. *This is new!* I thought to myself. I approached the crew, a group of students and scientists from San Jose State University using radar to map the fire plume and its behavior. They were collecting real-time data for research purposes, and to better model fire behavior in the future. As I was speaking with them, I felt a sharp sting in my wrist and looked down, almost dropping my camera. A bee had just stung me. The crew laughed and said they'd been getting stung all day. Somewhere, a beehive had been burned up in the fire and the displaced worker bees were pissed off and stinging anything in sight that looked yellow. "Shit," I muttered.

I jumped back into my car and headed down the road to an immolated hill. It had a better view of the rapidly growing spot fire. At the crest I encountered a burned-out trailer and a view of scorched earth. Two plastic deck chairs, partially melted, lay on their sides next to the trailer, miraculously intact considering the earth itself was burned and the trailer home was a total loss. The manzanita brush was entirely burned. The Rocky Fire had moved uphill to the home and spared nothing in its path. A short distance away, a vintage, junked car sat in the brush, totally burned over.

The sunset with the wildest and most intense magenta, cyan, and purple drifted into darkness, with a full moon in the sky, turned blood red by the sun. The red moon and sky were a foreboding of more fire to come.

Kent Porter drove up in his car—as it turned out, he'd scouted the area too. We were making pictures of the strange light and the moon and the fire, and I felt another sting in my wrist. This time I dropped the camera and reflexively ran as a bee lodged its stinger into my wrist bone. Reeling from the sting, I went to my camera, upturned on the ground and covered in white ash. Bent at the lens mount. *I was zero for two on the bee attacks*, I thought.

I had an extra camera body but was now hobbled making pictures for the rest of the night, changing lenses for different scenes. On the broken camera, I was able to push the wide-angle lens closer to the camera body to keep the plane of focus flat, although the lens mount was bent. Some of my favorite images that day were taken with a broken camera. Such is rolling with the punches at fires!

Kent and I stayed there until dark, framing the spot fire through the window of the burned-out trailer, an image of climate change and fire impact. During the entire series of photos during dusk, the color palette is hard to describe. Even the photos barely do the scene justice. And it was a good thing I had extra camera bodies. Redundancy is important at incidents. It was also a reminder for me not to panic with bees. I also learned to expect that sort of insect behavior in the future.

Leaving in the evening, I looked back at the trailer and remains of the car on the ranch hill. The ground was charred. Everything was gray. It reminded me of my first drive into the Rim Fire past the Hetch Hetchy reservoir, where everything was completely immolated.

On the third day I needed to regroup. Replacement camera gear was overnighted to me. I went into Lakeport to pick up the replacement camera gear and got a haircut in town. Firefighters on their days off were getting buzz cuts in the town barbershop as pyrocumulus formed on the other side of the lake. I felt far from home, out in the field. It was a little uncomfortable, but I was feeling creative and in a good stage of personal and photographic growth. I was starting to feel decently seasoned with fire amid the strange scene.

The swelling on the sting marks on my wrist was starting to go

down, and the broken ash-covered camera sat useless in my bag. Despite the setbacks, the images I shot were being shared around the country as I plotted a course back home after chasing fire in Lake County. It was that sense of delirious satisfaction I'd had during the Powerhouse Fire.

It would be another short trip back home to SoCal.

ROUGH TIMES AT BUCK ROCK LOOKOUT

Like the Rim Fire in Yosemite, my first time in Sequoia and Kings Canyon National Parks (SEKI) was for a wildfire. I stopped into the national park heading home from the Jerusalem Fire, which started while the Rocky Fire was still burning, on the other side of Morgan Valley Road in Lake County. After a short break in Southern California to rest after the Rocky Fire, I found myself speeding back up for the Jerusalem.

When I returned to Lake County, the Jerusalem Fire was largely off in the wilderness. While the fire behavior was similar to the Rocky, there wasn't the visual drama of photographing fire up close and personal. The thousands of firefighters close to the Rocky also made it a fairer firefight. I made some nice night exposures under a full Milky Way, then decided to boogie out after an overnighter.

I'd been reading reports of the new Rough Fire in SEKI and the Sequoia National Forest growing each day in the western Sierras. Fire-fighters had managed the blaze for natural resource benefit, but hot and dry weather in the Sierras caused the fire to grow rapidly, and eventually fire managers decided to actively fight the blaze. From what I could see on the Buck Rock fire lookout tower, the fire had potential for some dramatic night images. After weeks of chasing outrageous fire conditions in chaparral, a nice night in the mountains photographing fire under the stars sounded pretty nice. I knew from the El Portal Fire to take the risk.

Driving along the eastern edge of the valley on Route 99, I was able to see the Rough Fire pyrocumulus, and went up there for a night. Jeff again joined me after the Jerusalem Fire.

It was a two-hour detour each way and worth checking out. From what I could tell, the Rough Fire was way off in the wilderness, with an opportunity for some nice cross-valley photos of a Sierra fire front. After my experience documenting the French Fire the year before, I was set on working the star-filled scenes and sense of scale of the Sierras. At the Rough Fire most of the park was still open, with a road closure, passable to media, farther down the highway closer to the fire.

On the way up the mountain I stopped for gas, food, and coffee, and mapped out access to the Buck Rock fire lookout tower to try my luck at night photos. As the daylight waned and the pyrocumulus grew safely in the distance, I bobbled up and down in my Subaru going up a rutted seasonal Forest Service road to Buck Rock fire lookout. Like many lookout towers, this one perched on top of a steep granite rock outcropping, the highest point for miles around. This meant a near-vertical climb of two hundred feet or so to reach the tower. At nearly 8,500 feet in elevation, I was huffing and puffing in my fire boots with camera gear slung on my back. The view was incredible, stretching 360 degrees from the fire itself, to the Central Valley, to points deep in the Ansel Adams Wilderness.

An older gentleman—a retired Central Valley farmer and Buck Rock volunteer—was manning the tower. He was using the radios to act as a repeater site for fire crews in the valley down below in the park and sending in reports on fire behavior. He showed me the Osborne Fire Finder, a vintage mechanical tool used for triangulating the approximate coordinates of a wildfire from the lookout. Gifford Pinchot would be proud of how the spot was run, his "little GPs" still running around managing fire. Its weathered wood frame, covered by layers upon layers of caked, dried white paint, housed a simple desk, chair, and some wildfire-related items. Through borrowed binoculars, I looked at the Rough Fire, only miles away as the crow flies, but only accessible by helicopter. The fire felt far away, for the time being.

I asked if I could come back later that evening to photograph, and the lookout gave me the okay to walk part-way up the stairs to where a security gate kept the tower safe at night. He slept in a campground at lower elevation. The beautiful summer afternoon turned to dusk, with crickets chirping, mosquitos buzzing, and the sweet scent of pine wafting in on the evening breeze. I hiked back up the stairs for night shots, completely alone in the forest on a giant rock outcropping in the Sequoia National Forest. Buck Rock also had an open Wi-Fi network, so I was able to catch up on wildfire news across the country and check in with friends and family to let them know I was safe. I started making multi-minute long exposures.

The images on the Nikon's LCD screen delighted me. They were the perfect combination of starry sky, mountainous terrain, and fire behavior that had changed as humidity increased and the day cooled. With a super wide-angle lens, I framed trees in the foreground, which the fire tower overlooked, leading your eye into the smoke, flames, and stars. I felt the wind on my face, the cool alpine breeze, a sense of relaxation and presence.

As I breathed a sigh of relaxation, I began seeing a few shooting stars every minute. It was the Perseid Meteor Shower, which I'd read was happening but completely forgot about. As I made more pictures, I watched the meteors fall from the heavens into the fire and smoke. A dance of fire, stars, and meteors. Space, earth, humankind all colliding on a grand scale. I felt small like I often do at fires. A sense of awe and wonder, and a bit of fear. If only the millions of people in Los Angeles, San Francisco, New York, and Washington, DC, could see this. Maybe we would have a greater sense of urgency on the unfolding climate emergency, the places we stood to lose, and the places worth protecting.

While ruminating on this, an inversion layer set in, and just as quickly as I put on a longer zoom lens to punch into the flames, the smoke started to settle down over the fire. It looked like blankets of orange and purple had descended over the lowering smoke column. Done for the day, nature was putting the Rough Fire to bed for the evening. Exhausted from the long drive, yet another NorCal Fire roll,

and the weight of my thoughts, I decided to do the same and to meet Jeff down on the main park road that runs through SEKI.

Jeff and I set up our trucks at a scenic pullout in SEKI overlooking the fire in a canyon above the South Fork of the Kings River. We made dozens more long exposures of the fire moving up the canyon, now more visible under the inversion layer at lower altitude. We checked with passing firefighters to make sure our sleeping/photo spot was safe. They chuckled since the fire was "miles away." I drifted off to sleep in my cot with my camera still set up on the tripod, flames dancing on the horizon outside my tent mesh.

The next morning, satisfied with photos and halfway home from Northern California, I headed back to SoCal again to regroup.

A ROUGH RETURN

After a week in California post–Rough Fire, chasing local incidents like the Cabin Fire in the Angeles National Forest, I was enjoying spending part of August at home resting and covering fires while being in my own bed at night. With landscape photography trips and regular photography work commitments, the hours were adding up. There were half a dozen smaller blazes during the summer of 2015 that required me to drop everything I was doing.

A few days after leaving the Rough Fire, hot and dry conditions became pervasive across much of California and the Pacific Northwest, and wildfire activity exploded again. In Washington, the Okanogan Complex began, and the Rough Fire exploded in size, moving quickly southward. I realized the fire was burning through the heart of Sequoia and Kings Canyon National Parks, with few barriers to slow it. Fuels were dense, the drought was at its peak, and fire resources were stretched thin by fires all over the state.

Returning to SEKI, the Rough Fire was a different beast. It had morphed from a beautiful fire in the backcountry to an inferno creeping up toward the main highway through the park, closing most of

it. The town of Hume Lake was under direct threat, and the summer camp was evacuated. The quaint national park now took on a sinister undertone. What was a nice respite from the fire sieges of Lake County earlier in the month was following the pattern of the Rocky and Wragg Fires. The Rough Fire just wouldn't quit. Lower overnight humidity and explosive dry vegetation led to aggressive fire behavior that made containment difficult. Add in steep terrain and few roads, and it made it harder to corral.

I returned to Buck Rock fire lookout to find the older volunteer gone, the fire tower now staffed by full-time wildland firefighters, looking tired and grizzled after days on the fire line. Radio traffic was more frequent, and the evacuations in Hume Lake were being discussed. I walked down the stairs a bit to stay out of the firefighter's way and hopped back onto the open Wi-Fi network.

Twitter was lighting up with news of a burn over at the Okanogan Complex in Washington. Three firefighters had been trapped during the initial attack and were dead. I was watching SEKI get burned up, and news traveled faster than the fire itself through the ranks fighting the blaze.

In the afternoon, the mood at the fire changed. People were less willing to talk to me, and radio traffic was more direct. This could've been anyone at the Rough Fire too. I sat there on the stairs leading up to Buck Rock in the hot sun and cried, watching the Rough Fire pyro-cumulus move southward. I cried for the firefighters who'd just died far too young, their families, crewmembers, the community of Wena-tachee being impacted by fire, the losses at the Rocky Fire, Lake Fire, Jerusalem Fire, Wragg Fire, and now the Rough Fire. It had piled up and I had to let it all out.

Online, there was talk of wrapping the lookout tower in heat-resistant foil for when the blaze moved toward the tower. I went back to Hume Lake where the ICP was located, and they were packing up to retreat and move it down the mountain, since the fire was getting close. As Type 1 fire engines moved into the town for structure protec-tion, I watched a member of the command staff roll up the "Incident

Base" reflective sign while things were being shut down. It felt like the flag being lowered in preparation for an enemy capturing a capitol. I'd never seen a retreat like it before.

Jeff had come back to the fire with me, and we spent the night in Hume Lake as dozens of engines filtered into the stage. The spot where we'd camped with a distant view of the fire seven days prior was immediately threatened by flames. Every few hours a siren would sound. We surmised that the town, normally home to a religious summer camp and cabins on a lake, was testing the system in case firefighters decided to evacuate.

That evening, we stood on the edge of the lake, with dozens of aluminum rowboats stacked like the Sydney Opera House. The fire in the distance reflected off the water, and onto the hulls of the boats. The normally silver aluminum tone glowed orange and yellow, reflecting the light on the water. The Rough Fire was here. Summer was gone. The camp, the park, the town—it was all in danger of being burned.

The next morning the Rough Fire jumped the main highway in the park to the north, ripping uphill and further threatening Hume Lake. I went to take a look, and it was a half-mile wide flame front coming uphill. The road was the only way in and out, and a hotshot superintendent pulled over in his patrol truck to yell at me and tell me to leave. I quickly obliged.

By then my food and water supplies were running low, and I had a tire pressure sensor going off, so I retreated downhill to get gas, fill up my tire, and grab supplies. I stopped by the new ICP to check in and say hello to the public information staff, one of whom had escorted me at the French Fire, and went back up to the fire in the park. The Fresno County Sheriff's deputy wouldn't let me in, so I couldn't access the fire. Same story at both checkpoints. After calling the information officer, they had triggered the exception to the 409.5d media access law, citing limited ingress and egress to Hume Lake. While the roads would be crowded with engines trying to leave if it was a worst-case scenario, I was perturbed that they wouldn't let a small hatchback wagon in to make photos.

It had been another frustrating event with lack of access, but there wasn't much I could do about it. In retrospect I understand why the IC made that decision—three firefighters had just been killed the day before in Washington, tensions were running high, the Rough Fire was behaving erratically, and there were limited escape routes for the firefighters. By the end of the day after I left, however, the media was being let back in. You win some, you lose some.

LOOKING BACK

Eighteen months later in the spring, I flew over the Rough Fire burn scar on a commercial flight to Seattle that took me over the Sierras. I looked down at SEKI and could see the fire's footprint from 30,000 feet. Ultimately, over 150,000 acres had been incinerated, the largest wildfire in Fresno County's modern history, and one of the largest in California period. The Rough Fire had left its mark.

Shortly after covering both trips to the Rough Fire, I wrote a first-person narrative essay for the online publication *Mashable*, summing up my feelings and experiences after the Lake County fire siege and the Rough Fire. I was beginning to realize that I was more than just fatigued, I was feeling the effects of vicarious trauma. I felt isolated. Though, I wasn't alone in that. Mineral King Preservation Society director Lisa Monteiro, who lived in nearby Shaver Lake, said of the Rough Fire:

"You feel so like an island almost because all this is going on and it's so all consuming for you when you live there and then the rest of the world just doesn't seem to care."

Monteiro had moved to Shaver Lake with her family during the winter of 2015 and spent her first summer in the mountains breathing wildfire smoke and worrying about possible evacuation notices. Many residents in the area were affected by the same concerns. Eventually the museum she directed received so many fire questions from residents and visitors that they published an informational website on the bark beetle and other factors leading to those fires.

In 2015, the fires in Lake County, the Sierra National Forest, Sequoia and Kings Canyon National Parks, and the San Bernardino National Forest were a confluence of drought, ensuing bark beetle infestation and kill, and near-record temperatures. Every time I drove back to the LA Basin and Orange County, summer continued on as normal. Pool parties, nights at the bar, beach days, and traffic on the 405. I was coming back tired with my hair smelling like soot, emotionally and physically wracked. It was exhausting to put this in the back of my mind and go back to being social under normal circumstances. I began feeling like I needed to put a mask on just to be what others perceived as "myself."

The rest of August was a blur of resting and trying to live a normal life. There were still fires and the drought was still in full effect, but most of the fires had been in fairly rural areas, with towns and cities being spared. But California's luck was about to run out.

NO LIGHT

I drove into Middletown from the south and all I could see were the burning pilot lights of broken gas lines amid the rubble. Power was out to the entire town. More precisely, there was no power to be had; the lines had all burned down. Abandoned cars lay on the side of the road, scuttled during the evacuation or when civilians were rescued by firefighters. The town center was unrecognizable. The only artificial light came from emergency floodlights. A swing set left standing in a park swung in the evening breeze as smoke was backlit in the glare. The occasional emergency lights of fire engines painted the silhouettes of immolated washing machines, cars, cabinets, and bathtubs. The taste of fire and char hung in the air, permeating the cool evening.

Flames burned in the hills all around town as crews sporadically tried to put out spot fires or protect what structures were left. I set up my tripod in front of a destroyed home that somehow had its front garden arbor still standing. On a partially burned sign, creaking in the wind, were the words "This is Where I Belong." Otherwise, it was just twisted metal and a torched 4Runner on the front curb. That house's severed gas line burned where the kitchen once stood, casting a dull glow onto skeletal trees behind the property line.

Virtually every dedicated wildfire photographer was in Middletown or had already been there, assigned to document the blaze that

ultimately destroyed 1,955 structures and took four lives, burning over 76,000 acres. On the first day of the blaze a wall of fire came down a ridge into Middletown, and a helitack crew was forced to deploy their fire shelters with mild injuries. A helitack crew is a specialized group of wildland firefighters that lands in remote spots via helicopter to scout the fire, bring supplies, and make the initial attack quickly in hard-to-reach spots. It was a close call, too close for comfort, and set the tempo for the rest of the blaze.

Fire burned through so fast that the elderly, and those at risk or without good communications, weren't able to get out in time. This was a chilling precedent set in the 2003 Cedar Fire. I shuddered at the thought of it happening again under stronger winds, or in a larger town with more elderly people. The chaotic radio communications the first day of the fire reminded me of the Butts Fire, but with more panic and urgency.

I was in Dallas on a corporate photoshoot and felt helpless inside the convention center as the blaze raged. On two hours of sleep, I hopped on the first flight back to Southern California, landed, grabbed my fire gear, and then drove ten hours up to Middletown in Lake County. On the final hour of the drive, Kent Porter called to brief me about the fire. He'd become sort of a wildfire photographer mentor to me, imparting his wisdom and experience about the area to help me understand the fire. He was generous with his time and advice, and his guiding words gave me energy and confidence to photograph through the night. It was late in the evening and pitch dark when I arrived upon a scene of destruction.

After photographing in Middletown, I split a motel room—in the same motel where I stayed during the Rocky Fire six weeks earlier—with four other photographers. The group of photographers piled into the hotel room at 2:00 a.m. We had connected for safety and accountability since there was no way of getting help in the fire zone. It was me, Jeff, newswire photographer Josh Edelson, and Pulitzer Prize–winning *LA Times* staffer Marcus Yam. We'd all go on to photograph more fires together, and this was our first time covering the same one all at

once. We debriefed each other, with a mix of shock and a little dark humor sprinkled in to lighten the heavy mood. We are all from different cities with different specialties within photography, but united by the common purpose of photographing wildfires in our backyards and home forests.

I NEVER KNEW THE DAYLIGHT COULD BE SO VIOLENT

After a few hours of sleep, the morning light brought in the full scale of the destruction to my camera lens. The entire downtown was more or less leveled. Buildings stood here and there, but they were the exception. At the remains of a burned business with gym equipment, a bent barbell still sat on the bench press rack, curved in a gentle upturned U shape, two forty-five-pound plates on each side. Burnt dumbbells sat on racks, weight machines collapsed with only the steel weights and cables left. Steel melts at around 2,500 degrees, so while the barbell didn't melt, the fire was hot enough to cause the steel to bend. The melted aluminum rims of cars in the parking lot were in pools of dried metal on the ground. Aluminum starts to melt at a little over 1,200 degrees.[39]

Burn patterns on the metal of car bodies and melted aluminum of wheels and engine blocks dotted the town—amid parking lots, in ditches alongside highways, in driveways. The burn patterns on the steel body panels were incredibly beautiful on a macro level, a patina of brown and ash that turned the metal back into something closer to rotting wood than anything manufactured by humankind. In the destruction, here was a sort of strange beauty wrought by the flames. What we forged was melted down again by fire. Perhaps there was poetry somewhere, but on the ground in the smoke and rubble, it was absent.

And this was just the destruction in the center of Middletown, where the wildfire changed from consuming brush to consuming fuel in the form of buildings as it jumped from structure to structure in the wind. As I drove on the highway west out of town, homes dotted in

dense pines were also leveled. The fuels were completely consumed like at the Rocky Fire and Rim Fire, the entire forest blackened. The air was thick with an inversion layer haze and smoldering toxic materials in vehicles and homes that had combusted. I developed a serious migraine while trying to shoot in some of the lower-lying valley areas. Marcus the photographer later told me carbon monoxide was highly concentrated in those low-lying pockets, and I was actually experiencing mild carbon monoxide poisoning. After this, I would become forever wary of inversion layers in areas that had just burned.

I also decided to wear a P100 half-face respirator in the future in the rubble of driveways and sidewalks to protect my lungs and long-term respiratory health. Smoke in the Sierras is one thing, but the combustion byproducts of all the manufactured materials in modern homes are a totally different story. I thought of first responders on 9/11 walking in the toxic remains of the World Trade Center, and the long-term health effects, cancer, and premature death their cohort experienced. One of those suffering from health issues was my high school English teacher. Obviously, I was not a first responder, and this was not an era-defining terror attack, but the remains of buildings posed a similar safety hazard. I didn't want to take any chances. The P100 mask seals around the mouth and nose, blocking 99.7 percent of toxic particles. This is not an SCBA, or Self Contained Breathing Apparatus, and does not provide an independent supply of air, but is sufficient enough for quick forays into burned areas where toxic materials may be present. Enough to make some photos while minimizing risk.

So, through the sweat of a silicone mask and goggles, a haze of destruction.

Farther into the woods a vintage delivery truck lay in repose amid torched pines. It was hard to tell if it was an old rust bucket formerly hidden among the brush, or a true victim of the fire. The result was the same either way. Across the gravel road, there was a driveway and . . . nothing else. Everything on the property had burned. Downed power and phone lines were tangled in broken glass on the ground; singed remnants of pine needles, pine cones, and bark littered the ground.

The charred remains of forest creatures like squirrels and mice were also scattered, frozen in agony of their last moments, ears burned away, mouths open, upturned to the ashen skies. The only comfort I took in this dead zone was that most of them died quickly. This area between Middletown, Harbin Springs, and Cobb covered much of the primary fire impact area.

The active body of the Valley Fire was far out in the hills and mountains, but the damage was done. I'd made the photos documenting the scene. I was beaten up, tired, demoralized, saddened. I had been at the fire for fourteen hours and decided to call it and head home.

I drove south out of Middletown, listening to Florence and the Machine sing, "You can't choose what stays and what fades away." None of us could choose what fire took, nor what went up in flames. Not I, not the firefighters, not the homeowners, not the politicians. This was not "good fire." This fire was violent, heartless, brutal.

I fought back tears the whole ten-hour drive home.

A REVELATION IN THE LIGHT OF DAY

I found myself leaving the Valley Fire completely demoralized. I'd started summer with increased confidence and experience. Now I had the equipment, basic wildfire training, and fire line experience. But it barely prepared me for the fire behavior, destruction, and human impact I'd see in Middletown. I had the technical tools on paper, but realized I needed to develop the emotional and psychological resilience to these megafires and WUI blazes that were obliterating towns. The abstraction of climate change was no more; this was climate change in the most acute form.

The feelings I experienced while at the Valley Fire were partially captured in images, but afterward I increasingly found writing a way to express what photos did not always convey. While the images were sometimes hauntingly beautiful, there was also a visual austerity that didn't always account for the human element in my work.

Time featured some images I made at the Valley Fire. Two days after

I returned, Instagram interviewed me on their blog, greatly increasing the platform I had to share my work. But it was bittersweet. I was grateful for the recognition, and more importantly that millions of eyes were seeing the images of climate change impacts on their fellow humans. I just wish it hadn't taken nearly 2,000 structures being lost, four deaths, and a town forever altered for that message to get the attention of large media outlets.

The Valley Fire was the last major wildfire I covered during the 2015 season. My relationships were in bad shape. I saw firsthand why first responders and firefighters in particular faced similar relationship challenges and had high divorce rates. It's tough to maintain relationships and have a family life when you are never home and feeling like those outside your world don't truly understand what you see. I had difficulty adjusting to regular life in Orange County after the Valley Fire. The neatly paved roads, cookie-cutter subdivisions, manicured lawns, and full swimming pools despite the drought were visually and ethically offensive. I felt like an island, again.

I didn't know at the time that I was suffering from vicarious psychological trauma. My girlfriend and I broke up a month after the fire. I was still processing seeing the death and destruction at the Valley Fire and needed time to unplug and rest. Yet I went into winter of 2015 and spring of 2016 determined to focus on fires, working on physical fitness, equipment setups, and research. It provided a distraction from the breakup, but the gnawing feeling of exhaustion was creeping in.

Something was going on, both with my emotional health and the wildfire climate in California.

FIGHT FIRE WITH FIRE

June 22, 2016

I stand on a dozer line virtually on the US–Mexico border, under the stars, amidst the smoke and sweat. The one-hundred-plus-degree heat of the day has cooled and the humidity has mercifully gone up, while some crickets chirp in the distance, seemingly unaware of the 6,000-acre wildfire bearing down on them. The Baseline Fire inmate crew from Sonora rests after completing an hours-long firing operation to protect Star Ranch and the town of Campo east of San Diego. For a few minutes they get to eat a sack lunch and put down their forty-five-to-sixty-pound loads. Division Juliette has quieted down, for now. Their 10 p.m. "lunch" is soon over, and they're called to stand up and watch the "green" for rogue embers causing spot fires on the wrong side of the fire line. The crew drove nine hours straight from the town of Sonora near Yosemite National Park, went straight to work, only slept for a few hours the night before last, and spent all of last night awake holding the fire line.

By late June, the Border Fire was already the third-largest wildfire I'd covered in California. I'd gone to the Sherpa Fire in El Capitan Canyon in Santa Barbara earlier in the month and covered the San

Gabriel Complex in the foothills of the Angeles National Forest. That complex was in sight of downtown Los Angeles. While both blazes took days to contain, the main fire activity was over within twenty-four hours. Both of these demonstrated that 2016 would be another intense fire year. Winter had been dry, and the drought was still going strong. Record high temperatures across the state baked fuels. It was beginning to feel like Groundhog Day with temperature records constantly toppling. The season was in full swing. I was single, focused, slightly jaded, and felt like I was fairly seasoned coming into my fourth year of photographing wildfire.

The Border Fire was in fact on the US–Mexico Border. US Border Patrol agents on ATVs monitored the fire line, and its remote nature meant there was little media coverage. I basically had the fire to myself. The first day, I drove down on my own to check out the fire and explore. I'd not covered a fire in that area in some time and wanted to get some experience on how the onshore and offshore breezes battled in the steep rocky terrain of the most southern district of the Cleveland National Forest. Coincidentally, I had a view of another part of the Cleveland National Forest in Orange County from the balcony of my condo. As a national forest in an urban area, the forest districts are actually mountain islands bisected by freeways and human development. Due to its fragmented nature, I was actually closer to the Angeles National Forest headquarters in Arcadia, west of Los Angeles, than the Cleveland National Forest headquarters in the San Diego area. It took three hours to drive 120 miles to the fire, owing to San Diego rush-hour traffic. Once I made it out of the city and headed east on Interstate 8, I climbed out of the coastal plain and into the mountains of eastern San Diego County.

I arrived at the blaze and made images of the Sonora inmate crew on the fire line and took long exposures of the fire moving uphill. It was a quiet, peaceful night with a cooling breeze after dusk and crickets chirping. Overall, it was a low-key, pleasant hike, which was a relief after the 110-plus-degree heat of the San Gabriel Complex a few days prior. I was also in my new fire-chasing rig, the "Fire Wagon"

as I called it. The Fire Wagon was a ten-year-old, extended-wheelbase Ford Expedition SUV. It had 180,000 miles, and I outfitted it with radios, off-road tires, and secure camera storage. It was the fire-chasing machine I'd wanted, giving me more space and off-road capability compared to my Subaru. I made frames of the crew, the fire, and called it an early night back home.

The next morning, I awoke to texts from my friend Gino from up north. He'd been assigned as the leader for a bulldozer strike team and had texted me in the middle of the night as he rolled south with his units through downtown Los Angeles, avoiding the heat and traffic. He encouraged me to come down with the possibility of hopping in the passenger seat to embed with the crew that afternoon. I balked at another 120 miles down to the fire, battling rush-hour traffic again. But I remembered the ride along with Gino the year before at the Wragg Fire and knew it could lead to unique images and access. I set course back to Campo.

On the way into the fire, Gino called me before losing reception to share a fire update. It was burning in a region where multiple firefighter fatalities had happened in the past decades. There were rumors swirling of two civilian fatalities in the fire, which ended up being tragically true. The steep hills, dry fuels, and battling weather patterns led to erratic localized winds and volatile fire behavior. Despite the summer heat, a chill ran down my spine. There was a legacy of death.

We needed to keep our heads on a swivel.

Stopping on the side of the road to take a weather reading, I could sense the spirits of those firefighters on the dry wind. They were sending me a warning to stay aware. Gino and I met in the parking lot of the only gas station in Campo to "tie in" or meet up for the ride-along.

And once again I was with Gino in his ancient pickup truck, bouncing along another dirt road. I honestly couldn't believe that the old piece of shit was still running. He'd used the spare tire after getting a flat, and the cable and winch for the spare tire dangled under the truck, banging against the frame as we went over every bump. I was worried one of the wheels would fall off. But as we bottomed out and

tossed up the hill, we came upon the fire on the hill above town. It was the opposite side of the hill I'd photographed the night before, as the blaze continued to threaten the town itself and surrounding homes. I sat on the roof of the truck, viewing the scene as Cal Fire started a heli-torch operation from above to try and start a backfire. I'd never seen it before. The helitack crew had a hopper full of ping pong balls filled with a flammable substance, allegedly napalm or some combustible substance and fed them through the device where they were ignited and dropped onto the fire below. They were trying to deny the front of the Border Fire from hitting the town by reducing fuel in its path. The helitorch operation met with limited success, so it was time for plan B.

While I took pictures, Gino worked the radios and told me inmate and hotshot crews would try for a nighttime firing operation by hand instead. This meant that crews would use drip torches, flare guns, and incendiary fireworks to start the backfire. In order for the plan to work, it would take a little luck to make sure the backfire didn't blow back over the containment lines they'd constructed to corral it into the main fire. The sky darkened and the fire crews prepared to fire out—to burn the fuels in front of the fire, hoping to slow its progress by depriving it.

The firing operation began at dusk, and I walked out among the hotshot crew working to ignite fire. They were using drip torches and fusees, standard tools for firing. A couple of them also fired flare guns with incendiary rounds, sparkling against the dark blue sky. Eventually the stars joined the sparkle, and the flames and embers were coaxed out of the increasing humidity in the brush. Soon, embers danced over the crew's heads, blue helmets bobbing in the chamise chaparral and chainsaws ripping away. The smell of diesel mix, burning brush, and the yells over the noise of equipment dominated the scene. I would've missed it if Gino hadn't let me embed. Relationships in the fire world meant something.

Amid the action I used a lens suited for low-light to blur the move-ment of the hotshot crew and inmates firing out. A frame on the LCD screen stood out, dozens of firefighters with saws, drip torches, Pulaskis, and incendiary devices blurred with a slow shutter speed against the

backdrop of flames. It was the art of human, earth, and fire in one dance to save the town of Campo captured in half a second. Being the only photographer out there witnessing this dance of firefighters was sublime. It was a privilege and a treat to witness firsthand. I continued to work the scene until the firing operation was successfully pulled off. The threat to the town of Campo was mitigated and I came away with some powerful wildfire storytelling photos.

I said farewell to Gino and hit the road. Doing five hundred miles in two days and chasing fire took a lot out of me, so I was looking forward to sleeping in my own bed. I was able to take advantage of the full promise of SoCal's myriad freeways late at night. The Fire Wagon was proving to be a capable fire-chasing rig: good power, space for my equipment, and the four-wheel drive to take me down fire roads. Having a hot shower and a fridge was worth the effort. I'd learned in 2015 that building in rest time and real beds, when possible, made a difference in my energy and focus on the fire line. I'd be ready for whatever fire threw at me next.

FOURTEEN
FATIGUE SETS IN

After the Border Fire, it was clear that fire season was in full swing in California. The Central and Northern Sierras were still fairly quiet, and most of the fires I photographed were generally within Southern California. I took advantage of the lull in fires to start dating again. I'd taken that winter and spring to take time for myself, to travel, and to work on physical fitness. I'd also built out the Fire Wagon and felt like I was in a good place, despite realizing how challenging it was to build a social foundation after moving back to Orange County from Los Angeles in less than a year, work on a big photo project, and date.

Realizing I'd left my social life on the table in 2015, I was determined to better balance life and chasing fires. Jeff had approached me about a documentary that was being produced for a large online streaming platform called *Fire Chasers*, and after connecting with the producer I joined on as a subject and consultant, thinking of it as a way to further share my fire documentary work.

The production had problems from the start. Budget and bureaucracy issues meant that the film crews missed many of the pivotal 2016 fires that Jeff and I photographed. The size of the production unit (three camerapersons, three sound techs, and three producers) meant logistical complications with vehicle caravans and lack of training for the crew. The production crew had PPE, fire shelters, and rudimentary fire information,

but I still felt uneasy. While Cal Fire lent their PIOs at fires for access and did their best to assist, the production company simply wasn't used to working on such short notice. Jeff and I had already learned to live like firefighters, dropping everything to get to a fire. We'd be on the fire line photographing flame fronts and WUI impacts while the producer and crew were telling us they'd be "on set" tomorrow or the day after. By the time they showed up, the fire was either out or there was little left.

Turns out parachuting production crews into wildfires wasn't easy.

A prime example was the Erskine Fire near Lake Isabella in Kern County. It was a wind-driven fire with Mojave Desert brush that burned down many homes and killed two people. It moved so quickly that elderly retirees weren't able to evacuate in time. Even on the second day of the fire when I arrived, homes were being lost, abandoned by firefighters due to lack of defensibility, futility in the wind, and lack of water and resources. The production crew was nowhere to be found. I was also frustrated by two Type 1 strike teams just a few miles down the road, staged and sitting there, while structures were burning. Residents who hadn't evacuated were running around in shorts and bandanas, eyes red and stinging from the ash and embers, frantically trying to save what they could from neighbors' yards.

A ranch-style home was hit by embers, and fifteen minutes later smoke started coming out of the roof and attic vents. This meant that an ember had found its way into the attic and wedged itself in the roof insulation, smoldering until the material ignited. It was difficult even with water and plenty of resources to fight this type of structure fire. It spread within five minutes to the entire home under wind and ignited a tractor, a truck, and outbuildings. I did a quick look to see if keys were in the ignition to move any of the vehicles, but there were not. Another fire photographer was able to move a pickup truck closer to the highway and out of harm's way.

My frustration was compounded by the structure loss, lack of committed fire resources, the missing film crew, and missing the first day of the fire. I was on call for a client meeting that was canceled. I blamed myself, but how was I supposed to know? I needed to take some days to take on new business. Fires wouldn't pay the bills in the long run.

I started to feel overwhelmed: the breakup, dating ups and downs, the *Fire Chasers* production, fire season, trying to grow my photography business. I had not processed or fully recovered from the emotional fallout of the Valley Fire and the 2015 season. I was just tired, and kind of over fire. I just wanted to live life.

That evening Jeff and I parked on a hill disengaged from direct fire, photographing the fire front ripping up a ravine and threatening homes under the Milky Way. I framed a burnt-out Joshua tree with the fire in the background. It became the cover for *Terra Flamma: Wildfires at Night* that would be published a few seasons later. The pink hues of the sky, out-of-focus tree, and light from the air attack plane all put together elements of the fire into one frame.

Later that night we hiked into another thicket of Joshua trees, perhaps a few thousand of them that were totally burned. In the frame were headlights illuminating the skeletal remains of trees, fire on the hill, and the Milky Way. It was a scene of destruction, yet also one of sublime natural beauty. How could fire be so beautiful *and* so destructive?

The second afternoon I met up with the Trabuco Tigers Type 2 crew, a hand crew from the Cleveland National Forest close to my house. I'd trained with them for my basic wildland fire training before formally attending wildland academy in Arizona that previous spring, and I was excited to photograph them. It ended up being a slow evening with the crew staged in a parking lot looking for spot fires and embers, but there were none to be found. We did a gridding exercise, and I decided to drive home that morning after pulling an all-nighter, stressed out about a girl I was seeing long-distance who ended up cheating. I was a wreck of anxiety and exhaustion and wanted to be in my own bed.

ENTER SAND FIRE

As July marched onward, SoCal got hit with more fire weather. On a Friday night (it's always on a Friday) the Sand Fire started north of downtown LA in the Angeles National Forest, north of Sylmar on the west side

of the forest. It was an area overdue for fire that had been spared during the massive 2006 Station Fire that burned much of the forest. Some of the fuels hadn't burned in decades. I had dinner plans with family, and as it tore uphill into the mountains, I decided to skip the fire.

My phone was getting dozens of texts during dinner. We were sitting on the patio of a country club drinking red wine with the view over a golf course, as I watched drift smoke move over the LA Basin from the fire into Orange County. It was a privileged viewpoint. Fire-fighters would be spiking out eating MREs and evacuating houses, and here I was downing bread rolls and steak. I was a phony fire chaser and climate-change photographer. I also had plans to have a drink with a woman I'd been getting to know after the Dallas disappointment. I had to decide whether to go cover the Sand Fire that evening or meet up with her. Feeling apathetic, I bailed on the fire to hang out while my friend in Redondo Beach, thirty air miles away, texted me that he could see flames from his front porch.

I had missed the chance for night shots but arriving early the next afternoon didn't disappoint. The fire was blowing through Little Tujunga Canyon and up into Placerita Canyon, nearly burning over the Bear Divide Ranger station where a US Forest Service hotshot crew is based. Coming up around a bend into the burn area was a massive pyrocumulus that was 15,000 feet into the air with hues of orange, purple—and gray sky behind it. Driving in, there was evidence of extreme fire activity. The hillsides were a moonscape with totally consumed fuels. Drought had made the fuels dry, it was hot, and there were canyon winds. It was the same story at all the fires for 2016. Stuff was just burning intensely.

The Little Tujunga Hotshot crew was cutting line on the road up, and they looked like they hadn't slept since the day before. They'd probably pulled an all-nighter on initial attack and were going to get some rest. It looked like they'd been through hell. Continuing toward the smoke, the fire activity was so intense that I couldn't drive all the way through. I went down around the 210 freeway to the back side of Placerita Canyon on the north side of the forest. My friend Ryan

reported that the mountain road was "impassable" due to rockfall, debris, and fire. I tailgated behind a strike team of five LA County Fire engines running lights and sirens on the freeway.

Once at Placerita Canyon the fire column started rotating at the mouth of the canyon on its way toward homes, indicating extreme fire behavior. It was the leading edge of the pyrocumulus I'd seen from the other side. As the fire moved out into the hills, air tankers tried to stop the inferno, and the US Forest Service shut the road to media so fire engines could get through. It was frustrating because I had the training to safely be in there. But since it was LA, every person with a camera and press pass suddenly became a fire photographer. There were dozens of people trying to get in to take pictures. The congestion on a narrow mountain road would be a recipe for disaster, so I demurred and stepped back for a wider perspective. The picture I made of the column at the intersection became one of the most widely shared images of the fire on social media.

At the closure intersection, donkeys milled about in an empty field, seemingly oblivious to the fast-encroaching danger. I thought we were about to see hundreds of homes get destroyed, but the fire moved into a bowl and petered out, the air tankers were able to slow the fire enough, and engines were able to conduct point structure defense. A historic movie ranch and some homes were sadly destroyed, but broader destruction was averted.

I have dashcam and GoPro footage from the drive into the canyon. Overhead, an orange sky filled with smoke is punctuated by a DC-10 VLAT supertanker flying overhead. In front of me is the strike team of engines, lights and sirens blaring. Once the fire began to moderate for the evening, I decided to skip night shots and head back to Orange County. Due to the 409.5d closure exception, access wasn't great, and I wanted to see the new gal again. So I skipped a second night of long-exposure photo opportunities to live my life. Balance.

The next day I actually went to brunch with friends from the gym before dragging myself back to the Sand Fire. The edge of fire that had blown out the top portion of Placerita Canyon Road was now moving

west toward other critical roads in the area, now with easier access to media. I posted up at a dirt pullout with a good view of the approaching flame front, as the day grew hotter and fire activity increased.

Dozens of other photographers and news camera people also had the same idea, and soon the two-lane country road was chock full of media and fire engines. The active flank of the Sand Fire was moving through a county park toward the road at a fast clip. I moved the Fire Wagon to face down the road and out, in case I needed to quickly escape.

A three-person camera crew in a silver SUV drove right up to the flames and hopped out to start filming. No sooner did they leave their vehicle, without proper PPE or fire shelter, than the fire started burning uphill over their car. I and everyone else farther away at the scene started screaming at them to move. They looked like deer in headlights and continued to film. A couple of expletives later and a battalion chief screaming at them, they finally got into their car and sped out as flames almost burned them over. Thirty seconds more and they would've been burn victims. Their recklessness underscored how serious the fire was. I retreated to a more distant viewpoint closer to the freeway, suburbs, and away from clueless reporters.

Moving around the subdivisions between the forest and the 14 freeway, Los Angeles County firefighters engaged in structure defense as Firehawk water-dropping helicopters moved overhead to defend homes in cul-de-sacs. A Firehawk is a military-spec Sikorsky UH60 Blackhawk helicopter converted for fire use, or sometimes they're purpose-built. Los Angeles County Fire operates a fleet and they are powerful tactical tools for fire suppression in vulnerable WUI areas. The fire now threatening homes was less intense backing fire at that point, but to concerned residents defying mandatory evacuation orders, it was incredibly concerning to see fire so close to home. In a county where the medium home price was $575,000,[40] it represented years of residents' work, hopes, and dreams. The fire captains on blocks were as much crowd control with LA County Sheriff's deputies as they were firefighters. It was another scene of collision between human development and wildfire into a densely populated bedroom community.

After a rough morning and afternoon, the fire finally started looking better, and I grew optimistic that the worst was over. I was helping to guide and photograph with an audio reporter and writer from the Center for Investigative Reporting and took them into fire camp to see if there were any stories. There were dozens of engines already being released from the fire, so I knew it was time to head home. I was already regretting not making night shots.

I clearly was sensitive to fire impacting my relationships. I almost felt shame over bailing on easy photos for the *Terra Flamma* project. Creatives know the feeling of impostor syndrome. If I was such a fire photographer, why didn't I drop everything to focus on the night aspect of my project? In retrospect, I wasn't giving myself any credit for trying to balance my life.

Still, I made pictures but missed the focus of *Terra Flamma* (you know, the "wildfires at night" part). It was a missed opportunity. I had swung too far into apathy, and balance was critical. By the end of the season my perspective changed to, "It's okay to miss some fires and photos." There would always be more fire. It's not stopping or slowing down. The actual fire may be different, but there will always be more infernos. Time with family, friends, and partners is never guaranteed.

Eventually I'd learn to lean into my own creative direction, take ownership of it, and find a better balance, but 2016 wouldn't be the year.

MAD MAX

I drove the Fire Wagon onto the freeway shoulder, amber strobes flashing, past a mile of stopped traffic on the northbound 15 freeway. I rolled up to the California Highway Patrol closure at the offramp diverting traffic from the eight-lane interstate and was waved right on through to an empty highway.

The Blue Cut Fire had started that morning in the San Bernardino National Forest and was ripping with high winds and heat through the forest and high desert around the Cajon Pass, destroying homes and forcing the closure of the main highway between Los Angeles and Las Vegas, costing millions of dollars per hour in lost commerce. I'd been at the pool and beach all day on a date, and this time I had brought a passenger—my date was coming to the fire with me.

We could see the smoke column from my house during the day, but I wasn't going to miss a perfect beach day in good company. This coincidentally was the same person whom I'd bailed on the Sand Fire twice to hang out with. I wasn't going to miss more night shots, so I tossed her my spare Nomex PPE and helmet and off we went.

Coming up the Cajon Pass we went around a curve, and it was a wall of fire on the western side of the highway where the flames were licking power lines and impacting structures. I'd never seen a freeway that empty at night. The 14 was shut down at the Sand Fire, but

farther away from actual flames. There was fire all around the interstate. Moving farther up the hill, I spotted a glint of chrome to the right, and as I drew closer realized it was the burning remnants of an eighteen-wheel semi truck. The cargo was on fire and smoldering, the cab totally melted. Part of the engine block survived, and the only part left standing was the exhaust pipe assembly, designed for higher temperatures. Under a full moon, it was a scene straight out of *Mad Max* or some other postapocalyptic movie. On the side of a major interstate in the desert, a burned-out hulk of interstate commerce, victim to fire.

Cars were abandoned on the interstate and exit ramps, so tow trucks were moving the vehicles to a central impound lot where motorists could reclaim their autos postfire. I ran into Jeff and had my date take a picture of us on the empty interstate. Uphill, the historic Summit Inn on Route 66 at the top of the Cajon Pass, where you enter into Hesperia and Victorville, was also destroyed. As a big Route 66 enthusiast myself, this was incredibly sad. All that remains is the sign, spared because it was standing by itself in a gravel parking lot. The remnants of the building were bulldozed, and the lot sits empty, a piece of history vanished.

Continuing toward Wrightwood where the fire was also burning, I stopped at another burned out Joshua tree forest under the moonlight. Under the dim reflected sunlight, you could make out a moonscape in the distance going uphill. A structure, a school bus, and a swing set were all torched. It was another postapocalyptic scene, and this time reminded me of the original *Terminator*, when the whole world gets nuked. It looked like a bomb had gone off under the sky, reflecting pink and purple from the fire below under the glow of the moon.

After making dozens of images of intense fire behavior and its immediate aftermath, my date and I began to backtrack down the two-lane highway toward shuttered I15 to make our way home. It had been a long day, but I made one last stop to rephotograph the dead Joshua tree forest. I stepped out for a self-portrait, then invited her out onto the ash, carefully, to take a photo of her against the fire. After making the frame, I walked up to her and embraced amid the pale

specter of the burnt forest under the moon and stars, fire roaring in the background. It felt a little irresponsible, between the apocalyptic feel of the Blue Cut Fire and my growing nihilism that summer. But in that moment, it was simply a rush.

She was wearing a pair of Nikes, and walking out, she stepped on hot ash and burned the sole of her shoe. My fire boots were untouched, but it snapped me back into reality and situational awareness. I had allowed myself to let go for a moment, and her sneakers paid for it.

DAY 2: OFF THE RAILS

I reluctantly returned to the Blue Cut Fire the next day, as the production crews for *Fire Chasers* had finally shown up after the bulk of the fire had moved into the backcountry and moderated. Immediately, one of the on-scene producers tried to start staging my conversation with Jeff and my photography of the fire. This was supposed to be a documentary and not some weird directed piece. I protested and decided to drive off and do my own thing. They insisted on throwing one videographer in the truck with me. Fine. At least it would actually be documentary stuff instead of whatever reality TV drivel they were trying to gin up.

That afternoon after filming and photographing for a few hours, and seeing more houses tragically get lost, I found out one of the crew's rental Suburban had burned over during a flare up at a quieter part of the fire with an extremely rare, six-figure cinema lens inside the vehicle. I saw a photo of the burned truck shortly afterward, which mysteriously got deleted soon after. In asking the Cal Fire PIO attached to the film unit, they gave a canned response, and they looked fairly shaken up. I knew they were embarrassed, but it wasn't their fault. It was probably the producer pushing in a dangerous situation. If it wasn't for the safety plan and "stepping into the black," or burned area of a fire, by the Cal Fire firefighters, it could've been a worse story. Ironically, it was also an example of a common fatality situation, a flare up on a quieter part of the line causing injury or fatality. The film crew was a liability now.

I think the vehicle burnover fully derailed the production. There was still almost no footage of me. Not that I personally cared much, but they kept trying to get crews out and kept failing to deploy them in time. It was getting entertaining, honestly. I felt bad for the videographer in my truck. He looked like he'd been through hell. I offered him some Gatorade and drove him back to base camp that night to meet up with the rest of the crew. Some of his personal items and gear had been destroyed in the Suburban. I had no qualm with the videographers and sound techs. The guys doing the filming were just doing their jobs. My issue laid squarely with the ongoing management failures of the production and their inability to listen both to Jeff and I, and the firefighters when things were worth filming.

By mid-August the producer had blown most of the budget and the production company and streaming distributor fired him, since there was still little actual "fire chasing" footage. This came as no surprise to me. Hollywood drama ensued, Ari Gold in *Entourage* style, and one of the heads of original programming called Jeff and I in for a meeting in their swanky Beverly Hills office. That morning, the fired producer immediately started harassing us via phone and email, attempting to influence our perspective prior to the meeting. I was already totally over the whole documentary and was considering options for stepping away from the whole mess for material breach of contract. Ultimately, I decided just to toe the line, and step back in my role as a consultant, since there wouldn't be footage of me anyway.

I'd been at fires and at the beach, so having to dress up in an air-conditioned office in LA with a stocked snack bar featuring three La Croix flavors, Snickers, and Perrier, was over the top. It was so clear the production company and streaming distributor were disconnected from reality on the ground. The fired producer and the content heads at the studio were spinning two different stories, but the end result was still the same: when the fire hit the Pulaski, there just wasn't a film crew in the right places at the right times. I decided to chalk the whole thing up to experience and continue focusing on my work.

The drought was at its height and towns like Porterville in the

Central Valley were literally running dry. Residential water wells were not producing water, and the city had to put water tanks in people's front yards. The documentary could go to hell, and I'd keep focusing on the important stories instead of petty turf battles in the entertainment world. One foray into Hollywood production was enough to leave a bitter taste for future film projects.

Going forward, I resolved that I'd focus on my own work and photos at fires, getting back to basics—breaking news, educating the public on climate change, supporting the wildland fire community. I'd evaluate new projects and proposals coming across my desk on an incredibly selective basis and charge for that expertise. Years of sweat equity was almost ruined by those who parachuted in and didn't care. The four-part series ended up streaming online and was met with lukewarm success and mixed reviews. The wildfire community largely panned it on social media, since they used a structural firefighter in European turnout and bunker gear for the promotional poster. It just completely underscored the ineptitude of the whole venture. I was grateful I'd only made a cameo and was listed in the credits. Looking back, if the original producer had put his ego aside and listened to the experts on covering wildfire, and not been so combative with the studio and production company, they could've made a great documentary.

Ultimately *Fire Chasers* focused on a female inmate firefighter, who later revoked her consent to be filmed, and an LA County helitack crew. Various crews were also critical of that angle, as they felt it represented one small slice of wildfire, rather than the backbone formed by hand crews and other line diggers. Despite my issues with the documentary, I was glad Jeff got exposure and *some* documentation of what wildfires look like in real time. The inmate crew focus was also beneficial for the public to see, especially a female face on the fire line in a world dominated by men.

Until writing and reflecting on 2016, I'd been fairly quiet about my involvement in *Fire Chasers*, partially because of disappointment, and partially because of its reception. But it's an important part of

my fire coverage and professional and personal development. For those who parachuted into wildfire, they've since moved on to other projects and are no longer involved in the fire world. But I'm still here and proud of it.

The people who trust you with a camera always come first. It was an important life lesson. Putting that trust first and prioritizing stakeholders rather than outside interests was paramount. Outsiders didn't necessarily have the long-term benefit of the wildfire world in mind. It feels good to speak and write my truth now without sugarcoating it. I didn't care how big the studio was or who was running it. It meant nothing to me. And it was not only the botched production, but the anxiety of relationships, unresolved vicarious trauma from past fires, and just being exhausted with relentless wildfires.

I loved chasing fire and photographing it, but at what personal cost?

The Blue Cut was the last major fire I covered in the 2016 season. SoCal was spared large Santa Ana fires and NorCal fires were all-too-distant or small for me to cover. We dodged a bullet during fall 2016 in SoCal. That the season faded off into frustration and disappointment summed up the year. It was personally challenging, but I still made many pictures for the project I was proud of, but more importantly I grew tremendously personally and professionally. I came out stronger, more streamlined, more experienced, and less willing to tolerate bullshit. I'd been through the wringer and came out in one piece, mostly.

After the weird fire season, *Fire Chasers*, and the ups and downs of dating, I was grateful for the rains to come in fall and to have an unusually early end to fire season. I enjoyed the longer-than-usual break leading up to the 2017 season. Turns out I'd need that rest.

ORANGE COUNTY'S FIRE FUNNEL

I took a pretty long break between 2016 and 2017. Between the early season ending and major winter rains that helped put a major dent in the five-year drought, I left the country for a month. I then took an extended road trip through America, so I didn't return to California until late August. I'd taken the fire season balance to heart and based on forecasts felt I could skate by traveling until August, returning for peak fire season later in the summer. I was trying to work smarter, enjoying the summer months to live life, while also making room for fire. For once, it wasn't just all drought: we had some relief.

I chased a few early season fires in June throughout SoCal. Two of them were nearby in Orange County. They were explosive in their fire behavior for being near the coast during June. Both these small one-day fires occurred near the coast with higher humidity, but with decent onshore breezes. This told me that the fuels were incredibly dry, and that a little wind was all it took for major fire behavior, even in less than critical conditions.

Back in California by mid-August, the season started to heat up in the Sierras and Northern California. I chased three fires but missed most of the action due to travel. However, the Railroad Fire between Oakhurst and Yosemite produced a quiet photo of a single burning tree throwing off embers in an otherwise burned forest. It was shot under a full moon,

and the image speaks to me of quiet nights in the forest chasing fire from afar, the crickets chirping, and alpine breeze I love so much.

That quaint form of chasing fires from afar with mountain views was shattered in October when SoCal was hit with multiple offshore Santa Ana wind events.

I stood in a cul-de-sac in the Dominguez Ranch subdivision of Corona, just on the other side of the Santa Ana mountains from Orange County, taking cover from an ember shower blowing into my face. I deployed my specialized WUI face shroud for heavy fire conditions to protect my eyes, nose, ears, and neck from burns. Quickly, I donned fire goggles, put gloves on, and threw on a second Nomex interface coat for better thermal protection from the homes I was about to see burn. The helmet camera was rolling, cameras bouncing on their elastic straps as I speed-walked toward the end of the driveway. The homes were built at the front end of a huge bellows moving through the canyon between Orange County and Riverside County, a historically bad fire area that funneled hot, dry, Santa Ana winds from inland to coast.

Palm trees thrashed in the wind coming down the canyon, and I was surrounded by fire on three sides. Dozens of houses directly abutted the open hillside terrain. Type 3 fire engines sped in, hooking up to fire hydrants, and running hose lines into backyards to prepare for the impact. Over the din of wind and engine pumps, firefighters yelled out instructions to their crew. Residents were still evacuating as police drove up and down the street, sirens blaring, and yelling on the loudspeaker "THIS IS A MANDATORY EVACUATION, LEAVE NOW!"

A man piled valuables and household items into his sedan, backed up, and sped down the hill as embers and ash landed in his driveway. Wind chimes at the house across the street clanked in the unforgiving dry wind, an eerie and imminent harbinger of the flames that were about to engulf the upscale homes. I jogged around clicking away, trying to capture the action.

I took a few deep breaths while taking pictures, reminding myself to stay calm and focus. I needed to let the adrenaline keep me aware, but not give me tunnel vision and shaky hands. I needed to stay calm

enough to create—again, I was finding balance. It was my fifth season chasing fire, but I still fought my instinct to be scared shitless and panic. I had to trust my training and experience to guide my movement making photos on the fireground.

A few houses away, I spotted three firefighters from an engine crew running into a backyard with hoses and followed them in after asking permission. Fire was coming into the backyard and throwing embers into the patio area. They charged the hose lines and yelled, "WATER!" as they started knocking down burning brush outside the patio and spraying ornamental yard vegetation that was burning. This went on for a few minutes as I photographed, embers showering every which way in the wind. Quickly, the crew kept the fire from overwhelming the house. They also hosed down exposures, or sides of the house where embers were falling. This area was safe, for now.

Leaving the cul-de-sac, I bumped farther up the hill to follow the fire front hitting the next street of houses. The structures I approached weren't so lucky. A symphony of smoke detectors and fire alarms were blaring in multiple homes. The shrill beeping of smoke detectors joined the noise of diesel engines and water pumps between rotor wash from night-dropping helicopters. Whenever I heard smoke detectors going off at a WUI fire, I knew homes were burning.

Firefighters opened a garage and feverishly used tools to start tearing out drywall from the side of a house, where embers had wedged their way into a vent and ignited the garage. There were enough engines and hoses deployed on the house that they were able to stop the spread. The garage had moderate damage and the house likely needed a deep cleaning from smoke, but the home was standing and would be habitable after repairs. It was an incredible save, as the house abutted the Cleveland National Forest and was at the top of a small drainage the fire blew right up into. The long exposures I made from the driveway of the brush adjacent to the home showed smoke swirling due to erratic local winds.

A little luck, some brush clearance, and great firefighting.

The house survived for a few reasons. First, stricter building codes after major fires in California meant that newer construction in the

WUI, and areas considered "High Fire Hazard Severity Zones," had to be built to stricter standards. This means fire-resistant roofing materials (not wood), smaller mesh on vents to keep embers out, mandatory brush clearance, and barriers at the ends of yards. All these factors, combined with an aggressive initial attack by firefighters, saved the house. Defensible space gives crews a buffer to work with when defending a home from fire. If the fire can move to another house with full intensity, it makes it harder and less safe to defend. The space allows firefighters to get hose lines and engines between the home and the fire. It also reduces fire intensity because the fuel load is reduced.

For every homeowner, real estate developer, and politician who decried California's strict building codes, I challenge them to stand on this street in the middle of the inferno and tell me those building codes were worthless. *I dare you*, I thought to myself while sweating through my goggles and feeling ash particles cake around my mouth and dried out lips.

After covering the structure defense, I went farther uphill away from the fire for a wider-angle shot. Setting up my tripod, I was greeted with a view of a glowing mountain with millions of hotspots burning and homes right below. A sea of fire engines were moored to fire hydrants in front of each house, lights flashing in the night. It was as if the road in the subdivision had become a harbor for half the fire engines in the county. It was a sight to behold in the mutual aid system, with departments from all over SoCal banding together to save the community with minimal damage. Satisfied with the images I'd made, safe, and grateful that homes were not totally lost, I called it a night.

CANYON FIRE, REDUX

The smoke column had already blown out and was leaning over as I sped inland on the 241 toll road toward the flames. On the right was a sign that said "DANGER, ENTERING HIGH FIRE HAZARD SEVERITY AREA." You didn't have to look twice to see why.

I pulled off the highway to make a scene setter of the Canyon II Fire, thirty minutes after it started. Another Santa Ana wind event, just weeks after the Canyon I Fire in Corona, was now immediately threatening structures in Anaheim Hills just down the road. It was another historically bad fire area.

The fire was moving into homes in another upscale subdivision. I'd just visited the neighborhood to buy truck parts from a firefighter, oddly enough. Traffic was snarled as residents rushed home to evacuate and gather items. I kept pulling over for police and fire engines as they sped by. At a traffic light, kids lined up in front of an elementary school, teachers sweating under smoky skies with furrowed brows. Harried parents literally grabbed their children and took off to get out of the fire's path.

Just down the road, a flank of the fire was burning brush on a road directly across from houses. There were no police or firefighters present yet. I was standing in the road with a resident walking into the brush, garden hose in hand, to try and quell fifteen-foot flames. I told the man holding the garden hose he was putting his life in danger, but he just ignored me. There was plenty of defensible space, and the road provided a good fuel break, so his sacrifice was needless risk.

A Type 1 heavy Sikorsky Air Crane helicopter came by and dropped more than a thousand gallons of water on the spot, helping out. I was worried the man was about to get burned over. Just in the nick of time, an engine arrived and so did the cops. The police yelled at the older man on their PA to leave, and so did the firefighters, taking over with a reeled attack hose line off the engine. The homes were safe. I was frustrated because residents were just in the street, blocking fire engines with their cars, rubbernecking. I didn't blame people for being worried about their homes, but the impact on first responders trying to fight this active fire was a detriment to their own community.

Moving closer to the hill where the fire ignited was a different story. I saw dark puffs of smoke rising from where the fire front moved through, which was a horrible indicator of homes burning. I came to a cul-de-sac on a hill where multiple houses were burning down. Firefighters were trying to protect exposures on neighboring houses—the burning houses

were write-offs. In the high winds, it was a struggle to prevent the flames from spreading to the tightly packed houses next door.

I ran into an engine crew that I knew from the Cleveland National Forest. They were doing structure exposure defense on a home with crumbling walls. They weren't trained for structure fires but were able to spray water on the house from the outside. Within seconds, a wall collapsed and got dangerously close to falling on one of my friends. I dropped my cameras and rushed out to him, but he was fine and had already gotten up from next to the rubble. It was a huge adrenaline spike and scared the hell out of me. I went farther down the street to where two more homes were ablaze. I took nearly two thousand photos that day amidst bursts of action and dozens of homes impacted by flames. I sat in my car to quickly file photos with the *LA Times*, culling down a first edit of a few hundred images, then one of fifty, then a final cut of twelve to fire off to the editors in downtown Los Angeles. One would end up on the front page the next morning.

A group of Brea City firefighters had larger hose lines, spraying hundreds of gallons of water per minute on a burning house to save the one next to it. Flames leapt out of windows, directly touching the intact house next door. The captain had a spray stream of water on the neighboring house's stucco wall to try and keep it safe. There were more firefighters in the backyard trying to corral the flames too. I heard glass window panes cracking from the heat and falling to the ground, and rafters within the home collapsing. I kept my distance and let the crews work but was right there getting soaked by a mix of water and ash as the wind blew spray back in my direction. I kept having to retreat to clean off my camera lenses and dry off my cameras so they wouldn't get ruined.

The GoPro footage on the camera showed the massive fire and complex WUI conditions. I was proud to be documenting this fire for much of Southern California to see.

Moments later, an ember blew into my Nomex pants through a tear and burned my leg. It hurt like hell, but I checked the injury, and it was dime-sized, only a first-degree burn. Not much to worry about. I'd dress it after the fire with burn gel. I went to the house next door

where Halloween decorations were knocked over on the front lawn. The home was on fire. I crouched low on the ground to get the skeleton riding a motorcycle with the burning house and palm trees in the background. Soon the house would be a skeleton too.

Continuing along the fire impact area, I came upon a mansion that was a total loss. Firefighters were putting out hotspots in the home, a hulk of its former self. Burned cars sat in the driveway while hose lines ran into the house, despite a possibly unstable roof. I followed a firefighter in and saw an iMac on the front lawn, covered in water. I wondered if the data was salvageable.

At the front of the structure was a partially burned home office with holes in the roof, smoke and water dripping off the immolated rafters. It dripped onto a nice leather chair and desk, and a burned map of the world clung to the wall. This was someone's home, uprooted and never the same again. I felt horrible for the owners who would come back to a destroyed house. At least some of the neighbors' houses had been saved. There was a sinking feeling in the pit of my stomach every time I saw a home destroyed, despite firefighter's best efforts, and this was no exception. Friends were evacuated, texting me, asking if certain addresses were okay or still standing. This was very close to home.

I covered the fire front through dusk, chasing embers as they hit homes and crews as they struggled to salvage damaged houses with burning attics and garages. I stood in the county park watching a helicopter make a last drop for the day at dusk, next to a burnt-out prickly pear cactus as the sky turned to pink from the smoke blowing over the ocean. My leg hurt from the minor burn, and my knee was throbbing from falling onto concrete earlier. I decided to go home, ice my leg, and rest up.

Early that morning, a series of fires started in Napa and Sonoma Counties in Northern California, and wrought havoc at the Tubbs and other fires. The next day I had an assignment in LA for the *New York Times*, so I needed to rest up in case I decided to cover those blazes. The Canyon I and II Fires were simply a warm-up.

SEVENTEEN
SMOKE IN THE VINEYARD

THE ATLAS

As I readied for bed awaiting the forthcoming Santa Ana wind event in SoCal where I'd chase the Canyon II Fire, the Tubbs Fire and half a dozen other wind-driven blazes erupted in Napa and Sonoma Counties late that same evening. An extremely strong north wind event, the rough equivalent to the Santa Ana wind in NorCal, was bringing gusts of eighty miles-per-hour blowing in an offshore direction. The Tubbs Fire started between Santa Rosa and Calistoga, and in minutes was on its way to becoming a historic wildfire incident.

I stayed up until 1:00 a.m. monitoring Twitter and listening to the online fire scanner feed. Radio chatter was frantic, overlapping, and hints of panic flashed in sound bites. I couldn't keep up with new fires being dispatched, people being rescued from burning homes, and mass evacuations occurring. All the bad things that can happen with a new fire were happening at once, in multiple places. I was texting with fire photographers in NorCal, my firefighter friends, and was extremely concerned over the firestorm that was hitting town—flames had been spotted over the 101 freeway and a hospital had already been evacuated. But I also had to consider the fire danger in SoCal, *and* I needed rest. I quickly realized I may end up covering fires in SoCal, then having to go

after more fires in NorCal, essentially covering a statewide fire siege. I called it a night and, the next morning, found myself chasing fire twenty-five minutes away from my house.

The morning after the Canyon II Fire, I woke up with a swollen knee twice its normal size, and my leg throbbing from the burn from the ember that flew underneath my Nomex pants the day before. I cruised up to the LA Rams training camp north of the city to photograph my story for the *New York Times*. I dutifully shot it, then checked the fire activity in NorCal. I was already partially en route to the fire siege, and I had my equipment ready. I was tired, but my heart and mind said to go, so I set course for the firestorm.

After another long drive up the Central Valley, I arrived in Fairfield late at night, just southeast of the fire. A haze of smoke sat over the valley to the east, and I headed up a winding country road to where I'd heard Air Attack talking about the Atlas Fire forcing evacuees to shelter in place. It was the same general area, so I knew the conditions were extremely dangerous. Residents on rural properties were trapped by the fire, and a California Highway Patrol helicopter had to land and rescue people trapped and about to be burned over on their property.

As I headed up Wooden Valley Road, past steep hills, scrub oak, and a vineyard, there wasn't much to see. I was worried I'd gone to the wrong end of the fire and hit a dud. Then I rounded a corner and BOOM, a wall of fire was in the hills all around me. I was between two vineyards that provided a fuel break, but two fire fronts moved in the hills above me on ridgetops. The fire was hung up on the ridge, but there was backing fire in the grass, and flames shot up seventy-five feet as each tree "went" or caught on fire.

I pulled up in my little Subaru, which had since replaced the broken-down-too-soon Fire Wagon, to the side of the road and hopped out to make long exposures. As I grabbed my Nikon, tripod, and a 24–70 mm standard lens, a gust of wind picked up and the vines swayed in the breeze. The fire picked up a bit on the hill, and the yellow smoke and fog lights from my car gave the green vines even more of a green glow. I made a few pictures before moving on. That shot would

be featured by *WIRED* magazine and other outlets as a scene shot of the fire siege. I was the only member of the media at this part of the fire because it was so far-flung and all the attention was on fires in more densely populated areas to the west.

As I moved farther up the canyon, the hills got narrower, the fire behavior intensified, and became more erratic. Near a driveway, I saw a hotshot crew buggy and headlights bobbing up and down in the glowing woods around a bend in the road. I parked my car and heard the roar and thunder of multiple chainsaws running. On closer inspection, it was the El Dorado Hotshots cutting fire line on structure defense trying to save a winery that dated from the late nineteenth century. It was an interesting contrast, the hotshots doing their work in the woods cutting line, but as immediate structure defense. They were also firing out and trying to keep a pile of hay from igniting the building. I followed them as they tied in their handline with the road, saving the structure. Turns out I'd also run into them at the Wragg Fire in 2015 when I rode along with Gino during the blowup.

Speaking of Gino, this fire was on his home turf. He was part of the Cal Fire Lake Napa Unit (LNU)—their headquarters and his barracks were just over the valley. These fires were hitting his friends' houses. I had texted him the day before but hadn't heard much. I imagined he was in the thick of firefighting and focused on saving lives and property. I'd also reached out to Kent Porter, but he was also going through hell as a photographer who was in the midst of the firestorm and watched hundreds of homes burn down. I followed his photos and updates on Twitter and gave him space to work.

There were so many fires, so much radio traffic, confusion, and fire front chaos that I had to trust my experience and intuition on the fire line. I didn't have time to get my radios programmed for all the channels, and was only getting scattered command and division traffic, or better data from Twitter when I had cell reception. I was using in-person conversations with firefighters when safety and time allowed, and otherwise watched the fire to adapt on the fireground that night at what been named the Atlas Fire. It was named for nearby Atlas Peak.

After photographing the El Dorado Hotshots saving the vineyard and buildings, I went to make more long exposures, but a wash of embers came downhill over my car and ignited grass nearby. That was a clear trigger point for me to leave the area. I did not have good communication, no lookout, and there was only one way out. I filed photos with the newswire and peeled out. Things can change in a second, and after my experience at the Powerhouse Fire during my baptism of fire, I wasn't going to make the same mistake twice.

FOUNTAINGROVE

On day two, I was on assignment for the *Washington Post*, with an early deadline (3:00 p.m.) for print. Meaning, I had to get up super early and chase photos before major fire activity increased so we could have a dateline for that day.

It was a haul to the western side of the fire from Fairfield. For two hours I drove through thick smoke up into Sonoma and the eastern side of Santa Rosa to Fountaingrove. What I saw was horrifying. Multiple neighborhoods leveled, virtually everything from brush to house was immolated for miles. I spent most of the day driving around the impact area getting a feel for where the fire front was, what had been destroyed, what was in danger, and values at risk. It was sort of an overview day and a scramble to make photos by deadline.

During the afternoon I drove into the Fountaingrove neighborhood, an area of upscale homes northeast of Santa Rosa, right into the path of the Tubbs Fire front. The first hours of the fire saw hundreds of homes destroyed here, with entire blocks leveled. The fire had spotted over golf courses, through trees, and across cul-de-sacs. Rows and rows of homes were mere rubble, swimming pools filled with debris, dead and burned animals in the street. It was hard to tell what was wild and what was a pet. I didn't have the wherewithal to look closer. Before I went past the police checkpoints, an older man begged me to tell him if his house was safe. "Please, can you try and drive by?" he asked, after

I said I wasn't able to since I was on assignment. I saw the sadness and anxiety in his eyes and voice, and I couldn't say no. I was headed into Fountaingrove anyway, so I told him I'd do my best. He gave me an address on the golf course.

I drove in past roving police patrols looking for looters, and engines looking for hotspots. I came around the bend to the block the house was on and audibly gasped. Every single home was leveled without any signs of life. A pit in my stomach, I stopped to make a few photos before I had the courage to pick up the phone and dial the man's number.

He picked up and I asked if he was sitting down. After a sigh and a long pause I continued. "Sir, I'm sorry but your house is gone."

"What about the neighbors?"

"I'm sorry, the entire block is destroyed."

I felt horrible, and there was another long pause.

"Well do you see any cats? We had one in the house when the house sitter had to evacuate."

There were no signs of life. "Maybe they were able to escape to the golf course." I knew full well that the cats had probably been killed. My only hope was that they succumbed to smoke inhalation and didn't suffer. This was the only thing keeping me from losing it on the phone.

Resigned, he said, "Okay, thank you. I need to go . . ." and hung up. I put down the phone and broke into tears on the sidewalk next to the rubble of homes.

Gathering myself after the call, I combed the perimeter of the property looking for any signs of the cats. I didn't see anything.

I needed a few minutes to pause and gather my wits, but I had a deadline to make, so I moved on to the Journey's End Trailer Park off the 101. It was closed as a crime scene since senior citizens weren't able to evacuate in time and had perished. From the ramp to the freeway, I was able to make photos looking down into leveled rows of mobile homes. Arson investigators sifted through the rubble, and police tape surrounded the complex. The name Journey's End was cruel. For some residents, it's where they met their appalling fate in the smoke and embers. It made the Valley Fire look like a warmup.

I can't imagine the shock, pain, and trauma of losing your home. But it's worse to not even know whether your house is still standing. Since that fire, when I've checked on houses, wildfire victims have told me it allows them to start the grieving process. Not knowing denies you the ability to start processing your grief.

There's also the question of journalistic ethics in checking in on structures. Incident command prefers to send out official reports and sometimes notify homeowners, but that can take days or weeks. My personal code is that at fires I'm a human being first, and if it doesn't affect the fairness of my coverage or my ability to make photos, file on deadline, and do my job, then I will try and let someone know directly if their home is safe or not. I know if the tables were turned, it would make a world of difference to me.

The rest of the day was spent photographing destruction. A burned fire station, a melted tricycle, a basketball hoop, melted puddles of aluminum, and the husks of Teslas where the battery fires had melted the surrounding metal. There was no longer fire in this area, just loss, and what was once a neighborhood. It was clear the Tubbs Fire came out of the forest with a terrifying speed. On the other side of the 101, fast food restaurants and big box stores also lay in ruin.

BRIEFING

I called it a day and was able to find a place to stay.

I got up at 5:30 a.m. to make the 7:00 a.m. briefing at the Santa Rosa Fairgrounds on my third day covering the fire. Most of the fires were still uncontained, and while not in the middle of Santa Rosa, flames were threatening homes on hills and in more rural areas, setting up a more WUI-type pattern, which I was used to. My friend Gino had been promoted to battalion chief and was in charge of helping with ops. I'd finally been able to get ahold of him, but he was exhausted and in the firefight of his career.

The guy in the clunky pickup running a dozer team was now using

his local knowledge and experience to help run a massive, historic, destructive, and deadly wildfire as part of ops. He went from a red hat to a white hat, and Cal Fire finally made him get a new truck. I missed the little red pickup, but the new rig was fitting for a newly minted battalion chief, and there wasn't much time for nostalgia in the middle of a fire.

All my experience from the previous four seasons was coming together to let me focus and be safe. I had prepped for this scenario, researching historic fires, thinking about the shots to make, access, logistics, and ethics at a major fire siege. It was all coming together, and my training was now being put into practice.

I walked into the fairgrounds, which turned into a miniature city and fire camp at 6:45 a.m. National Guard soldiers manned the entry areas with M4 assault rifles. A thick smoky inversion layer hung over Santa Rosa. At the morning briefing I tied in with Gino, who was sitting in the front row with all of the branch, division, and ops chiefs. Half a dozen media members stood off to the side. Radio reporters, TV crew, writers, photographers. The Wine Country Fire Siege, namely the Tubbs Fire, was now a major international news story. The quiet firing operations of the Border Fire with Gino last year was still an embed, but now a major national Type 1 Incident. Same firefighter, different blaze. Gino introduced me to a few division supervisors. They were all bleary-eyed, stressed, and exhausted. Their neatly pressed uniforms and brass bugles were offset by day-two five-o'clock shadows and worried brows. Hundreds of firefighters piled in for the briefing.

The IAP, or incident action plan, outlined fire weather, objectives, challenges, division maps, and expected fire behavior. It was forty pages long. The incident commander, Brett Gouvea, had combined multiple fires into the LNU Central Complex. It belied the complexity of the fire. The sober briefing outlined structures lost, fatalities, and upcoming fire issues. There was a heavy inversion layer and aircraft were grounded, so I went back to Fountaingrove to find a higher-elevation viewpoint of the burned homes. I was able to get a vantage point showing blocks of destroyed houses and burnt forest. The photo ran A1 on

the cover of the *Washington Post* the next morning. The image looked down at blocks of upscale homes along a golf course, each single parcel totally leveled, the homes burned to the ground, leaving nothing but a pile of stucco rubble. The grass on the golf course was still defiantly green, a twisted contrast to the lost homes.

WALK OUT

One of my assignments that day was to photograph the remnants of a home far back in the hills that had been destroyed the first night of the Tubbs Fire. The couple living there had taken shelter in their backyard pool as the fire burned over, struggling to breathe in the unheated water, surrounded by smoke, ash, and superheated gases. I meandered to the house through downed trees, a collapsed power line, and more police patrols. All that was left standing out front was a gate and, between the two pillars, smooth stones spelling the phrase "Walk Out." After the Tubbs Fire burned through and the couple survived, they literally walked out down the road until they were rescued. There were other residents who took refuge in their pools, and some perished. The survivors were the lucky ones.

I climbed out onto the unburned diving board and made a wide-angle photo with the board leading the viewer's eye into the pool, turned ashen green-gray, with burned branches reflecting off it, and the skeleton of the garage and house in the background. It reminded me of the pool and burned home at the Volcano Fire in 2012. This was a quiet shot but one that put a deeply personal story on the destruction. It also ran A1, on the front page of the *Washington Post*.

The whole scene felt like I was desecrating a grave. I was probably the first person back into the property. Nobody had cleared or tagged the house yet—though I had been given permission to be there, I felt like an interloper to someone's great loss. But I was steeled knowing that millions were seeing my images. We couldn't hide from this. People had to see the acute effects of climate change in their literal backyards, or what was left of them.

I barely made it back to cell reception in time to edit and file the photos. I was so exhausted I had to take a break. I got a motel room far from the fire and proceeded to sleep for a few hours before going back out on the fire line. I was physically and emotionally tired, and there was more fire and destruction of neighborhoods to photograph. I tried to cry after going to the Walk Out house, but was so dehydrated and my eyes were so ash-caked that the salty tears barely flowed and stung my bloodshot eyes.

HOTSHOTS IN THE VINEYARD

After a day of destruction near Santa Rosa, Gino connected me with Cal Fire and hotshot crews protecting homes in rural Sonoma County near Moon Mountain Road. It was a winding rural path up a steep hill to both cottages and luxury homes overlooking wine country.

I watched the hotshots drag drip torches of fire through the edge of the vineyard, while Cal Fire S2s and a DC-10 air tanker dropped thousands of gallons of flame retardant overhead. They were trying to keep this part of the Nuns Fire from moving over another canyon. The fire eventually burned through, but at a slower speed due to the firing operations of the crew. It was another strange scene to see firefighters move about the vines, covered in small wine grapes. It was the middle of harvest season and millions of dollars of grapes were being smoked out on the vine. The smoke taint would ruin part of the harvest.

The Plumas Hotshots conducted their business like cool-headed professionals, moving in a dance, just as the El Dorado Crew had during structure defense a few nights prior. They moved with purpose and intent, not a single motion wasted. And the whole crew, women and men, did this with forty-five pounds of equipment on their back at virtually all times, in hot weather, without a single flinch or complaint. Anytime I saw a hotshot crew cutting line and burning out, I was truly impressed and took a moment to appreciate their combination of craft, firefighting, and landscaping skills. It was days like these that

reinforced my respect for hand crews, out there in the dirt doing the tough manual work of fighting fire.

LAST MORNING BLOWUP

After spending the better part of a week on assignment photographing the Tubbs Fire, Atlas Fire, Nuns Fire, and Patrick Fire, which became the various LNU Complex fires, the fire weather wasn't over. I received a text from Gino one evening after his shift indicating an "ominous" wind forecast, not dissimilar to the conditions that ignited the fire siege.

I called it an early night to rest up for the wind event that might materialize again overnight. I was holed up in a Best Western in Rohnert Park, about thirty minutes away from the fire evacuation zone, grateful for electricity, running water, AC, and some mild smoke relief after four days of fire coverage.

My photographer friend Jeff was staying a few rooms over. I left my phone ringer on and told him to be ready for a flare-up overnight should the wind materialize. I set an alarm for 4:00 a.m. to check fire conditions. Firing up Twitter in half-slumber, I saw the fire was blowing up again on the southeast end of the Tubbs Fire, and making a run for Highway 12 in Sonoma. ("Fire Twitter" is a mixture of official fire department accounts, wildfire experts, scanner enthusiasts, and reporters. I have a list of trusted accounts that can provide lightning fast information as it gets shared over the radio. I turned my radio on, and the IC was sending in the cavalry to meet the wall of fire.) I'd left my boots unlaced and tucked into my Nomex fire pants, so if I had to gear up to chase the blowup, I'd be able to do so quickly. I texted Jeff and told him to get moving. Five minutes later I was speeding back to the fireground, straight for the new front that was now moving quickly toward more houses. I could see the glow while en route. "This isn't good," I muttered.

Coming up Highway 12 past Santa Rosa, dozens of fire engines passed me as I pulled over, speeding toward the wall of fire coming

downhill into a grassy field. I pulled up to the police roadblock, showed the officer my media credentials, and he yelled, "Get out of here!" I politely replied that I was allowed access to the fire area, and he yelled again, "I don't care what the law is, GO!" Wanting to avoid confrontation, I obeyed and drove in another way. I was legally allowed access and yet arguing was futile. Law enforcement was also stressed, tired, and traumatized. I needed to pick my battles and give first responders plenty of leeway.

I set up my tripod and started making long exposures of the fire rolling off the hill. A tree nearby ignited and spit off thousands of embers in the breeze. Engines were able to stop the fire in the flats, but the main body of fire continued to the east toward downtown Sonoma. As the sky started to turn blue and the first rays of predawn light filtered down into the valley, radio chatter picked up that homes and wineries were being hit farther east, so I continued to chase the fire front.

The battle continued around Sonoma, where I found fire crews extinguishing a burning garage that had started to ignite the main house on fire. The issue was exposed wooden beams, which were essentially hundred- and thousand-hour fuels that were difficult to quickly put out. Thick pieces of dry structural wood have lots of potential energy, and flaming structures act like logs on fire. They smolder for hours, reigniting when new material is exposed to oxygen. Every time firefighters put out the fire with a hose, a new piece of the garage roof reignited. In the wind it kept blowing embers onto the house. All it takes is one ember to wedge inside a vent and burn the house down. Ornamental vegetation around the home was also burning, but with persistence and sweat equity, crews were able to save the home. They also used pikes and other firefighting hand tools to tear down higher pieces of construction to bring it down to the ground to keep the embers from flying.

Down the road, more fire was burning around a vineyard. Jeff and I drove to the top of the hill for a view of the fireground. I checked Twitter and AQI stations, which were reporting extremely hazardous

air quality AQI (air quality index) of over 400. I could feel it in my lungs, like I was breathing in a thick soup of ash and particulate matter. I hacked up gunk. *This can't be good for my long-term pulmonary health*, I thought as I donned my P100 respirator. I already had serious asthma and needed to be cautious. Despite the risks, I felt that wearing the respirator and minimizing my time in the worst affected areas would allow me to tell the story and make the photos needed.

I looked goofy but PPE is important. As the sun rose and my blood-shot eyes strained in the orange light, I also donned my fire goggles with tinted lenses. In my black fire helmet, Jeff took a photo of me in the vineyard, and I looked like some sort of cyborg of the Anthropocene. There in the vineyard, watching fire impinge on a structure and the vines on the edge of the field singed by fire, was the epitome of climate change in the twenty-first century. It was chaos. Air quality, fire, evacuations, structure loss, health impacts. Emotional trauma too. This was the smoke in the vineyard, the defining moment of the 2017 Wine Country Fire Siege for me.

My rumination was interrupted by a piece of wood igniting next to the winery. I ran down the hill to tell the fire engines staging by a barn to check it out. They sent an engine up and extinguished the fire. I'd like to think that was my small contribution in helping to save a structure.

ALL THE HOPE WITHIN YOU DIES

On my last day covering the fire, I spent more time photographing in Coffey Park. The fire had moved through after day one, and it was already an aftermath zone by the time I arrived. Almost every home in the subdivision was destroyed. Coffey Park was an upper-middle-class neighborhood with homes in neat rows packed fairly close together, which provided fuel for embers from the Tubbs Fire spotting west over the 101 freeway that transitioned into an urban firestorm. Across the highway the Journey's End trailer park was destroyed, home to fixed-income

seniors, but most of the housing destroyed in Sonoma County was considered "upscale" in an area known for its high cost of living. A steel garage door was wrapped around a concrete parking pole, a car flipped completely over in the center of the subdivision. There had been some sort of fire whirl that caused tornado-like winds and vortexes. I'd never seen anything like it.

My assignment that day for the *Washington Post* was to create a photo series of the aftermath. I focused on the items around a home that one could still identify. Perhaps the strangest was a bright red Weber grill, sitting untouched in an otherwise wrecked backyard. No doubt the grill's fire resistance and isolated location caused it to be unscathed. I focused on dried puddles of melted aluminum from car wheels. I also made images of burn patterns on melted car door paint, the shattered glass in the rear window, an upturned mailbox. The tire marks in dried flame retardant, and the overall scene of destruction. It was a sorrowful sight, and I felt physical pain in my heart and adrenaline in my stomach for the loss. It was getting into the afternoon, and I filed images. I felt like it was time to start heading home after five days of photos.

Leaving the fire closure area on the way to one of the few remaining open gas stations, I saw a couple of Santa Rosa PD squad cars parked on the sidewalk with a man being arrested. They had removed his shirt to search him. An empty backpack and tiny bicycle were on the sidewalk with the contents laid out. There were perhaps a dozen cell phones, jewelry, and a handgun. The police were taking him into custody as a suspected looter.

He had been, allegedly, breaking into the few homes left standing in Coffey Park, taking advantage of the chaos to steal from others' loss, trauma, and misery. I kept taking photos, and the police on scene asked me to step back as they placed him into a squad car for questioning. I felt anger, because it was pretty obvious that the man was looting.

After this, I realized it was time for me to disengage both for physical and mental health. It was time to go home.

I got back home and started unloading my car, caked in dirt, ash,

and pink stains of flame retardant from miles on roads slick with the stuff. A neighbor asked me if I'd been at the fires, and I gave her some sort of half-hearted answer that I don't even remember. I showered, went straight to bed, and didn't leave my house for most of the week.

CONCLUSION

What happened at the Tubbs Fire was like getting seriously injured in the seconds after bodily trauma. You know you're hurt, you know it's bad, but you're stunned and not sure what happened or the extent of the damage. Santa Rosa, Napa, and Sonoma Counties were ripped open and damaged. In the days after the fire, civilians and first responders were just starting to reel and process from the carnage. The combination of drought, then a wet winter, strong north wind event, and WUI building locations combined into the tragically historic firestorm. We were seeing the real-time effects of climate change—the stronger oscillations between wet and dry years, and the development of homes in fire-prone areas. Most of Fountaingrove was built in the footprint of the Hanley Fire in the 1960s, which burned under conditions similar to the Tubbs in 2017, except instead of open space and ranches, it was full of subdivisions.

In retrospect, I had also begun to experience the effects of psychological trauma from the level of destruction at the end of the fire. The fire burned into the city, an urban firestorm of proportions that I'd come to fear after seeing the Valley Fire in 2015. Kent, Jeff, and I had talked about the possibility, but to really see it happen was horrible. I also felt that same sense of despair that I had after the Valley Fire.

I felt especially for my local photographer colleagues. This was where Kent worked, his hometown, his family evacuated. He'd been through the wringer. Gino the firefighter had been too. Eventually Kent would be a part of a Pulitzer Prize–winning team for his marathon coverage of the fires. He deserved it. Gino ended up having to testify during the civil lawsuits after the fire, due to his early presence at the

blaze. Ultimately, the Tubbs Fire killed twenty-two people, destroyed over 5,600 structures, caused 1.3 billion dollars in damage, and burned over 36,000 acres. The rest of the blazes also took lives and destroyed homes, but the Tubbs was the worst. The Tubbs became the deadliest and most destructive wildfire in modern California history up to that point, and the 2017 season still had one more record to shatter.

THE GREAT WESTERN FIREBREAK

NIGHT ONE, LA CONCHITA

December, 2017:

> *I stood on the beach south of Carpinteria at 4 a.m. photographing the western head of the Thomas Fire on the shuttered US 101 freeway. Over the last seventy-two hours the Thomas Fire has run amok in Ventura and Santa Barbara Counties, torching 110,000 acres, destroying hundreds of homes, and is only five percent contained. The longest Santa Ana wind event during the* Terra Flamma *project has started half a dozen large wildfires in Southern California in December.*

Ryan, Sam, and I were dozing on the access road to the beach when his radio went off. Heavy fire was approaching the La Conchita neighborhood wedged between coastal bluffs and the 101. We raced over to see a wall of flame 100–150 feet high being pushed downhill by the Santa Ana winds like waves crashing onto the shore, directly into the path of dozens of homes.

Embers sailed into the bougainvillea and ignited the palm tree next to the home in La Conchita. *Palm trees are candles in the murder wind,*

popped into my mind, from the Bad Religion song "Los Angeles is Burn-ing," written after California's 2003 fire sieges. History was repeating itself.

Engines came screaming in on an emergency Code 3 with lights and sirens blaring, and firefighters jumped out of their brush rigs to reinforce the overwhelmed crews struggling to hold fire back from running over the community. Palm trees were exploding on fire on every street corner, throw-ing thousands of embers into yards and roofs. Residents sat on the sidewalk stunned, blinded by the smoke and ash, having refused evacuation orders.

I walked down the street and saw yet again a solitary man in a yard surrounded by fire, garden hose in hand. He was spraying water at a wall of fire burning in vegetation next to a mobile home. The embers washed up and tucked themselves into the roof eaves and window frames. He was enveloped in the ember storm wearing just a sweater, baseball cap, and hoodie. It was only a matter of minutes until the home ignited and burned down.

I was worried I'd see a man die in the next few seconds, burned by flames and suffocated by hot gases. The images of dead wildlife and the death count from October were fresh in my mind.

I gently tapped his shoulder as he struggled with the wind, fire, embers, and water spraying everywhere. "Be careful! Your life isn't worth it." I could only step back and raise my camera to my face, making frames. No sooner did I start clicking the shutter than another strong gust of wind picked up. As the frame blacked in and out at nine times per second, I saw flashes of fire and orange as embers the size of half dollars hit us, showering the left side of my body in heat. The Nikon's viewfinder was a pulse of hell, and in the center of the frame a man without adequate protection took the same hit. The man lifted his arm and garden hose up to protect his face. *Shit*! I thought to myself.

I mentally went over where the burn kit was in my car, in case one of us was hurt. I thought about where the fire engine was in case I had to run and ask them for help. My burn kit was minimal and didn't have supplies for anything more than minor injuries. If I hadn't been wear-ing two layers of Nomex, goggles, gloves, a helmet, and face shroud, I would've been burned.

It's a miracle the man—named Jack Oren, whom I'd later speak to—was okay. I guess his hat and sweater were just enough to keep him from being seriously hurt. As the thought passed, a firefighter burst into the yard past the low chain-link fence and ordered Jack out of the yard. He took the garden hose himself. Realizing the danger was also about to directly affect me, I jogged out of the yard via the same fence. I barely missed bumping into another firefighter running headlong into the ember shower, firehose in hand. The flames from the burning bougainvillea had died down momentarily, and the house looked like it was going to be okay once fire engines got their hose lines charged.

I stepped back into the street, out of breath and covered in a mixture of ash and sweat that was like a charcoal face paste. I continued to amble around the neighborhood as more engines arrived to douse flaming palm trees. I spoke to a resident on the sidewalk, and it was as if their body was there but their mind was not. They were not in immediate danger, so I moved on. Covered head to toe in PPE with gloves, goggles, and shroud, my vision was fogged, and I was sweating all over my camera, fogging the viewfinder. I found a firefighter hosing down a palm tree. It was a familiar scene.

In the end, firefighters saved every single home, except for some fences, a detached garage, palm trees, and unfortunate ornamental brush. What would've been new and major structure loss became a very close save. The homeowners owed firefighters their gratitude.

I left La Conchita exhausted, having just stepped off a plane hours earlier and driven in directly from LAX. I met up with my friend Jeff, who'd come out from the desert to cover the fire, and finally fell asleep around 4:30 a.m.

BACK TO THE BEGINNING

Before the Thomas Fire started, I had a solo vacation planned to Hong Kong for three days. It was a matter of hours between getting back to

the US from Hong Kong and the Thomas Fire before reaching the beach and firestorm at La Conchita. Last-minute plane tickets were cheap, and after the Wine Country Fire Siege my heart and soul needed a break from America. Hong Kong on a direct fifteen-hour flight from LAX seemed like just the ticket. Modern but foreign, far yet a single hop across the Pacific Ocean. I packed a backpack and a small duffel for a fast and light trip and to clear my head.

I went against my gut instinct and decided to continue on with the trip after canceling the flight then un-canceling it minutes later when the Thomas Fire ignited. *To hell with it*, I thought. I was going on this trip, fires be damned. It would probably be out the next day.

I locked my house up, walked outside, and immediately felt a cold, extremely dry Santa Ana wind. The pine needles rustled on the old trees off the street. I felt it in my bones, and the dry air sent a chill down my spine. This was fire weather. The air reminded me of summer afternoons in Taos, New Mexico, where super-low relative humidity occurred in the five-thousand-foot mountains of the Carson National Forest, dropping into single digits.

I could *feel* it. It felt like fire. I quickly pushed this thought away and stopped by my then-girlfriend's house for dinner before heading on up to LAX. We hadn't had significant precipitation yet for the fall, and after the Wildomar Fire in October and the Wine Country Fire Siege up north, Southern California wasn't out of the woods yet. It was primed for danger. Somewhere between eating dinner and leaving for LAX, a power line sparked near St. Thomas Aquinas Seminary outside of Fillmore, and the Thomas Fire started. Pushed westward toward the ocean by screaming Santa Ana winds, the fire started ripping to the ocean.

Leaving around 11:00 p.m., I could see smoke covering the Santa Paula River plain. *Of course this fucking happens*, I thought. When I finally wanted to take a break, fires would still be burning through California at breakneck speed. As I drove toward LAX on the 405, I checked into my flight and my iPhone started lighting up. The SoCal Fire network page group was pinging with fire updates. By the time

I got to Sepulveda Blvd., I was on the phone with American Airlines canceling my ticket. Dammit, I was going to another fire during the initial attack in Ventura. The trip to Hong Kong was not to be.

Or maybe not. Against my better judgment, and in a fit of frustration of yet another fire upending any semblance of normal life in 2017, I rebooked the flight. Fires be damned, I was going to Hong Kong.

I would come to regret it.

When I landed in Hong Kong, I was still checking updates from the West Coast. The fire was progressing rapidly. So, despite having just flown over the entire Pacific Ocean, I scuttled the rest of the Hong Kong trip, and booked the first plane back to Los Angeles. The next plane back was in eight hours, so I ran into the city and got ramen, had a drink, and bought a watch. I was able to shower at the airport knowing I'd walk straight off another fifteen-hour flight and drive straight to Ventura. The weather forecast was still bad, with Red Flag Warnings across SoCal and multiple fires burning in the LA Basin.

I spent eight hours in the city stuffing myself with dim sum before going back to LAX and getting into an airport lounge to take a shower. It would be the last shower I took for a few days. My car was in LA, loaded, ready to go with fire and photo gear.

Flying back north on approach from Central California over the coast, smoke was visible hundreds of miles away having filtered into the coastal Santa Ynez Mountains north of the main body of fire. Flying into LA, three pyrocumulus clouds were visible. The city was ablaze. I was flying into a moderate fire siege and late to the party. Leave it to me to finesse it like this.

Once I cleared customs, I took the shuttle to the Park 'N Fly lot at LAX and immediately put on my Nomex pants and fire boots in the back seat of my Subaru with jets flying overhead. I threw my suitcase in the back, grateful for having packed my entire fire setup.

I hopped in my car, and eight hours later was hit by a one-hundred-foot wall of flame as the Thomas Fire bore down on the La Conchita neighborhood. It was December and we were witnessing what would likely become one of the top ten most destructive wildfires

in California history. Back-to-back fifteen-hour flights and chasing fire until 5:00 a.m. had taken its toll.

That evening before the fire hit the Pacific, I started covering the fire up in Ojai as flames danced on hills framed by blinking Christmas lights of prancing deer on homes in town. The weekend getaway spot from LA seemed surrounded by fire. I was driving around with photojournalist Marcus Yam from the *LA Times* and watching the orange glow filtered through a lit-wire decoration of a reindeer. The glow of flames reflected off windows framed by multi-colored holiday lights. It was surreal and heartbreaking, a far cry from stuffing my face with dim sum in Hong Kong twenty-four hours before.

As the evening waned into the early hours of the next day, I decided to head west toward the coast to see the view from the beach. I met with Ryan and his girlfriend Sam in evacuated downtown Ojai as we headed twenty miles west to the coast. I stood on the beach, walked out to the tidal zone, and the crest of a wave washed uphill on the sand. The water lapped on my fire boots in a foam before receding. The glow of the fire reflected off the wet sand as the wave crept back to the surf.

I had seen it all.

I truly felt what firefighters meant by the Great Western Fire Break, colloquially known to most of us as the Pacific Ocean. We watched the Amtrak Pacific Surfliner cruise south along the tracks, with fire in the background. Then the call came in for La Conchita and we sped off.

TORO CANYON WITH GINO AND CAL FIRE

After the first days of action at the Thomas Fire, I ran home to Orange County for a weekend of rest. I was soon back at the fire when Gino was deployed to the Thomas Fire as a strike team leader of five Type 3 brush engines. He was placed in charge of high-end properties in Toro Canyon in Montecito. The area had experienced fatality fires in the 1970s, and a sundowner wind event was forecasted. I leapt at the opportunity for another embed with Gino. Who knew what the evening would bring?

We hopped in his shiny new battalion chief rig. (I missed Gino's beater Chevy.) He fought to keep the truck in service as long as possible, driving the beater while other captains and BCs were driving fancy new rigs. That truck was an embodiment of Gino's firefighting ethos. Bells and whistles weren't important. What mattered was fighting fire, and Gino did it.

The young Santa Ynez Mountains of the Los Padres National Forest rise steeply behind the coastal cities of Santa Barbara and Montecito. They bely a geologic violence that shapes the natural beauty of the area. The cities are built on the alluvial fans from the mountains' erosion. The steep peaks end at gentler slopes with canyons carved out by eons of rock falls, floods, and ensuing debris flowing to the Pacific Ocean. This geography combined with wind impacted fire behavior at the Thomas Fire both in Toro Canyon and deeper in the forest. At the coast, onshore marine winds pushed inland and battled with offshore winds, and a localized effect called sundowner winds drove increased fire behavior in Toro Canyon. Sundowners are related to Santa Ana winds, but are distinct in terms of when they occur, literally at sundown. Santa Anas typically peak after midnight and immediately prior to sunrise.

At dusk I stood with Gino and three firefighters at an abandoned home perched atop a steep hill. We could see the Santa Ynez Mountains down to the Pacific Ocean—it was a perfect vista to monitor fire behavior as we cracked jokes and talked about the predicted winds. Air tankers worked a line of flame retardant on a nearby mountainside, trying to protect power lines and paint the ridge before sundown.

As the sun set, a quiet fire backing down the mountain exploded into a dangerous flaming front. The winds kicked up in the early winter dusk, pushing fire toward us. The flames were moving fast downhill and toward homes Gino and his crews were tasked with defending. The situation deteriorated in just minutes.

Riding shotgun in Gino's truck, we started checking on individual fire engines tasked with defending specific houses. We arrived at a house with lots of decorative wood and eucalyptus at the top of a hill, a very

difficult structure to save. The crew had worked all afternoon to prep the structure for defense, running hose lines and cutting brush. While speaking with the crew, the division superintendent called for all crews to be pulled from homes down to the safety zone due to fire behavior. Gino said to the captain: "They're pulling the entire division!"

We looked over the hill and saw the glow of fire fast approaching us. The engine captain prepping the house argued with Gino, pushing to stay and save the home. He'd prepped the home all day with his crew. The firefighters needed to retreat until it was safer. I saw the frustration in the captain's eyes and his dedication to protecting the property. The awful narrow roads and previous burnover history in the area made command nervous, and rightfully so.

On the way down the narrow winding single-lane paved road, we stopped at a particularly vulnerable house at a Y junction. Gino said, "Hold on Stu!" and tossed his helmet on, hopped out of the truck, and proceeded to fire a few rounds from his incendiary flare gun at the base of a brush-laden hill under a home. He was trying to start an emergency backfire before the actual fire hit the home.

Afterward Gino said, "The fire would impact that house very very hard . . . like a wave crashing on a beach, and I thought if we could put some dots of fire on it, we could soften that blow. But left to stand by itself, I didn't have any confidence that house would be there when we returned . . ."

Gino started the backfire and made sure each of his five engines escaped safely. We were the last rig out as he stepped into the cab and drove off. The rush of wind preceding the fire front swept downhill through the orchards and clanking mailboxes. We sped downhill to the safety zone as spot fires ignited behind us.

I was skeptical that we were going to see that house standing again.

The safety zone was a mess of dozens of fire engines and pickup trucks. Dust filled the air amid the chaos of everyone pulling off the division and hiding out. After sheltering in the safety zone, the strike team decided to do "fire front following." This means going back in to save homes where the fire has just burned through. Engines pull back

for safety during the worst of the flames, then speed back in when fire intensity subsides to protect homes that may be on fire.

It was a risky and aggressive tactic—fire would be everywhere. But it was the best chance to get in and save homes before embers got into attics, vents, and crawl spaces and ignited the houses.

Gino and I raced back to where he'd dropped the dots of fire. It looked like the house was okay. We went uphill around an orchard and were completely surrounded by fire. The cabin of the truck filled with smoke and my eyes wrenched shut in an involuntary reaction, temporarily blinding me. I was recording video on my phone and Gino said: "Stu, maybe we went up here too early." I slowly regained my vision. Of course Gino was used to this, and I was in awe at how hard he and his crew pushed to save houses. Gino knew his stuff, and would do his damnedest to save houses, but he knew what he was doing and he wasn't going to endanger anyone for homes that were just death traps for firefighters. Engine crews streamed in after, immediately engaged on two homes that had fire burning the decks and outbuildings. If the engines had arrived just five minutes later, both houses would've burned.

At the first house, a captain was in the driveway moving a partially burned scooter away from burning trees. A vintage Jeep burned in the background, and a coop of chickens didn't make it. But the house was saved, except for the singed deck. A truly miraculous save. The next house was also still standing, but barely. A large empty wooden water tower was on fire, and they were engaged for hours keeping the burning tank from destroying the house. In the end, they pulled it off!

Downhill was an Airstream trailer in a valley of embers and fire. We were only able to drive down a little bit due to the residual heat. I raised my camera and made a photo—it reminded me of the Mountain Fire in 2013, like peering into hell. The entire canyon was awash in the glow of fire and embers. You could see the heat shimmer and wind currents moving along the sidewalls and in the air. Hours earlier, this area had been well away from the fire; now it was completely burned.

I was peering straight into the coil of an oven, a million plants in a heated glow. It was brush that wasn't actively on fire, but that had just

burned through and was now simmering in the coals of what used to be flora and fauna. Imagine a campfire as the last flame goes out when the pile of logs has burned through and multiply that tens of thousands of times over.

Once the homes were saved and there was a moment of downtime, Gino FaceTimed his wife and two daughters to say goodnight. I made a photo in the truck as he spoke to their tiny faces on the iPhone screen on the dash mount of the truck. His tired face was reflected in the faint blue glow of the screen, fire in the background. The photo summed up the impact of these blazes on firefighters. Long hours away from family during the holidays, missing family gatherings, parties, birthdays, and anniversaries. It added up. Yet they were putting it all on the line, literally their lives, to save houses. When the homeowners came back after the fire, they'd see standing homes and never meet the women and men who kept them safe.

We ran downhill to get gas, and on our way back into the fire ran into the division superintendent. Gino and the division sup sat in their trucks facing each other, talking about strategy and fire behavior. The division supervisor started complaining about media photographers driving around the fire area and being a safety liability on narrow roads. I sat in the truck and shuffled my legs over my cameras on the floor of the truck to not blow my cover. Gino exclaimed, "Yeah, those dang media!" They laughed about them being all over the place. I could barely contain my snickers until he rolled his window up. I felt like I'd just infiltrated the Pentagon, and it was nice to have a laugh amid the chaos.

FIRING OPERATION
PENDOLA GUARD STATION

After the battle in Toro Canyon, Gino's Cal Fire Lake Napa Unit (LNU) strike team was repositioned deep in the Los Padres National Forest backcountry. Their objective was to fire out a forest road to increase containment.

The firing operation was far back in the Los Padres near Pendola Guard Station. It took an hour on windy roads just to reach the spot and find firefighters. It was a remote operation and over a mile of brush needed firing. I stopped and grabbed ten pizzas to bring out to crews, which were operating on sack lunches and MREs. It was a great way to make new friends. Gino and his strike team appreciated it.

The crew started firing when I got there. It was a dance of embers, water, fusees, bombs, and flare guns. They were trying to burn the south side of the road while keeping the embers from burning on the wrong side. It was challenging due to the twists and turns of the road, making it "technical," as Gino put it, to keep the embers from flying by and starting a spot fire on the wrong side.

One small spot fire did start, and in their exhaustion the firefighters called out "Division Alpha!" to contain the spot fire. It was about two by two feet, and five firefighters attacked the flaming pile with hand tools. I chuckled because they were using the Incident Command System on a fire one could extinguish in seconds. It was one of the first times I'd laughed since the fire started. The camaraderie amidst sleep deprivation was heartening, and I felt grateful to photograph and tell a story the public didn't often see.

I left late again and watched the fire burn in the far interior of the Los Padres from Camino Cielo Road. Camino Cielo is a ridge route with one side viewing the rugged interior of the Santa Ynez Mountains and the other the oil derricks on the Pacific and the city of Santa Barbara. Fire burned under the thermal belts and low clouds. I left at 3:00 a.m, and barely made it home without falling asleep. I should've spiked out in my car and stayed there overnight.

When I woke up the next day around noon in my own bed, Corey Iverson was dead.

Corey was a Cal Fire firefighter killed in a burnover that morning, just hours after the Cal Fire strike team I embedded with finished their work.

Corey was on a quiet piece of the fire by Fillmore and the blaze flared up, trapping him in heavy unburned fuels. He was unable to escape or deploy his shelter in time. He left behind a wife and a

two-year-old daughter. The mayday call went in at 9:30 a.m. as the spot fires increased. I was crestfallen.

At first, I didn't know if it was one of the men or women I'd been photographing earlier that morning. It was a sickening punch to the gut not knowing, and despite the strike team being okay, one of their brethren had fallen. The danger of the Thomas Fire was real and felt too close.

I felt fragile. Not some macho Rambo traipsing around fires with a camera dodging falling trees and flames to take photos, but human— vulnerable, soft flesh that could be burned or torn apart in an instant.

For the rest of the fire, I was acutely aware of the thin margin for error. Falling trees, winding roads, explosive fire conditions, high winds. Frigid nights during the last firing operations days before Christmas, the families that would go without their loved ones, hundreds of miles away in some cold and lonely patch of fire line, or in a mass sleeping trailer or a tent in the Ventura County fairgrounds parking lot.

I'd end up on that fire line just before Christmas.

USFS ASSIGNMENT AND
COLD FIRING IN THE LP

Three days before Christmas, I stood with firefighters deep in the Los Padres National Forest miles north of where Gino's crew worked. The firing operation buttoned up the last few miles of open fire line at the Thomas Fire. We witnessed the flames that pushed the Thomas Fire into the largest fire in modern California recorded history, at the time. It was strange to watch such an ignominious historic climate event. It was also my first formal assignment for the US Forest Service, using a contract I'd signed with the Bureau of Land Management a few years prior. I was officially assigned to the incident, with a radio programmed to speak on the incident and an identifier number written on my Subaru in white paint marker. I still missed the Fire Wagon, but the Subaru was reliable and turned pretty tightly. Oh and it got double the gas mileage. It was

different than working on assignment for a newspaper with paltry day rates and tough deadlines. I had much greater freedom to make photos, both time and access-wise. Saying I was assigned to the incident and being able to hit people on the radio helped both with situational awareness and getting to the right place at the right time.

The firing operation began, and I ran into a firefighter wearing a soiled red Santa hat. It was his thirtieth birthday, and he was wearing the hat since it was a few days before Christmas. A burst of red among the not-quite-yellow Nomex brush shirt and earthen tones of brush and burned ground. A few members of the El Dorado Hotshots made it down to the fire, and as they walked along with a drip torch on the fire line, a small fire whirl emerged. Ben Strahan, one of the hotshots, quickly shepherded me away from the whirl, now leaning outside of the fire line.

Ben said, "Follow me," but I lingered, so he tugged at my pack and started pulling me away, since the active flame began to lean out toward us as it sucked in oxygen. Without being aware of that behavior with the firefighter, I learned an important lesson of monitoring what the fire is doing at all times, even during a controlled burn. And I appreciated that he was looking out for me.

Like the firefighter who was working on his birthday before Christmas, Ben wore a Grinch shirt that said, "Sleighing It!" I appreciated their humor. Ben was texting with El Dorado superintendent Aaron Humphrey, sending him photos of the crew working. The rest of the El Dorado Hotshot crew and families were having a Christmas party in Placerville. I sent Aaron a few photos, and he replied back:

"Dude his family is at my house for a Christmas party right now. His boys will love this!"

I sent a few more and he replied: "I just showed his wife and boys, they were over the top excited!"

Being able to show the firefighter's family photos of their dad working just before Christmas, five hundred miles away, made everything worth it. It was one of the most fulfilling moments of photographing wildfire, that photos were at least making a difference on a small human level.

Back at the firing operation, the Ventura County hand crew was using the "terra torch" for ignitions. It's basically a flamethrower used for really getting a fire going. A truck carries a trailer filled with aircraft fuel, and it's connected to a device that looks like a pressure washer with a hose going to the fuel tank. A pull of the trigger button and out shoots a ten-foot spurt of flaming fuel, like a drip torch on steroids. The torch worked for a few hundred feet, but the fuel burned off quickly and the firing operation ended on that piece of land almost as soon as it had started. It was chilly and the fire weather conditions were finally beginning to improve. My assignment wound down, and I prepared to head home just in time for pre-Christmas festivities.

DEMOB

Before leaving the fire that afternoon, I stopped by the ICP to demob (demobilize, when you get processed and cleared to leave the fire) and get my checkout process initiated. I was exhausted—it was December 23 and the end of a grueling fire season. I was tired. Emotionally. Physically. My equipment was dirty and needed repair. My car needed an oil change. Vandenberg Air Force base to the north had launched a rocket the night before visible from the fire, and I was ready to blast off too.

Paper from the maps trailer at base camp is thrown out daily and can be used to wrap gifts. I snagged a dozen old Thomas Fire spread, PIO, and info maps to use for Christmas wrapping paper. I decided to keep one. I framed that map and hung it on the wall of my office. It shows in vivid color the spread of the Thomas Fire over two weeks. It's a visceral daily reminder of how many miles the fire covered and how I was present for much of the fire as it raged from mountains to sea.

At the time the Thomas Fire was the largest wildfire in modern California history. It burned for over a month until torrential rains put it out, causing even deadlier mudslides. I flew back early from a trip to China and missed holiday parties, events, and a Christmas parade with family to cover the blaze.

The Thomas Fire also occurred as a statistical outlier in December, when the rainy season typically takes over the state. After a near-record dry fall, fuels were parched across the Southland and we had a Red Flag event lasting more than fourteen days, which was unprecedented. NWS Los Angeles Incident Meteorologist, and fire forecaster Rich Thompson, who was the IMET at the Thomas Fire when I was on assignment for the Forest Service said, "The duration of the Red Flag conditions was essentially unprecedented. The fuels were extremely dry with record level ERCs. And the fire behavior was off the charts (large flame lengths, ROS, long-range spotting, etc.)."[41]

It burned from the high country of the Los Padres National Forest to the beaches of Santa Barbara County, to the backyard of Ventura City Hall, from celebrities' homes in Montecito to the orchards of Fillmore and the Santa Paula River Valley. I spent several nights watching the fire burn to the Pacific Ocean, deep in the Los Padres National Forest backcountry, and in the orchards of Upper Toro Canyon.

The fire incinerated nearly 282,000 acres, caused over two billion dollars in damage, destroyed 1,000 homes, killed one firefighter and one civilian, and eventually drove the deadly Montecito mudslides in winter 2018 that took twenty-one lives. Historically, California's deadliest, largest, and most destructive wildfires occur in October and November. As the bounds of fire season grew wider with climate whiplash, I felt these outliers would become more frequent.

Over the span of nearly three weeks, I made multiple trips to the fireground to document the fire that burned into the next year. The Thomas Fire was the largest megafire to happen until this point. It killed. It destroyed. And right on the heels of the Wine Country Fire Siege, it was a sign of things to come. Firefighters and climate scientists called it a new normal, but there was nothing normal about any of this. The fire behavior, the weather, the destruction. I simply called it "our new climate reality"—one that was unpredictable, capricious, and worsening.

And I look at that progression map daily in my office.

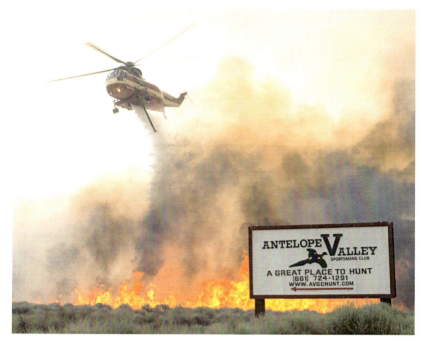

A helicopter drops water at the Powerhouse Fire off Lancaster Road in Fairmont near Lancaster, California. June 2, 2013. The Fairmont branch of the Powerhouse Fire jumped Lancaster Road and caused heavy smoke in the area. This photo was about one minute before I ran back to my car, twisting my ankle. There were over 1,000 firefighters assigned to the blaze and multiple structures were lost.

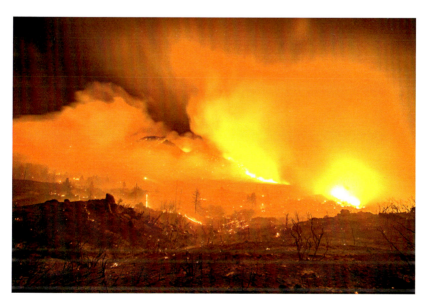

The Mountain Fire on Monday evening, July 16, 2013, near Mountain Center, California, in Riverside County. At least two structures were destroyed. This was the first pine forest fire I covered at night. Driving around in the dark, I shadowed other fire photographers for safety, since I was still learning fire behavior and fire line safety.

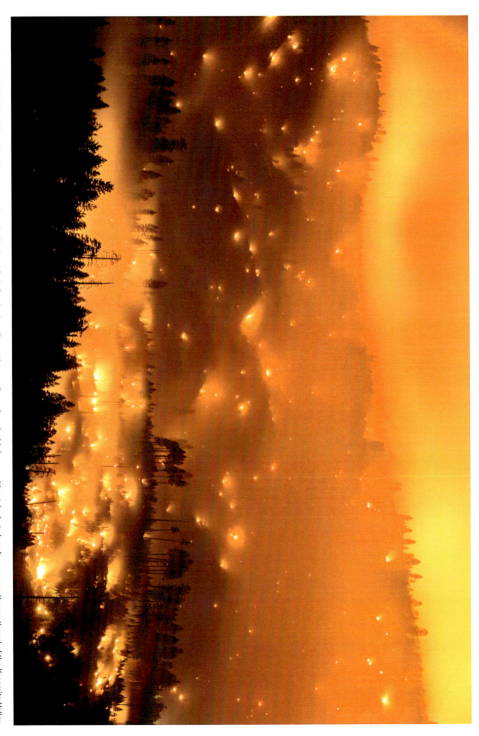

El Portal Fire, July 2014. The El Portal had no access, since the National Park Service heavily restricts media, so I made this image with a telephoto lens from across the south end of the Yosemite Valley. This blaze taught me that not every image needed to be up close to the fire. Sometimes the story can be told from far away.

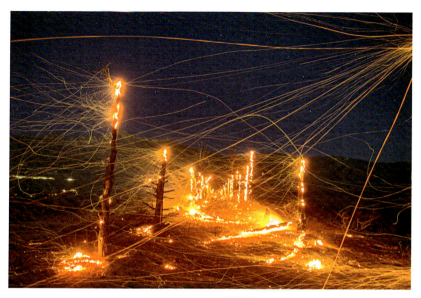

The Etiwanda Fire burns in Rancho Cucamonga, April 30, 2014. Air support was grounded at this blaze, and I was in the middle of moving to downtown Los Angeles that morning. No homes were lost.

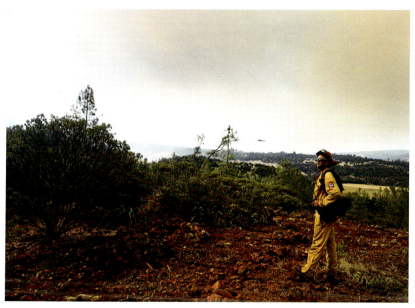

Early July 2014 at the Butts Fire in Napa County, where I met Gino running the bulldozers. This image was taken when he took me to a pond to see helicopters pick up water up close. Little did I know it would kick off a friendship that continues to this day.

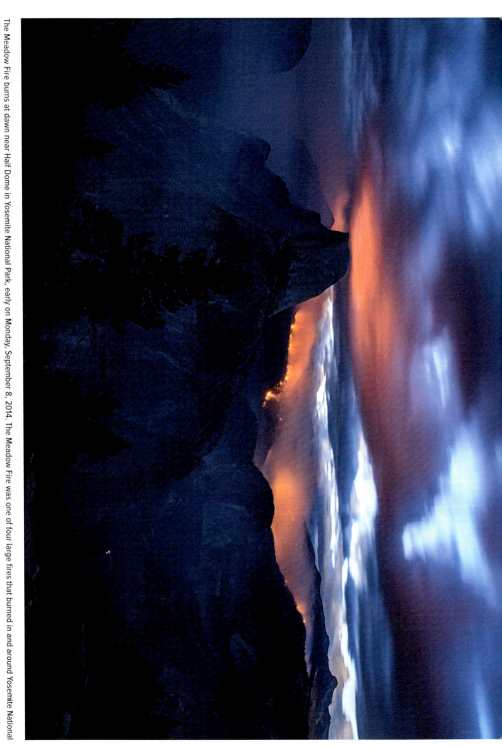

The Meadow Fire burns at dawn near Half Dome in Yosemite National Park, early on Monday, September 8, 2014. The Meadow Fire was one of four large fires that burned in and around Yosemite National Park during summer of 2015. I pulled an all-nighter to make this image from Glacier Point.

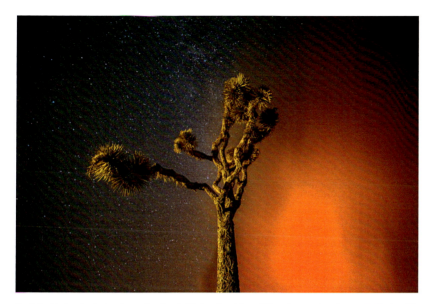

The Lake Fire burning in San Bernardino County Wednesday night and Thursday morning after coming back to life and burning thousands more acres. The fire was over 20,000 acres and 27 percent contained. Rim Rock was under a mandatory evacuation and Pioneertown was under a voluntary evacuation. This is another long-exposure image, taken farther away from the fire. Shot in June 2015. I ended up buying a rural cabin not too far from where this image was made.

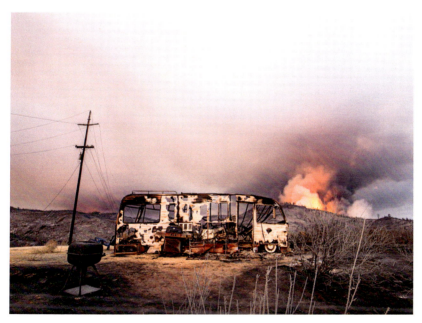

The Rocky Fire burns overnight near the town of Clear Lake in Lake County, California. A burned trailer creating a scene of Armageddon at this fast-moving fire. It was summer 2015, and I was driving back and forth between home in SoCal and the multiple blazes in Lake County.

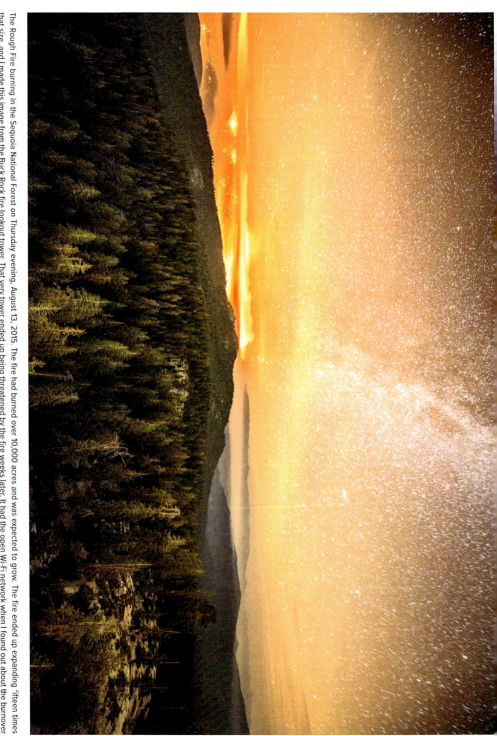

The Rough Fire burning in the Sequoia National Forest on Thursday evening, August 13, 2015. The fire had burned over 10,000 acres and was expected to grow. The fire ended up expanding "fifteen times that size, and I made this image from the Buck Rock fire lookout tower. That very tower ended up being threatened by the fire weeks later. It had the open Wi-Fi network when I found out about the burnover fatalities in Washington State.

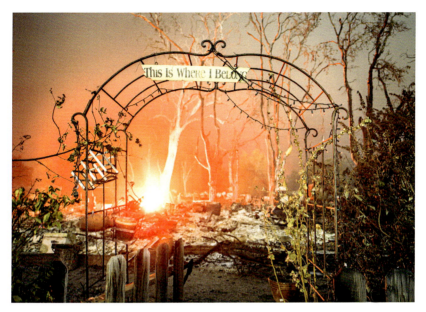

September 2015, the Valley Fire burned through Middletown in Lake County, capping off a deadly and destructive summer in hard-hit Lake County. Nearly 2,000 structures were destroyed. The smoldering remnants of this home in the town center with the sign reading This is Where I Belong brought tears to my eyes.

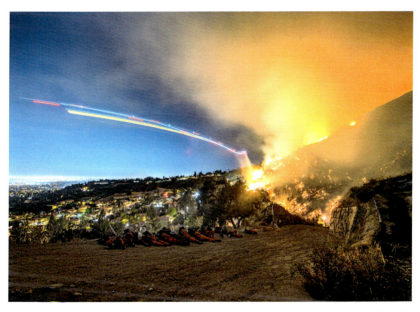

The 2016 San Gabriel Complex happening during a record-setting heatwave in late June 2016, leading to triple digit temperatures at a fire I could see from home in Orange County. This image was made later in the evening on the first day of the fire and captures the inmate firefighters with the Angeles National Forest, suburbs, and downtown Los Angeles faintly visible in the wide angle shot.

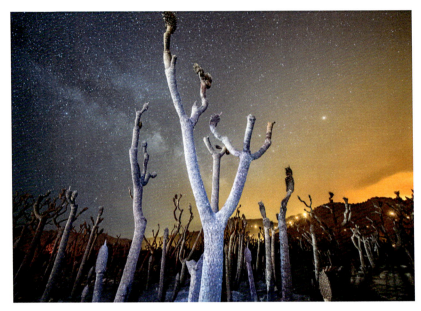

The Erskine Fire burns near Lake Isabella and Kernville—the blaze was 0 percent contained. This blaze started right after the San Gabriel Complex and led to fatalities and hundreds of structures lost. The destruction of many Joshua trees was also stark against the Milky Way and fire-filled landscape.

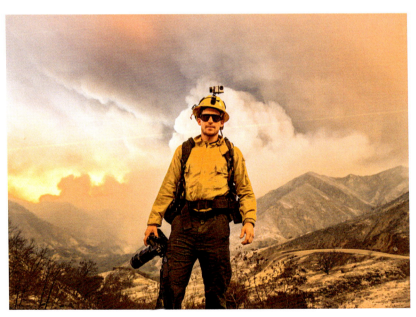

July 2016, at the Sand Fire, when the blaze blew out into Little Tujunga Canyon. Viewed coming into the blaze from near the front country of the Angeles National Forest. The image was taken with one of my cameras by an off-duty wildland firefighter who tagged along for the day. This is an example of the PPE I wear alongside my cameras while documenting blazes. While the cameras I use today are newer, the protective gear is about the same.

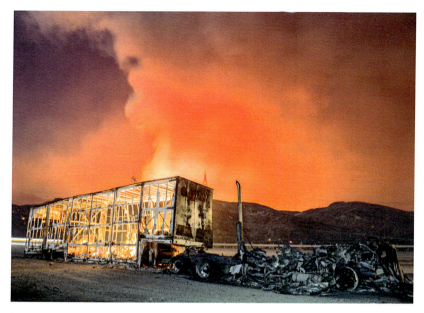

The August 2016 Blue Cut fire was the last large wildfire I covered in 2016 after dealing with compassion fatigue and struggling to balance my personal life with covering wildfires and climate change. Interstate 15 in San Bernardino County was shut down between Victorville and San Bernardino, and this burned semi made it feel like *Mad Max* or some other apocalyptic film.

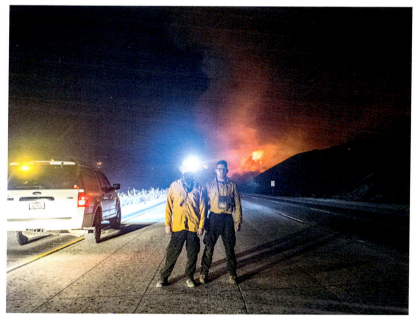

My multitalented artist and photographer friend Jeff Frost and I posed for a quick photo on the emptied Interstate 15 shortly before finding that burned-out semitruck further up the road. In the megalopolis of Southern California, driving as media on closed freeways is always strange, surreal, and terrifying for the reasons it's closed.

The Railroad Fire burns in the Sierra National Forest near the town of Oakhurst, California, Friday evening September 1, 2017. The fire was over 4,000 acres and threatened the Nelder Grove of giant sequoia trees. I arrived at this fire late in the night, and the only active fire in this portion of the blaze was a smoldering pine tree. With the forest floor lit by moonlight, this single tree continued to throw off embers. Compared to in-your-face compositions of seasons past, I was interested in sharing the subtlety of this scene from a storytelling perspective.

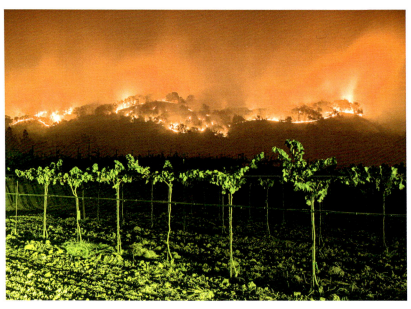

The Atlas Fire burns in Napa and Solano Counties Monday evening October 10, 2017. The Atlas was the first blaze I arrived to during the October 2017 Wine Country Fire Siege. I was the only photographer at this part of the fire and ran into the El Dorado Hotshots trying to save a nineteenth century winery. They succeeded.

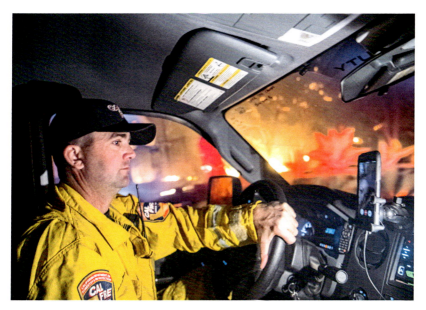

The Thomas Fire burns in the hills above Carpinteria and Montecito Monday December 11, 2017. By midnight the fire had burned over 230,000 acres, was 20 percent contained, destroyed 880 homes, and was the fifth largest fire in California state history. Gino at the Thomas Fire calls his family to say goodnight during a break in the action of defending homes in Upper Toro Canyon. I rode along with him that evening in one of the most intense nights of WUI structure defense photography of my career.

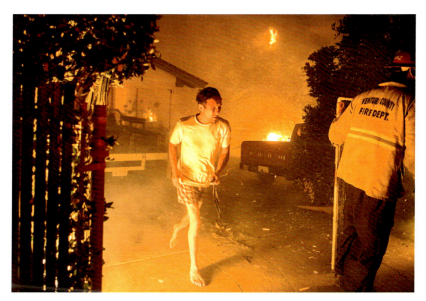

A resident evacuates his home on Quinta Visa Dr. and E Hillcrest Rd. in Thousand Oaks early Friday morning. Residents were awoken in the middle of the night by mandatory evacuations from the Woolsey Fire. (Sent to my editor at the time with this note: Resident had to leave with only the clothes on his back, wasn't able to get a name due to the heavy fire situation, he was whisked away seconds after taking this photo.) This was the image I took of Masao fleeing his home in the middle of the night.

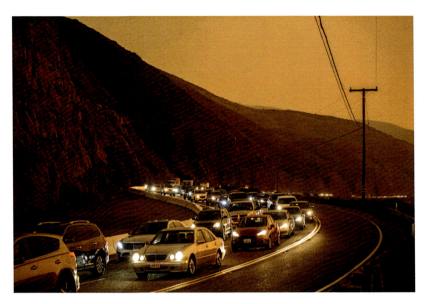

A line of cars heading west toward Camarillo on the PCH from Malibu as the Woolsey Fire forced mandatory evacuations. The Santa Ana Wind–driven fire was threatening thousands of homes and burning uncontrolled towards the Pacific Ocean. Driving into Malibu from the western approach via Ventura County, I pulled over briefly to make a few images and to let fire trucks pass me. It was strange that everyone else was leaving, and I was going in to make photos on assignment for the *LA Times.*

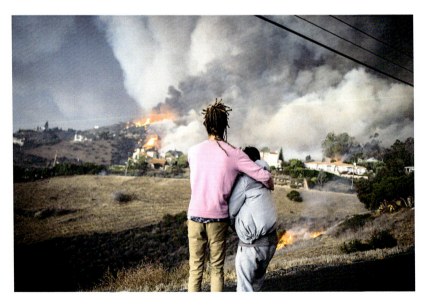

Residents with a home on Las Trancas Canyon Road watch as the Woolsey Fire approaches their home Friday morning. Minutes later the area was engulfed by a rotating column of fire. I learned later this was Sara Daoud and Jordan Pope, a couple who'd just evacuated the home they were living in.

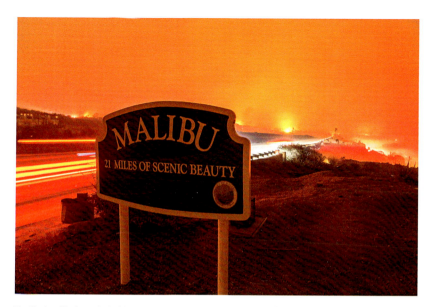

The Woolsey Fire burns in the hills above Malibu after the blaze burned to the ocean. This was the evening after the twelve-mile-wide fire front swept through Trancas Canyon and I had to shelter on the beach. It was chaos.

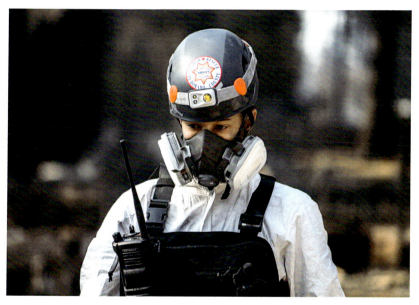

El Dorado County SAR volunteer Marijke Ellert searches a home for any possible human bodies in Paradise, November 2018. I was on assignment for *TIME* magazine, embedded with the crew. They hit on some points that had them call for a cadaver dog, but thankfully no humans were found in this home. Behind this property is where Marijke and her colleagues ran into the injured cat. I was at the Woolsey Fire when the Camp Fire ripped through Paradise, and this image was made about a week and a half after the fire started.

Murals and recovery in the town of Paradise, California, Butte County. Taken Wednesday, March 27, 2019. I returned to Paradise in spring of 2019, after attending a post-fire climate change action summit in Sonoma County. I wanted to pay my respects to the dead, and to see how the town was beginning to recover from its trauma. Muralist Shane Grammer had painted many of the destroyed structures, with permission, and seeing art among the pain and loss was a small silver lining.

Hike to Granite Mountain deployment site with Amanda Marsh outside of Yarnell, February 2020. I didn't take many photos during the hike—it was an emotionally powerful and overwhelming experience, and I wanted to be present for it to honor the firefighters who were lost. This was also the last reporting trip I made before the COVID-19 pandemic changed the world forever.

FIRE IN THE VALLEY

I sat perched on the stone wall overlooking the Yosemite Valley as burning trees crashed down a cliffside and rolled into the canyon. Overhead, the Perseid meteor shower dazzled me with shooting stars as the Milky Way formed a backdrop. Where the Ferguson Fire was burning, hotshot crews were engaged in a firing operation buttoning up the last piece of open fire line on a blaze that kept the park closed for weeks. It was one of the largest wildfires in the park in years, and one that impacted the entire park and surrounding communities at the height of summer tourist season.

Yosemite is one of the national park system's crown jewels, and it was under siege. As I set up my camera and made photos of this scene, I was in awe at finally having access to a wildfire in Yosemite. I was the only photographer there, and it felt like an incredible privilege and rush. The shutter clicked and on my LCD screen was a dance of stars, meteors, fire, and Yosemite National Park.

After five years of access challenges, I was on my first new Forest Service photo assignment, embedded with fire crews and officially assigned to the incident. Like the Thomas Fire, I had incredible access in areas closed to the public, and in some cases closed to media by the National Parks Service. It was like the fire gods had given me a birthday gift. I celebrated my thirtieth birthday on the fire line, ringing in my

fourth decade of life with air tankers and helicopters flying overhead.

The afternoon of my birthday, I stood in an empty and smoke-filled Glacier Point, overlooking Half Dome and the valley and thinking of the Meadow Fire years before, the Rim Fire and El Portal Fire where access was difficult. I thought about my fire journeys, the dud fires and the fire sieges, the structures, people, and lives impacted along the way. It was truly a moment of gratitude filled with humbling reflection. I wouldn't have had it any other way.

I was in my new pickup truck, freshly decked out for chasing fires. I felt present and focused, now in my sixth season of photographing wildfire. I felt in tune with the whole operation. My camera and fire equipment were an extension of my movements on the fireground. I had reached the peak, literally, at Glacier Point. This gave me an opportunity to photograph hotshot crews like the Horseshoe Meadows, Kings River, and Crane Valley Hotshots firing out along Highway 41 the day after the Perseid meteor shower.

The Horseshoe Meadows Hotshots, along with the Sierra Hotshots, stood on the side of Highway 41 at dusk, preparing for their operation. The firing module crews huddled close together on the dirt pullouts near their crew buggies, discussing tactics and plans for the back-fire and if things went awry. Brush engines from cities in the Central Valley stood by to support the burn and knock down any extra heat with hoses. It was dry and steep terrain. The fire was mostly contained, but this was their best chance to button up the open line. If the fire progressed farther into the Yosemite Valley, it would threaten the lodging, campsites, and buildings at the heart of the park. So far, the fire had burned in the Sierra National Forest and other portions of the park, sparing the nerve center of Yosemite. But it was still too close for comfort, and the weather was slightly moderating, so it provided a chance to burn without too much risk. The fire was not without its casualties, either. Cal Fire Dozer operator Braden Varney and Arrowhead Hotshots crew member Brian Hughes both perished fighting the fire, and their loss reverberated during the rest of the battle against the Ferguson.

The crews were extra careful on safety, as they always were, with a special focus on "snags" or damaged and weakened tree branches that could fall from wind and fire in a burn area. Just a week before my deployment to the blaze, Brian was killed by a falling branch near where I was working. He left behind a pregnant wife, a tragedy that shook the entire army of firefighters at the blaze, and the fire world in general. As beautiful as the burning park was, it was cruel in that it took the life of a hotshot. A child would grow up without a father.

The specter of his loss hung heavy over the fire. With each crashing tree and snag falling in the woods, you felt the thud reverberate through the earth. It was a reminder of your own mortality. Years of drought and bark beetle kill caused this—the dead trees from 2013 and on were still standing. They were "matchsticks" as one tree faller put it. The fallers sawed down damaged trees around the highway that hundreds of thousands of tourists used per year. It would be months before the road was safe to reopen to the public.

King's River Hotshot squad leader Jordan Flores said of the blaze: "That was the most stressful fire I've been on in a very long time! I got there the day it started . . . I was crew boss trainee when the first fatality occurred. It was an eerie feeling knowing that another hotshot passed away not far at all from where we were trying to protect a community. We fought our asses off that day and night for Brian Hughes and the Arrowhead Hotshots."

Flores did two "rolls" at the fire: one fourteen-day stint, two days off, then fourteen days more. The first fatality with Braden Varney happened on the first roll, filling in with a Type 2 crew. The second fatality with Brian Hughes happened on the second roll when Flores was back with Kings River. He said he'd accrued almost twelve hundred hours of overtime that season. This is why crews had their heads down and were working with fervor even three weeks after the fire started. I didn't arrive on my Forest Service assignment until late into the blaze, and to see them working with such dedication was a testament to their honoring of Braden and Brian's memory.

I first met Jordan running a fleet of helicopters dropping buckets of

water and tanks over fire torching in trees in steep terrain off Highway 41. He was holding a Bendix King Radio, the standard for wildland firefighting communications, and speaking directly with helicopter pilots telling them where to place buckets. It was an impressive sight to watch the dance of helicopters ferrying water back and forth from their "dip site." The site could be a pond like the K-MAX at the Butts Fire in 2014, or snap tanks, which are large soft-sided tanks set up in a field.

After fighting the blaze in steep terrain, Flores said of him and the crew, "We were beat! Physically and mentally." I heard the same from the Dalton Hotshots. At seven thousand feet with slopes over forty-five degrees in angle, hiking with forty-five-plus pounds of gear added up for days on end. Add in emotional fatigue from losing a hotshot family member and it compounded the stress.

When the crew was working Flores said, "Anytime we hear about a fire in the Merced River drainage, your hair stands up a little more than usual. You talk to any hotshot that's ever fought fire in there, and know it's always going to be a hard fire to suppress."

I watched Flores and the rest of his crew hike up steep terrain after cutting fire line all day, covered in sweat, dirt, and ash. I made a photo of another firefighter on the Kings River crew, sawyer Estevan Alvarez, his face caked in dirt from fighting the fire. It was a fleeting moment to capture, and it had taken days to get myself in that position. We were deep into Yosemite National Park near active fire. The general public was kept miles away, and even credentialed media had difficulty getting access. They came off the hill, loaded their rigs, and were off in five minutes. Being on assignment for the US Forest Service was a privilege. I was grateful to capture that moment after his shift while he was "rehabbing" or cleaning up his chainsaw.

Flores continued, "When we left that fire, I've never been so emotionally drained. From being almost next to two fatality sites on one fire! Most people in fire will never be that close to just one in their whole career. I happened to be next to two in four weeks."

Prior to the death of Brian Hughes, Cal Fire bulldozer operator Braden Varney had been killed when his dozer slid off a steep, narrow

dirt road above a drainage the first night of fighting the fire. He was in his home fire unit and backyard trying to contain the fire quickly. This fire hit close to home for many. His body recovery took a special effort, outlined in *San Francisco Chronicle* journalist Lizzie Johnson's moving essay.[42]

Flores echoed the sentiment: "It makes it a little more stressful knowing that it's our backyard, on our forest. You want to go out there and do your very best."

This was the Kings River Hotshots' and Sierra Hotshots' home turf, and they were determined to get the fire contained. It was tough work in steep drainages and terrain with limited access. It was challenging leading a crew of men and women that were also feeling the emotional fallout from the death of a hotshot crew member. Flores said, "It makes it difficult to lead the men and women knowing it's on their minds as well." This would explain the somber tone hotshots crews took when working. I could feel a sense of loss, an unease lingering in the smoky alpine air. Once Flores got home, he dealt with fallout I could completely empathize with.

"The Ferguson was by far the hardest one to cope with. I came home and couldn't really talk to my family about what had happened out there like I've always done in the past."

Flores and his crew were on a double-fatality fire, working in that area under the same conditions with snags and steep terrain. Flores was also at the Dog Rock Fire near El Portal in 2014, where a Cal Fire air tanker pilot crashed into a granite cliff and died. The weight of working on a wildfire where your co–first responders are dying is not something easy to process when you're working sixteen-hour days in the dirt and smoke.

Flores said it was difficult talking with his family because: "I could not imagine my own family getting a phone call or a knock on the door telling them that their son or father wasn't coming home. That bad day haunts me on every fire I go to."

Flores and the crew would go on to two more rolls at the Delta Fire in Northern California. Flores and the crew are based in Fresno,

which in addition to Sacramento, bears the front of wildfire smoke and air quality during the summer, due to their valley location. They are always cities I drive through on the way to fires, and for me Fresno is synonymous with large wildfires in the Sierra Front.

And as I drove off to the Ferguson Fire, the Holy Fire was ripping up the front country of the Trabuco Ranger district in the Cleveland National Forest. I could see one-hundred-foot flame lengths from my front patio burning up the mountain from twenty miles away, as I was prepping to drive six hours. The forest district I saw daily from my balcony was on fire, and I would miss it. But I was just one person, and there were many fires.

When I wasn't photographing fire crews, meteors, and burnout operations at the Ferguson, there was the aftermath of tens of thousands of acres of destruction. The large pine tree stumps burned for days after falling into the woods or being sawed down by fire crews and falling modules. I watched the same tree stumps burn for days each time I passed them on the road. Fire burned inside, consuming the pitch and sap underneath the bark, hollowing out tree skeletons in the ash. A tree would be on its side, looking normal on the outside, then fire would shoot out of its hollow base once it fell over. The insides of these still-burning dead trees looked like flaming pizza ovens.

Once on the ground, burned bark was inscribed with a geometric pattern from the heat. Damaged trees dropped for safety had the burn pattern on the outside, and the bark beetle galleries and marks on the inside amid hundreds of years of tree rings. Many of the trees that went down had seen war, famine, drought, and fire. But they would not survive the Ferguson. One part of Highway 41 was a natural uphill fire chute, and that segment of fire line looked like a bomb had gone off. The forest floor was covered in ash.

As the fire wound down, I looked for slower moments. El Capitan Meadow, devoid of tourists and covered in smoke, shrouded the sheer granite face from clear view. It was a truly strange site, and weird to have the park to myself with the firefighters. I photographed the pink flame retardant contrasting with the green moss and reddish-brown

bark of the surviving tree. To me, this image said just as much as peak action fire shots.

The season would continue as fires shifted south and the hot summer days of August shifted to the shorter days of fall, and Santa Ana wind season would start up in SoCal. I was still emotionally impacted by the brutal 2017 season, and now the low-level constant stress of snags and the losses at Ferguson compounded that fatigue. I had no idea the 2018 season was just getting started.

THE MEMORY REMAINS

I stood on a steep hillside in dense brush, near the town of Lakeport in Lake County. A wall of fire was cresting the ridge above me and about to slam down on top of a home. The wind was pushing the fire down toward structures as the VLAT jet engines whined overhead while the pilot hit full throttle after a near-stalling-speed fuel drop. Behind it was a C130 Hercules National Guard firefighting aircraft, trying to tag and extend a line of retardant in order to save the homes. The house at the top of the ridge was left undefended and deemed unsavable due to the topography and fire behavior. There was some defensible space but only a narrow dirt road for egress—firefighters didn't feel it was safe. As I livestreamed the scene on Instagram from the ridge, a spot fire erupted on the opposite side of the canyon.

Within minutes the wind would cause another spot fire to start downhill from me, an incredibly dangerous situation. I recognized this immediate threat and jogged down to the base of the hill near a gravel road. A Cal Fire engine crew was staged for structure defense, and my truck was parked facing downhill for a quick getaway. As the fire engulfed the home on the top of the hill and devoured it, erratic winds from the fire front hit our position. The two young Cal Fire firefighters let out a loud yelp of anticipation, put their goggles and gloves on, dropped their neck shrouds down, and charged their hose lines. Ash,

embers, pine needles, and debris flew through the air. Despite donning my own goggles, ash and heat still filtered through the mesh, and my eyes stung and closed shut. With squinted eyes, I fumbled with my own gloves to zoom the lens and adjust camera settings to document the scene.

Fire had come racing down the hill where I was standing minutes prior, and another Cal Fire Type 3 brush engine came speeding down the hill with a fifty-foot wall of fire behind us. The fire that had just ignited the hilltop home came roaring down the canyon, pushed by its own wind. The firefighters let loose on their hoses, hitting embers as they ignited fence posts, trash cans, and a woodpile. They yelled, "WATER!" and moved two hose lays around the structure at the bottom of the hill. A pile of junk and cars next to the home caught on fire and they were putting water on the pile to save the house. The junkyard burned but they saved the home.

I quickly moved farther north to where the rest of the fire front was burning homes. I ran into an LA County Fire structure protection group five hundred miles from home as more fire entered a eucalyptus grove around a home with dozens of marijuana plants. Firefighters were running hoses in to save this structure as outbuildings caught on fire. Thirty seconds later, embers hit a large wooden barn, and it was on fire before I even realized what was happening.

Wind was gusting twenty to thirty miles per hour with the fire front, and the eucalyptus trees exploded into fire. The firefighter with the hose line near me yelled, "GO!" dropped the hose, and started running. I was already twenty feet ahead of him when the whole grove went up in flames. I was too busy running back to the safety of the road to see if the grove experienced an "area ignition," but the heat on my back and the whoosh and boom of a fireball indicated it was possible. An area ignition is a rare fire event when a bed of fuel gets preheated, and basically ignites all at once. It's what killed the crew of Engine 57 at the Esperanza Fire in 2006, and here it put us all in danger.

Catching my breath and wits, I turned around to see the barn on fire with one-hundred-foot flames shooting from the top. A vintage BMW

parked in a field of dry grass was also on fire. Everything was a total loss. You could smell the pot plants burning in the smoke. There were no flowers or buds, but we all stepped back to avoid accidentally getting stoned in the middle of a dangerous wildfire. The crews did what they could to stop the fire at the paved road by the barn, but the heat was so intense they pulled back. I hopped to my truck, then the fire spotted over *that* road. I was unable to move or turn around because I was staying out of the way of the fire engines making six-point turns to leave. I looked to the field and barbed wire fence to my right. If the fire started hitting my rental pickup truck, I'd hop out the passenger side window with my fire shelter and run into the field to safety or to deploy the shelter.

With seconds to spare before the fire reached my truck, I was able to drive out. I went a mile down the road to catch my breath and reassess tactics. I saw Kent Porter driving down the road into the fray. We drove by each other and waved. He was also in the middle of documenting the firefight for the *Press Democrat* based in Santa Rosa. It had only been eight months since the Thomas Fire and less than a year since the Tubbs Fire. It was relentless.

While the River Fire was burning into homes, *four* more columns of fire were visible to the northeast as the Ranch Fire ripped into the Mendocino National Forest. Eventually, fire incident management would combine the two fires into the Mendocino Complex. Only months after the Thomas Fire became the largest wildfire in modern California history, the Mendocino Complex would unseat it at over 459,000 acres, with the Ranch Fire alone burning over 410,000.

I stopped by the air tanker base and helibase to see my firefighter friend Mackenzie and check out air operations. It was a flurry of activity as copters loaded up sling loads to bring to remote hotshot crews, and crews ferried supplies and fuel. There were copters from Cal Fire, the Forest Service, and the California National Guard. It was like a war zone, except the enemy was fire. It was close to one hundred degrees, single-digit humidity, and my feet were sweating in thick leather fire boots and wool socks. In the dry air, sweat evaporated off my body as soon as it came out of my pores.

As day turned to night, I returned to where the fire had ripped over the hilltop home. I drove up the ashen road alone, as power lines burned. I got to the house and it was a smoldering remnant of a structure. A chimney and dirty swimming pool stood, while the last remaining outbuilding burned. In the blue dusk, I looked down at the smoke below. A lot of homes were saved, but dozens like this one were lost.

I went back to the junkyard, which was still on fire. (Pro tip: junkyards in WUI areas are a great way to get your house burned down at a wildfire.) A rural fire crew was now running hoses to the house, clearly exhausted and slap-happy from being up for who-knows-how-many hours. They were cracking jokes and goofing around. When the firefighter charged the hose and started spraying water, it flew out of his hands and knocked his ass to the ground. I got a photo of it. They had over-pressurized the line. Embarrassed, he quickly recovered and got back to dousing flames.

Exhausted after chasing fire in the heat, I set course to the firefighter's house where I was staying down in Santa Rosa. On the drive back, I passed through the burn area of the Tubbs Fire. I wrote the reflection below a few months after the blaze. After the Thomas Fire, and now the massive Mendocino Complex, it was like driving through a darkened graveyard.

JOURNEY'S END

October 2018:

A year ago seems far away but the memory still feels raw. The destruction that began a year ago today in Napa and Sonoma Counties still draws chills down my spine. I arrived at the Wine Country Fire Siege a day after winds exploded into downtown Santa Rosa, with the Tubbs Fire leveling thousands of homes. As the search and rescue teams were doing secondary searches for bodies, as the stench of rotting animals, wild and pets alike, filled the

air along the roadside and in neighborhoods. Traveling up from destructive wildfires in SoCal, my sense of destruction and suffering was already acute.

The flipped-over cars in Coffey Park, the melted aluminum engine blocks and wheels in dried puddles where they melted as cars burned. Farther up the mountain the Nuns Fire still burned in the hills as hotshot crews fired out. The quiet moments at dawn, when I was sent out to photograph the wreckage in time for East Coast deadlines, were the most sobering. One morning, after briefing during a particularly nasty inversion, I went out to the Fountaingrove neighborhood where I'd scouted out a hillside vista a few days prior. The photo speaks for itself. The entire neighborhood, gone.

I can't change what I saw, what Santa Rosa experienced, what my firefighter friends and other journalists witnessed. They watched community after community burn. When people shrug off climate change, it's personal. I hear denial and head-in-the-sand arguments, and all I can think of is driving through block after block of leveled houses, trying to not run over the petrified squirrels in the road or the broken glass from exploded windows. Yes, there is an emotional response, but also a rational one.

Cold, hard aluminum puddles in the street from melted cars are cold, hard facts. You can't argue with a leveled subdivision and body bags. The images and numbers don't lie. We saw it in Redding this year, in Lake County, in Ventura, and we'll see it too soon at the next firestorm. The silver lining was the communities affected by the Wine Country Fire Siege coming together, neighbor helping neighbor, and the region pouring in support. Firefighters from all over the West came to help, and the cleanup and healing still continue.

Every time I'm watching a wildfire in the forest, it's a sight of nature under the stars. I also remember the Tubbs aftermath in Santa Rosa, a fire nobody should ever have had to suffer through. I'm reminded that despite making pretty pictures of fire, there

is a toll to be paid by those affected by them, and by those who fight it. And ultimately, I realize that I too am affected. But this isn't about me, it's about telling the story of wildfires and climate change in the West. Many others dedicate their time and energy to telling that story, and even more to fighting it each year.

This past July I stayed at an off-duty Cal Fire firefighter's family home in Santa Rosa. He hosted me while I documented the Ranch Fire. I was heading south on Highway 101 in the middle of the night after working for hours in Lake County at the River and Ranch Fires, driving through downtown Santa Rosa around 3:00 a.m. I was exhausted, running on caffeine and heavy metal. I don't really listen to metal, but it helps you stay awake on the roads and to get home safely. On the left I saw a dark void amid the lonely glow of the orange sodium vapor lights, the specter of burned palm trees rising into the air, hulks of once-living trees. I realized it was the Journey's End Mobile Home Park, where multiple senior citizens had been trapped and killed by the Tubbs Fire in the middle of the night, unable to escape the flames. Here I was, nine months later, passing through, toward a nearby wildfire that would grow to be the largest in California history, surpassing the Thomas Fire that happened two months after Tubbs. So much fire, so much destruction, in so little time.

As I drove past the phantasmagoric shapes in the dark, I turned my head back to focus on the road, Metallica's "The Memory Remains" blasted on the stereo, the words playing a twisted serendipitous melody.

"Ash to ash, dust to dust, fade to black."

THE BIG ONE, WOOLSEY FIRE PART 1

WOOLSEY FIRESTORM

So the violence and the unpredictability of the Santa Ana affect the entire quality of life in Los Angeles, accentuate its impermanence, its unreliability. The wind shows us how close to the edge we are.

—*Joan Didion*, The Santa Ana, *1965*

The fate of the Woolsey Fire was decided before it began. Fire history, wind, fuels, topography, and urban development predetermined the path and impact of the fire once it started. I wish the eerie prediction posted to my Instagram account below was wrong, but the fire had other plans.

Instagram, November 7, 2018:

Weather models are still showing a moderate and possibly strong ("record" in NWS Los Angeles words) Santa Ana wind event starting tomorrow midday and peaking overnight Thur into early Fri (unusual given that winds peak in the morning, not overnight) in Orange, Los Angeles, and Ventura Counties. Possible 70 mph mountain gusts or stronger are possible. Winds will linger

through Saturday. Another possible "strong" offshore push is pre-dicted Sunday or Monday per NWS Los Angeles.

My concern is that any overnight ignition that escapes fast containment in western LA County or eastern Ventura County will lead to dangerous rates of spread and evacuations when peo-ple are sleeping, a scary combo as we saw in the Tubbs Fire and Thomas Fire. This wind event will bring low single digit RH with explosive fuels, many at or close to record lows.

. . . I always keep my fingers crossed that we dodge a bullet, and so far we have this fall in Southern CA. But I'm also a realist, and the data and statistics don't lie.

The Woolsey Fire would begin the next day, November 8, at 2:24 p.m. and burn toward the ocean overnight in western LA and eastern Ventura Counties, rousing tens of thousands from their sleep and forcing them to evacuate. That same morning the Camp Fire in Paradise would also erupt, becoming the deadliest day in California wildfire history. Fire would burn from the Pacific Ocean to the fields of the Sacramento Valley in separate blazes that captured the national news cycle for days.

Cumulatively, over 30,000 homes were destroyed, and eighty-eight people died. It was a gamble to stay put in SoCal while Butte County was under siege but given my prognostications the day before and the fire weather forecast, I had an uneasy feeling for Southern California given the widespread fire danger due to the fuel conditions and predicted Santa Ana winds. As Woolsey Fire grew, the Camp Fire in Paradise had already destroyed the town. Meanwhile, I looked at booking flights into Sacramento that afternoon to cover the Camp Fire instead.

HISTORY REPEATS ITSELF

The night before the Woolsey Fire ignited and hours after sharing my wildfire concerns on Instagram, a gunman burst into the Borderline

Bar and Grill in Thousand Oaks and shot dead twelve people. Ventura County Sheriff's Sergeant Ron Helus was accidentally killed in the crossfire. I was up late listening to the police scanner feeds in Ventura County helping to direct a colleague who was covering the story for the *LA Times*. As he drove toward the crime scene wearing ceramic body armor, I was describing the perimeter, best media access, and scene for him.

We were in the midst of a moderate to strong Santa Ana wind event, and Thursday would mean more seventy-mile-per-hour gusts, record dry fuels at critical burning levels, and low humidity. I knew I had to get to bed. Southern California was ripe for a firestorm; current conditions mimicked past weather events that had led to tragic wildfires, such as the Cedar Fire, the Witch Fire, and the Bel Air Fire. All the books, articles, and pickup truck ride-along stories I'd heard indicated that conditions were in place for a historic firestorm repeat. Little did I know how true my near-worst fears would become. As the FBI arrived on scene in Thousand Oaks and frantic family members picked up brothers, sisters, and children from the reunification area near the Borderline Grill, I faded off to sleep, feeling anxious and unsettled.

I woke up groggy from going to bed so late the night before. I quickly prepped the gear I needed for the day: food, water, MREs, PPE, and fire boots by the door. Camera gear was already packed in the truck and ready to go with the requisite support bags, spare batteries, toolbox, sleeping supplies—everything I needed to be self-sufficient for a few days.

Morning weather forecasts and fuel reports reinforced the notion that western LA County and eastern Ventura County were some of the most susceptible spots for a new fire. A brief thought entered my mind about how awful it would be if there was a fire near where the Borderline shooting had just occurred hours before. In the world of fire and emergency services, bad things seemed to happen in clusters.

I came home from the gym and sat down after lunch to check my phone. It was 2:09 p.m. when I checked Twitter, which I compulsively do when there are Red Flag Warnings.

My pulse jumped at the tweet, and I texted it out to the dispatch

network of fellow news photographers and retired firefighters that track such happenings in SoCal.

2:10 P.M. PALLEY 301:

New fire in VNC (Ventura County): Santa Rosa Valley: Copter 6 reporting 1 acre in medium brush. Fire has now jumped Hill Canyon Road and is well established.[43]

As soon as I hit the send button, more tweets started popping up about the Hill Fire in Ventura County. Pretty soon there were six air tankers on order and hundreds of firefighters headed to the scene. The relative humidity was in the single digits, the Santa Ana winds were howling, the fuels had a probability of ignition of close to one hundred percent, and thousands of houses were in the direct path of the blaze.

It was go time.

I threw on my Nomex pants, T-shirt, and fire boots. I grabbed the bag of water bottles and Gatorade from the fridge, unplugged my laptop, and ferried everything down to my pickup truck, which was waiting in the garage. The time it takes to lace up a pair of fire boots is maybe three minutes tops, but when the adrenaline is pumping and you hear of a fire close by blowing up, it always seems to be longer. I yelled "Let's roll!" as I walked past the piece of melted aluminum hung as abstract artwork on my hallway wall. Ten minutes later I was on the road, hauling ass up the 73 freeway to Ventura.

As I geared up and hit the road to the Hill Fire, the Woolsey Fire was dispatched at 2:24 p.m. as I merged onto the freeway northbound. A second blaze in the same area heightened my sense of urgency. "It would be a long day," I thought. During wind events multiple fires often start, which is not good. This was one of those cases.

On a good day it's about a ninety-minute drive without traffic to the western edge of Los Angeles County from Newport Beach, about seventy-five miles. Leaving at 2:30 p.m. on a normal Thursday ensured the typical traffic morass of West LA and the 405–101 interchange

would be in full swing. I sat in traffic on the 405 in the Sepulveda Pass creeping past Mulholland Drive listening to the radio traffic. Firefighters at both the Hill and Woolsey Fires were asking for more resources as the blazes grew under strong and sustained Santa Ana winds.

The drive took over three hours, and by the time I accessed the Hill Fire and was on the fire line, it was getting dark. I found myself at a scrapyard smoldering in the wind. I photographed there for a few minutes and decided to try my luck at the Woolsey Fire. At the time, I was getting conflicting reports about whether the fire was expanding or dying down.

As I headed eastbound on the closed 101 freeway, I realized I was the only car on an eight-lane superhighway. Save for the occasional fire engine or police car, it was just me in the dark on a ribbon of concrete stretching off into the smoky distance. Strange.

Hearing radio traffic coming from Bell Canyon, I decided to check out the enclave of luxury homes directly south of the Woolsey Fire. As I drove toward Bell Canyon and the sky grew dark, I came upon a gatehouse at the entrance to the elite, wealthy community. Despite my press pass and PPE, I was denied entry. I was pretty damn frustrated by that, after seeing all the shit I had over the last six fire seasons, a private security guard and a plastic gate arm were blocking the way to a fire. I knew for a fact from tweets and my wildfire text group that other reporters and photographers had been allowed in.

I tried every trick in the book, citing the California media access law, describing my project to the gate guard, my qualifications, and experience, promising to check back in after an hour. But it was to no avail. He was blocking access to media, and it was a hill, or in this case a gatehouse, he would die on once the fire reached his position.

I had an impulse to just drive my truck through the flimsy plastic gate or off-road around it on the curb. I had a brush guard and it was designed to drive over things like downed trees and obstacles in an emergency. Of course, I immediately shot down the idea as ill-advised, foolhardy, and unprofessional. I had to swallow my pride and ego and turn around. But I would find a way in.

I found it mildly ironic that this hard-working person, being paid minimum wage or close to it, was still at the gatehouse guarding a neighborhood that was about to be impacted by fire and already patrolled by police, as is standard procedure when a neighborhood is emptied of civilians. What was the point of staying? They were within their rights to deny access to private property, but it seemed silly amidst the chaos.

Instead, I wound my way to the top of Woolsey Canyon Road at the entrance to the Boeing Facility (formerly Rocketdyne) where the fire reportedly originated. Perhaps there was an overview shot where I could get a bigger picture look at the fire? It was incredibly windy with little sight of the fire itself. There were no fire engines, only rubberneckers looking for a view of the fire, not unlike me. After a few minutes of scouting around, a large gust of wind came up on the ridgetop, nearly knocking off my fire helmet. For a gust of wind to knock a helmet weighted down with a headlamp, it had to be around fifty miles per hour.

Seconds later as the strong push of late-evening Santa Ana winds moved south into Bell and Woolsey Canyons, I saw the glow of the fire grow larger on a nearby hillside.

I still couldn't see the fire itself, but I set up my tripod and made a few long exposures. I kept my hands firmly planted on the tripod and remained motionless, lest the wind knock over my six-thousand-dollar camera setup. In the first four images, you can see the glow of the fire growing among the frenetic movement of brush and trees in the wind, looking like waves of water splashing in the ocean instead of still plants. After seeing the glow kick up, I made my way back to the Hill Fire, since fire visibility was poor from the edge of the Boeing property.

I cruised back on the closed 101 freeway and found firefighters at the Hill Fire parked on the side of the freeway, engines running. They were putting out hotspots in the pungent Caltrans mulch along the Conejo Grade, where the highway descends into the Santa Paula River plain. The view was tremendous: glowing embers on the hillside and the lights of Camarillo, Fillmore, and Oxnard in the distance. Somewhere off in the dark to the northwest was the blackened Los Padres

National Forest, immolated by the Thomas Fire eleven months prior.

The wind was really howling, and I could barely make stable pictures with the camera on a tripod. Firefighters were spraying their foam from the brush engines on the Historic El Camino Real sign. Other than wind, the silence was eerie. I spent an hour making landscapes and photographing the firefighters putting out hotspots. Then I checked my phone to see a message I'd somehow missed.

8:38 P.M. BABROFF 413:

Woolsey Fire says 3 hours till Oak Park is

impacted large resource order going in soon

Around 10:30 p.m., I drove to the north side of the fire in Simi Valley for food and gas. I had no idea what the fire would do. Based on my study of previous Santa Ana fires in the area, I decided to stick around. The text reinforced the urgency of the fire.

Historically, a significant percentage of Santa Ana wind-driven wildfires have made their biggest runs overnight as the winds howl through dawn toward the coast. During the 2003 and 2007 wildfire sieges in Southern California, I'd studied via text, interviewing firefighters, and looking at old maps and data. The fires all burned homes and killed people overnight when they were unaware of approaching danger and unable to escape the path of the inferno as they slept. The flames moved faster than firefighters could corral it and more swiftly than police officers could knock on doors to evacuate. I had to make a realistic, if somber, assessment of the situation, realizing identical factors would transpire before the sun rose again. The scenes I'd read about in history books and heard in firefighters' storytelling were repeating. I'd be ready for whatever happened next.

I stopped into a 7-Eleven to grab watery coffee, greasy hot dogs, and some mediocre sandwiches. *Just in case*, I thought, with enough processed calories to keep me awake all night and make my stomach hate me the next morning. I really hoped the fire would stop or slow when it hit the greenbelts around Oak Park. But the conditions were

just too ripe for something to happen. I bought a second turkey sand-wich for the possible fire breakfast that was going to happen whether I liked it or not.

A police officer from an unknown jurisdiction also stopped in, stocking up on snacks. His unmarked Ford Explorer Police Interceptor was parked out front. We passed each other in the aisle by the check-out counter, and made the briefest of eye contact, exchanging a glance that said, "Long night, huh?" He walked out the door and drove off as I paid for my provisions. There are so many quiet moments like this, ships passing in the night, inextricably linked by fate.

Stopping along the parkway down the road from 7-Eleven, I jumped out of the truck and climbed a short hill above a Simi Valley subdivision to get a better look at the fire. It was roaring southward and had exploded in size since that puff of wind caused the fire to take off on Woolsey Canyon Road. It looked like it was way up in the hills, but the wind wasn't stopping, and I could see the fire front phys-ically moving from my viewing position straight toward Oak Park, a wealthy subdivision. The flames were marching closer to homes. Even a fire moving at three miles per hour, a gentle walking pace, is life-threatening. It was fast enough to reach the ocean by dawn. Was this going to be the big one?

"You should probably start a pretty significant response."

I heard those words over the radio and frantically sent a text over to the group:

11:04 P.M. PALLEY 301:
Oak Park being impacted major structure
loss imminent

I continued to observe fire behavior from afar and spent a few minutes collecting myself and making sure all my equipment was in place. I consulted Google Earth to familiarize myself with the major roads in and around Oak Park, as well as the topography of the hills to get an idea of where the fire was headed, and how to make access. More

critically, I was identifying escape routes to get out if things went south once I went into the neighborhood.

12:06 A.M. NOVEMBER 9

It was past midnight when I drove around Simi Valley into Oak Park. A line of evacuating vehicles sped out of the neighborhood as smoke obscured visibility to 150 feet or less. The scream of fire engines pierced the howling wind. As I rounded a gentle curve, I saw fire at the end of the next block. The ember shower immediately hit my truck. Nearly horizontal flames tore off the hillside, making a direct beeline for thousands of houses. What happened next is a moment that is forever seared into my mind.

I turned onto King James Court in Oak Park and into a wall of fire, embers, and heat coming down from the road that faced uphill, in alignment with the winds. The street was being hit by a firestorm, and as I processed this scene and began to turn my truck around to park safely, the embers started washing over my vehicle and jumping across the street. Palm trees caught fire and were throwing off thousands of embers with each pulse of wind as a battalion chief careened down the street to safety in his own truck. This fire was burning through Oak Park in the next thirty minutes and my hands were shaking from the adrenaline.

I ran back to my truck to get gear out for the SHTF (Shit Hits The Fan) setup for ember storm/Santa Ana wind scenarios. I grabbed a second Nomex interface jacket for added thermal protection from burning structures, a passive P100 respirator to lessen intake of toxic particulates from burning homes, and prescription wildfire goggles to protect my eyes from the blowing firebrands in the air. I even had a special Nomex neck and face shroud specifically designed for urban firestorms and gloves to protect the thin skin on the backside of your hands. I was protected enough to ride out the storm alongside fire crews. The heat-resistant goggles are designed to shield your eyes from blowing embers and ash, while also allowing ventilation for sweat in

the dry heat. If this protective equipment wasn't adequate, it meant that I was too close to the flames and needed to back off.

I hopped back in my truck and hurriedly made a three-point turn, crossed the street to the south, and parked behind another car that had been left behind. It would shield me from the embers. As I parked, I almost got smacked by a blue porta-potty being blown down the street, no doubt weighed down by the contents in its tank. *Shit, that was a close one,* I thought to myself and cackled out loud. It helped diffuse some of the adrenaline coursing through my veins.

The GoPro footage I pulled from the evening shows me talking to myself and breathing in an attempt to keep calm, focused, and attentive as I walk through the ember showers. I also utter a few expletives, awestruck at the scene unfolding in front of me. I drove down a street and was confronted by more fire, which was engulfing a home.

A house was burning down with a $250,000 Rolls Royce Phantom parked in front. The home's roof was covered with fire. Three fire engines from Los Angeles County Fire and other city departments plus their crews had multiple hose streams on the home trying to prevent "exposures," or flames flying off the home from igniting the tightly packed houses on either side. With forty-mile-per-hour wind gusts, the fire jutted out into the night, inhaling oxygen and seemingly reaching for whatever else was flammable. The Woolsey Fire was alive, and it was furious.

I realized that the Rolls Royce was probably worth more than the entire salary of half the engine crew trying to save the car and other houses from burning down next door. Smoke detectors in the home screamed, beeping incessantly. Sirens and radios created an electronic cacophony to the destruction.

An army of additional fire engines showed up. Helicopters equipped with night vision attempted to make water drops on the home, as the fire front of the Woolsey careened down the street and up onto another hill in Oak Park. I turned around and watched the fire roll over hills and spot and throw embers over homes faster than I could drive around to the front of it.

My fellow wildfire photographer friend Ryan showed up, and I drove to a quiet area of the neighborhood to meet him. Given the severity of the situation, we decided to caravan with two vehicles for safety in case one was disabled. As we linked up, we noticed a home with a garage open, vulnerable to embers. We went up to the home and closed the door, and then a Ventura County Sheriff's deputy showed up patrolling the neighborhood. We identified ourselves as media and spoke for a few minutes.

Just twenty-four hours before, the deputy had lost one of his fellow officers, and now the VCSD was dealing with a massive wildfire in their backyard. I offered my condolences and, for a second, the cop command presence disappeared and the wall came down. Instead of a Ventura County Sheriff's deputy with a badge and a gun, I saw a fully grown man clearly grappling with psychological trauma from losing a colleague the night before, and now helpless as an area he protects burned. You could see the pain he was going through on his face and how his words, just for part of a sentence, held a tremble to them. The body language was unmistakable, vulnerable and, in that moment, very real. We offered him some Gatorade and headed back toward the fire front, now a mile down the street.

We were forced to keep hopscotching to the front of the fire to follow it. I was able to keep ahead of the fire at times and make pictures due to previous WUI fire experience, and situational awareness lent by the fire scanner despite the frenetic pace of radio traffic.

My scanner was connected to my truck's AV input, and the calls coming over the radio from fire and law enforcement hammered home the severity of the situation: "Immediate life safety threat" and "shelter in place." Ventura County Fire units were rushing to defend a fire station immediately in the path of the flames. Civilians were evacuating and the roads were clogged like rush hour. It was around 2:00 a.m.

Ryan and I weaved through dozens of streets following embers and structures burning, documenting firefighters taking stands where they could and trying to prevent burning homes from igniting others. The fire worked farther south through miles of subdivisions and it came out of the hills into Thousand Oaks and closer to the 101 freeway, nearly

four miles as the crow flies. It took me thirty minutes to drive that distance because of ongoing evacuations that snarled the residential roads. Residents in their pajamas and bathrobes were getting into their cars and leaving. We were on the edge of the fire transitioning from wildfire to urban firestorm.

Over ninety percent of Paradise in Northern California had burned that morning and I thought Thousands Oaks might be next. This was climate change across the state.

As I followed the fire burning south from Oak Park toward Thousand Oaks with Ryan, I kept hearing firefighters on the radio talk about "Hillcrest Drive" as a place where the flames were going to come off the hill and into the flatland area of homes in Thousand Oaks proper. The "flatland" encompasses parts of the LA Basin built on lower-lying areas, alluvial fans, or otherwise non-hilly areas.

3:43 A.M.
"REPORTS OF PEOPLE TRAPPED"

Over twelve hours after leaving my house to photograph the Hill Fire and four hours after I first drove into the firestorm of Oak Park, the Woolsey Fire impacted the flatlands of Thousand Oaks. A row of homes along Hillcrest Drive had windows illuminated by the glow of flames along the hilltop across the street, the flames reflecting in living rooms. I looked at the fire dancing in the windowpanes and felt a pit in my stomach. Come sunrise, some of that glass would be melted, soot-covered remnants of someone's home. It reminded me of the Thomas Fire in 2017 when Santa Ana winds were pushing the fire front downhill toward homes in La Conchita. The homes, quiet in their overnight suburban repose, were about to be disrupted by millions of embers.

Fire engines were positioned along Hillcrest Drive and I saw black smoke from structures burning on the south side of the street, opposite the hill where homes were densely packed. Ryan left for home and I parked my truck, grabbed my helmet and camera, and jogged to a

home where firefighters were converging. Embers were in the front yard, igniting vegetation, and there was a truck and trailer beginning to burn. I lifted my camera to my eye and began pressing the shutter.

Seconds later a bewildered man in sweatpants ran out of the house, followed by another man wearing nothing more than a T-shirt and boxers. The second man running out of the home said: "My house, everything is inside there," with a bewildered tone. He'd tried getting into his truck and moving it, but the back tire was already melting, and flames were licking the right rear quarter panel and the back right tail-light was melting. He was barefoot as firefighters yelled, "Go! Go!" and ushered him down the street away from the burning yard. One Ventura County firefighter politely held the front gate open, telling him to just keep walking down the sidewalk. It was absolute chaos.

The man walked off down the sidewalk as a gust of embers stung against his legs. I was brutally shocked for a moment, but my adrenals were too overworked to generate any kind of emotional response. I just kept on taking photos. The backyard of a neighboring home was on fire, and a few houses down the entire structure was ablaze.

The man I photographed in that moment is Masao Barrows, and the image of him fleeing in his pajamas in the middle of the night ran on the front page of the *LA Times* the next day. He was the symbol of the impact on communities of the Woolsey Fire on Day One. The moment lasted a mere fifteen seconds, according to the metadata in my image archive, from when I first saw the scene unfolding to Masao speed-walking to safety. I'm still dumbstruck that I was at the right place at the right time to capture this moment.

In a later interview with Masao, he said he'd been picked up, put in the back of a sheriff's cruiser, and dropped off in a parking lot. While inside the squad car there was also a rescued cat, and he had to fend off the panicked feline from jumping around and scratching him during his ride to safety. When he was dropped off in the parking lot of a shopping center, a couple that owned a shop was taking refuge in their store, also having been evacuated. They gave Masao a pair of sweatpants and that's where he spent the night.

Firefighters began the fire attack in the yard of Masao and his roommate's home where the vegetation at the front gate was burning. A trailer full of tools was also engulfed with fire, and the truck tailgate still had paint bubbling from the heat. Additional flames and fire were in the back of the house. Eventually, Ventura County firefighters saved the home, but with moderate smoke damage.

I continued to photograph other burning homes along Hillcrest Drive as the battle continued in Thousand Oaks. I could overhear radio traffic playing on the loudspeakers mounted onto the fire engines and it sounded like all hell was breaking loose. Units were making stands against the fire where they could, trying to save homes here and there. The main front of the fire was almost to the 101 freeway. If the Woolsey crossed over the freeway, it would hit heavier fuels in the Santa Monica range and become unstoppable.

It was 4:00 a.m. and I realized that this fire wasn't going to stop before sunrise. I was becoming delirious from dehydration, exhaustion, smoke, and going for fourteen hours straight. I did a tactical pause and realized I needed to disengage from the fireground and rest for a few hours, even if it meant missing a few photos. After making the picture of Masao I was also satisfied that I'd done justice to the civilians affected by the fire and the firefighters battling it, for now. It was also dawning on me that this would be a historic fire and I'd need to pace myself.

Eventually I found a parking lot outside of the fire's path and evacuation zones in front of a shuttered Toys "R" Us. Evacuees dotted the lot, and families were sleeping in their cars with piles of possessions haphazardly tossed in their truck beds and back seats. These short-term climate refugees were tired and scared. Young children were crying. It was unreal.

A few blocks down the street, a police barricade protected access to the Borderline Bar and Grill where the mass shooting had occurred the night before. While the FBI was doing ballistics testing and Hillcrest Drive was burning, I decided to bed down for the night in the back of my pickup truck in the parking lot. I was exhausted, home was eighty

miles away, and I needed to stay close to the fire for the next day of impending action.

At other fires I'd sped home in the middle of the night to catch a shower and a few hours rest in my own bed, but the situation was so critical that I was committed until this thing burned to the Pacific Ocean, if it came to that. I crawled into the back of my truck with my fire boots still on at around 4:30 a.m. I used an old jacket as a pillow on the plywood platform I'd built. Sirens, helicopters, and ongoing jolts of adrenaline kept me up. Eventually I dozed off into fitful dreamless sleep, encapsulated in a real-life nightmare.

I OF THE STORM

IS MALIBU BURNING?

FRIDAY, NOVEMBER 9,
5:58 A.M. BABROFF 413:
Woolsey Fire has jumped Highway 101 at
Cheseboro and is well established on the south
side of Hwy. winds pushing it toward ocean still

I woke up in the bed of my pickup truck to the vibration of the fiberglass camper shell rattling in the Santa Ana winds. The truck was swaying back and forth as gusts of offshore breeze pushed toward the Pacific Ocean. A few miles to the south, the Woolsey Fire had spotted over and jumped the 101 freeway during my three hours of sleep. I awoke to this text:

7:18 A.M. BABROFF 413:
Woolsey Fire mandatory evac from 101
all the way to Malibu ocean front

Already hot and dry, the smell of smoke and ash lingered in the air. I rubbed my eyes, popped in some eye drops, and opened

my emergency can of Red Bull stashed in my truck's DC-powered refrigerator.

7:50 a.m. I called the *LA Times* photo desk to check in with editors and was told a fellow photographer on team coverage was already stationed down in Malibu. My objective was to cover the aftermath in Oak Park, where I had photographed just hours before. As I drove to Wembley Road in Oak Park, I found the house from the night before burned to the ground, but the Rolls Royce parked in the driveway was unscathed. Typical to the immediate aftermath of wildfires, it was quiet. There were no firefighters or residents. It was that interstitial period between destruction and reckoning, the hours or days between the battle to save homes and the trauma of residents coming back to a neighborhood forcefully reborn by fire.

8:27 A.M. BABROFF 413:

Column collapsing extreme fire behavior on

Kanan no access due to heavy fire conditions

Fire is south of tunnels on the ocean side

Since the neighborhood was situated on a southward-facing hill, I quickly made pictures of the aftermath, because a behemoth was looming on the horizon. Like a nuclear bomb going off, the fire had hit the heavy fuels of the Santa Monica Mountains and exploded in size and ferocity as the sun rose, dropping the humidity even further and raising temperatures to dangerous levels. One of the most extreme pyrocumuluses I'd seen had formed in the aftermath, reaching tens of thousands of feet in the air over many miles, and was sheared off at the top due to winds. I filed my images from Oak Park and called the photo desk again. I told the editors that I needed to get down to Malibu, where I suspected the fire would hit the beach in a matter of hours. Radio traffic indicated generalized mayhem along the various roads between the 101 freeway and Pacific Coast Highway.

Once the images were filed, I made a beeline south through Oak Park down Lindero Canyon Road toward the still-empty 101 freeway.

Further text message reports and radio traffic indicated severe gridlock coming into Malibu from the east, with traffic flow at a near standstill.

In years past, driving through the Malibu area, I'd brainstormed the best way to access the area in the event of a major wildfire. Depending on where the blaze was located and current conditions—a combination of Los Angeles traffic, evacuations, and road closures—access could be nearly impossible. Entry from Santa Monica didn't make sense, and virtually every north–south canyon road from the 101 freeway was also shut down or blocked due to downed power lines or an active fire front. I decided to drive back down the Conejo Grade into Ventura County and enter from less-populated Camarillo on the western side of the fire. This entry point would help me avoid getting in the way of fleeing evacuees and arriving firefighters.

9:13 a.m. As I sped westward along the 101, I made good time as one of the only cars on the road other than intermittent law enforcement and fire engines. I came into the agricultural fields of Camarillo and Ventura County, passing Cal State University Channel Islands. The drift smoke from the Woolsey's pyrocumulus wafted high above the green strawberry fields. Farmworkers continued to labor under the smoky and oppressive conditions, and amidst the rush to get to the beach in Malibu, the contrast between the wealthy enclave of Los Angeles and migrant workers working for a pittance was stark.

Passing the fields, I ran into Oxnard for gas, coffee, and food at Jack in the Box. I grabbed a couple of breakfast sandwiches not knowing the next time I would have access to food. I'd eaten the second fateful turkey sandwich from 7-Eleven sometime the night before. Even for a severe wildfire like the Woolsey, some calories and caffeine go a long way to keep up energy, focus, situational awareness, and safety. After going nonstop since 2:30 p.m. the day before and a few hours of restless sleep in the back of my truck, it was a small moment to collect myself before riding again into the firestorm.

I fueled up and jumped back on PCH headed toward the towering column of smoke rolling over the ridges of the Santa Monica range. My phone was pinging with nonstop texts from friends asking for updates

and if I was okay. A couple of my journalist friends were hitting me up for interviews and photos, but there was little time to respond in the moment.

9:49 a.m. Dropping to Highway 1, or PCH, I stopped near Point Mugu to take in the scene. Two bewildered German tourists in a black Dodge Charger stood near the highway staring up into the sky at the miles of smoke billowing over the Pacific. To their right were marshes and coastal dunes, an idyllic California scene punctuated by darkness overhead.

10:05 a.m. The longer detour west on the 101 through Camarillo to the fireground proved to be a worthwhile bet, since the only vehicles I encountered past Point Mugu were fire engines and police cars I periodically pulled over for. In the other direction were thousands of cars in gridlock. I stopped to take a few images near spectators watching the smoke drift over PCH and the Pacific as a few stragglers stayed to shoot with their phones. If there were this many cars headed west, what was the scene like for those attempting to flee eastward toward Los Angeles?

Daylight gave way to dark orange which turned car headlights bright as if it was dusk. It was neither light nor dark, instead a rusty pall strangled the cerulean from the sky. The sky was somewhere between chaos and normalcy, fighting the smoke for an early nightfall.

It was like watching a horror movie where you know the protagonist is going to get taken out by the boogie man. In the moment you weren't totally sure what was going to transpire, but you had that gut feeling that shit was about to hit the fan. And like in the horror film, you knew what was going to happen, but you were desperately hoping for some sort of plot twist or miracle that would change the course of reality—at the same time knowing full well the trap was already set.

INTO THE INFERNO

As I passed the miles of cars lined up to escape from Malibu, I drew closer to the base of the pyrocumulus and source of all the smoke. Driving

PCH into Malibu and the Broad Beach–Trancas Canyon area, I saw a wall of fire in the mountains. It appeared to be at least ten miles wide from my vantage point. I was on the other end of the massive cloud of smoke I saw from Oak Park. It was an unstoppable force barreling straight for thousands of homes at the end of the coastal canyon wind funnels. A line of cars was still backed up, evacuating to the west, their headlights amber in the smoke, cars snaking down PCH.

10:21 A.M. PALLEY 301:
On PCH. All of Malibu north of
point mugu will be hit[44]

10:25 a.m. At this point it was a foregone conclusion the fire would burn to the beach and hundreds of structures were in the process of burning or were about to be decimated. I shuddered at the thought of those fleeing the fire in the canyons and feared the worst for those who didn't escape soon enough. I parked my truck on PCH just west of Trancas Canyon and watched the fire move downslope, pushed by winds. Radio traffic continued to indicate chaos in the canyons. Firefighters and civilians alike were forced to shelter in place due to their evacuation routes being cut off by downed power lines and walls of fire.

I ran into a fellow wildfire photographer and we discussed the deadly fire behavior. At this point all fire suppression activities were suspended as the focus of first responders switched to lifesaving only. The words came over the scanner "life safety is a priority," meaning that all units were to prioritize evacuations and protect civilians over saving structures.

I had to make a decision about what canyon I'd commit to. Continued radio traffic indicated many of the major canyons were still impassable, and from my vantage point the flames had not yet reached Trancas Canyon. I decided to head up the hill toward Trancas and dozens of mansions perched above the highway. It would be a gamble to meet the fire front.

As I drove to the top of Trancas Canyon to the edge of a vineyard, a man in his Porsche convertible was standing next to his car,

top down, in a T-shirt and flip-flops, staring at the flames. I politely told him that it wasn't my place to tell him what to do, but that if he stayed here much longer, he was in danger of being immolated by the inferno coming down the canyon. Debris was already landing around the property, and spot fires were beginning to take hold a half mile in front of the flaming front up the canyon. At this point, the fire was about five to ten minutes away from the structures farthest up the canyon. Eventually, he wised up and he left about five minutes later. Deciding to take my own advice, I hightailed it out of the area.

10:59 a.m. Just down the road from the vineyard at the top of Trancas Canyon, I paused to look back and make pictures of homes in the foreground. Out of nowhere, a few horses that had been turned loose trotted down the road, reminiscent of some sort of strange Four Horsemen of the Apocalypse scene. There is something primal and unsettling about a horse being at the scene of chaos, running freely. The same winds pushing the fire rustled the horse's manes, their hair swaying up their necks in the direction of their heads, turned toward the ocean. With the sun blotted out from the sky and all light around me tinged with rust-colored hues, it was uncannily beautiful. Going off instinct, the horses made their way down the hill on their own. At some point, they were probably rescued closer to PCH or taken to the beach for staging.

The Los Angeles County Sheriff's division which handles animal control, local Malibu residents, horse handlers, and others who helped rescue animals and evacuate them during the fire are heroes. They risked their lives to give animals a chance at surviving, and most of them made it to the beach to await evacuation with civilians. The rescued horses were, on the whole, stressed and probably dehydrated, but they were okay. In some cases, sheltering in place was the best option, like at Malibu Wine Safaris. Trying to tranquilize a giraffe would've taken three hours, and with the ample defensible space on their property, the animals were safest staying put.

11:03 a.m. After photographing the horses, I ran back uphill to the vineyard for one last look before the fire blew out of Trancas and

careened into the vineyard. Half a dozen spot fires peppered the periphery of the vineyard. I grabbed my iPhone to take a quick panorama to capture the scale of what was happening. Embers the size of sausages rained down around me, likely burning remnants of trees or homes lifted aloft by winds.

I looked out at the sea of fire burning on both sides of the canyon. Even more spot fires were unleashing all around, the wind rushing like a freight train. Another gust of wind blew leaves, sticks, embers, and hot ash into my face. I took a deep breath, exhaled an audible sigh, turned around, and stepped into my truck to head downhill. The fire would start impacting the area I was standing at within minutes and blow out the top of Trancas Canyon. It wasn't safe to be there, Nomex or not. My trigger point for fire behavior had been reached: it was time to go.

From that vantage point, it was the last time I'd see twenty-two buildings standing in upper Trancas Canyon.

11:09 a.m. The wind was continuing to behave erratically when I decided to take a weather reading, using my Kestrel pocket weather meter. Given the burning conditions, it really wasn't necessary to take this reading due to the obvious fire behavior, but I wanted to document the moment for posterity and for my own ongoing education about critical fire weather conditions. The reading showed the relative humidity at 8.1 percent, which was extremely low and meant very little moisture was in the air, allowing the fire to burn more intensely. Wind speeds measured between twelve and fifteen miles per hour at ground level ahead of fire, with bigger gusts, and certainly much higher winds were aloft directly in front of the fire. The high winds kept pushing more fresh oxygen onto the fire, propelling it forward. While I was taking the weather reading, the column of smoke and fire started rotating as the flaming front approached the wider canyon mouth where homes were.

11:11 a.m. Around the time I took the weather reading, I noticed a black Volkswagen Tiguan SUV with a couple inside coming downhill from the fire front. They paused on the narrow hillside road up Trancas Canyon, windows down, heads craned back looking at the fire

approaching homes. They stopped their car and got out, gazing at the approaching fire. It dawned on me that they had likely just fled from the top of Trancas Canyon. A later interview would reveal they had received no evacuation notice, either via reverse 911 or by authorities knocking on their door.

11:13 a.m. Two minutes after running into the couple, who I later learned were named Jordan and Sara, the first spot fire appeared on the main road to upper Trancas Canyon in front of the homes, again at least half a mile ahead of the main fire. Jordan had his arm around Sara, trying to comfort her. Sara was crying and wondering aloud why firefighters weren't there to help. She collapsed to the ground in a fetal position. Her screams pierced through the sound of the fire approaching, and her shrieks of anguish put me on the verge of tears. This scene is permanently branded into my memory.

Here I was, witnessing someone on the worst day of her life, while tasked to document the fire. While it's my job to tell the story during wildfires, including the emotional shock and trauma that happens to civilians, I still feel like an interloper sometimes, and witnessing someone's pain never gets easier. I had a job to do, and forty million people in California and many more in the world beyond needed to see what was happening in Malibu.

11:16 a.m. I went up to Jordan after making a few photos and tapped him on the shoulder. Like I had previously warned the man with the Porsche, I gently told Jordan that I wasn't in a position to tell him what to do, but that for their own safety they should probably leave now. I also expressed that I was so sorry. They didn't need to risk their lives and be further traumatized by seeing what was about to happen to their neighborhood.

The fire was rotating and exhibiting the most extreme behavior I've seen to this day. The fire front was at the top of Trancas Canyon literally spinning, essentially a slow-moving fire tornado. The column of smoke twisted and curled upward in a circular fashion like a turbine of incineration spooling up. It was a roar with a low frequency that sounded like a freight train.

I only interact with civilians at wildfires when it's an immediate life safety threat. I'm there to tell the story, not interject myself into it. However, with my fire training and fire behavior experience, it would've been negligent *not* to say anything, and should they have been injured, I would've felt partially responsible for not advising them of the danger. During emergencies people affected by disasters can sometimes go into shock, impacting the function of their prefrontal cortex, which impairs advanced reasoning, leading them to make decisions that fly in the face of common sense, if they can even make them. Even mild emotional trauma or shock can cause impaired decision-making in the face of imminent danger.[45] I'd seen it happen to panicked civilians refusing to evacuate at the Rocky Fire in 2015 and at a plethora of other fires.

A lone Los Angeles County Fire engine arrived in Trancas Canyon and tried to douse the spot fire. The crew deployed a hose line off the engine, but the spot fire exploded and roared uphill, so their efforts were futile. The engine captain then screamed "Get out of here!" at Jordan and Sara in a shrill tone that conveyed the crew's frustration and exhaustion. Defeated and in tears, Sara and Jordan sped downhill to safety.

In the moment, I thought of all the years these homes and streets had existed since the last fire, the hundreds of people who lived there, the memories, the thousands of guests, gardeners, handymen, and maids who maintained the property. All of these small moments and stories that took place in these homes, now being immolated by fire.

I felt the burden of memory, of what would soon cease to exist. Compound that with dozens of homes in front of the flaming front, I knew that even with an army of fire engines at each house, defensible space, and robust building codes, the limited power of humankind would yield to the wind, humidity, topography, and ultimately flames. The only silver lining I can find is that eight out of thirty homes survived in upper Trancas Canyon, including Sara's family home.

11:26 a.m. After Jordan and Sara left, the LA County Fire engine abandoned upper Trancas Canyon and headed downhill. I followed them to document their work and stay close to them for safety—I wasn't

taking any chances. The fire was continuing to ignite ahead of itself, with spot fires propagating the blaze. The situation continued to rapidly deteriorate, and the fire was moving faster downhill than I could drive. I did a 360-degree assessment about halfway down Trancas Canyon Road and realized that I had reached my trigger point to completely leave the area and head to the bottom of the hill. The fire spotted on a ridgetop 250 feet from my truck. The flames rose twenty-five feet into the air, showering debris on the road. "Shit!" I exclaimed as I threw my fire pack into the back seat of the truck and slammed the door. It didn't close, so I panicked and slammed it again. It was jammed. No luck. Whatever, it was time to get the hell out of there.

Driving down the hill with my truck beeping from the jammed open door, I realized my hands were shaking and that I was scared shitless. Maybe it was the exhaustion, nerves, dehydration, or shock at what was going on, but my adrenaline was out of control. I stopped toward the bottom of the hill and ran into other photographers and lingering residents fleeing the scene.

11:38 a.m. I was grateful to run into other photographers, talk with them, and be momentarily safe. I was trying to collect my wits when a woman ran down the street with her daughter looking for her husband. She was yelling at the same LA County engine that just got chased downhill by flames. More cars sped downhill, filled with pets, artwork, and personal belongings. The fire was on top of Trancas Canyon Park and moving directly toward streets of homes above PCH.

FIRE ON THE BEACH

11:42 a.m. The sky became dark, and I had to increase the ISO to 1600 on my camera, which is usually reserved for shooting at night or dusk. ISO sensitivity settings increase your ability to take photos in low light. Seeing the fire behavior, I headed even farther downhill to my designated temporary refuge area, or TRA, which was the brick parking lot across the street from Trancas Market near PCH, but still on the eastern side

of PCH in the path of the fire. The parking lot across from the market offered a few hundred feet of clearance on each side. While waiting to cross PCH to the beach I punched out the following message to SoCal Fire Dispatch:

11:46 A.M. PALLEY 301:
Houses gone left and right. Dozens.
Rotating column burning to the
ocean. All of upper Trancas is gone

11:52 a.m. Looking out my truck window, the fire was burning downhill horizontally, like a wave crashing. From three directions the fire was slamming into the houses I'd just seen and the places I'd just stood. I hoped nobody was left at the top of Trancas.

11:53 a.m. Sitting at the TRA in the car with headlights on, a fire whirl or "fire tornado" more than one-hundred-feet high spun uphill from Trancas Market. Based on fire behavior, visibility, and still being at my designated TRA, I decided that it was time to ride this storm out on the beach, which had been the safety zone I designated for a worst-case scenario.

This was the worst-case scenario. This was the big one for Malibu. Today was the day.

It seemed so surreal. I went into autopilot to make pictures based on my previous wildfire photography experiences and kept doing the work. In retrospect, I cannot believe the total shitstorm and how dangerous it was. People were burning to death and losing everything they had as I was making pictures.

TO THE SAFETY ZONE

11:54 a.m. I spotted a gap in traffic and darted across PCH to the Broad Beach safety zone. Decommissioned Black Hawk military helicopters converted for firefighting by Los Angeles County Fire

flew overhead, rattling my car window. It made the area resemble a war zone. Down the street, firefighters were using part of a parking lot off the sand as a helispot to provide helicopters with water. Looking back, I saw a curtain of smoke and fire eastward into the hills from PCH. Where I'd been parked minutes before was now peppered with flame.

12:07 P.M. BABROFF 413:

Fire directly impacting structures in north point mugu down to encinal canyon Life safety threats, Be very aware of erratic fire behavior and column collapse

I don't recall at this point if I still had cell reception or not, and I'm not entirely sure I actually got the text above in the moment—it might have come through later. I pulled into the parking lot for Broad Beach and there were civilians, firefighters, and some journalists taking refuge in the lot. An F-150 Raptor pickup truck was speeding down the beach southward, its bed loaded with paintings and furniture. Birds were flying out of the smoke and landing on the beach, looking just as shaken as we were. I looked back toward the Woolsey Fire and virtually the entire Santa Monica mountain range was on fire.

12:09 p.m. I turned off the truck ignition and stepped out onto the beach. I ran into Malibu residents, Heather and Peter Higgins, and their dog, Sparky. Sparky looked straight up at me and I made a few pictures. The Higgins' motioned that it was okay to pet their dog. I gave Sparky a few pats on the head and some belly rubs. It was suspended reality as Malibu burned and I stood there on the beach, petting this dog. Sparky gave me a moment of calm and sanity amidst the firestorm. All I wanted to do was say, "Fuck it," and drive home. I wanted to quit, thinking to myself, "This is the last fire I ever go to!" What good was a camera when it seemed like the whole world was on fire?

I walked back to my truck from the beach and tried to collect myself. My fire boots dragged heavily in the sand, and I felt sapped of morale and strength. I sent the following text to my friend Ryan, but I don't know when it sent, as cell service was down.

12:21 P.M.

I'm Numb. I'm at Trancas beach lot
taking refuge. Fire is at PCH

I hit "send" on the text, slumped in the driver's seat of my truck, buried my sweat and ash-soaked face in my hands, and cried.

PARADISE LOST

NOV. 8, 2018

10:09 A.M.:
Should I be heading to Butte County?

10:14 A.M. GINO:
Only if you want to be witness
to a tragedy.

ONE WEEK LATER

The search and rescue teams dug through the rubble of the home, hold-ing hand tools, and wearing white hazmat suits, helmets, and respirators to protect from asbestos and other toxic chemicals. They gridded and combed the lot, looking for signs of human remains in the town of Paradise. One of them called out "Tub!" where a handicap grab-handle and stall stood in what had been the bathroom. The home was flagged for a cadaver dog to pass over. The fact that a disabled person may have

lived there made it more likely they'd recover a body. The fire moved so fast that elderly and disabled people were the primary victims. The day before, the team had recovered bodies. They called over their handheld radio to add the lot to the cadaver dog's list of homes to search that day.

Gino was right, I was witness to a tragedy.

The team then spray-painted a neon orange X on the front driveway, with the SAR team and search info. Any burned-out cars also received the X to let other rescuers know if something had already received a primary or secondary search. The El Dorado County SAR volunteer team had their work cut out for them—along with dozens of other groups in CA. There were nearly thirty thousand structures to search. Already dozens of bodies had been recovered: elderly residents in their driveways, a parent and child next to each other in the driver's and passenger seat.

If this sounds graphic and traumatizing, that's because it was. The Camp Fire is what happens when we don't take decisive climate action, and despite evacuation zones, fuel breaks, and fuel mitigation, the ultimate result of building in WUI and fire-prone areas amidst a warming climate. Over ninety percent of the town was destroyed, and Butte County lost one-third of its housing stock in a matter of hours. I listened to radio traffic of bulldozers pushing abandoned cars off the road on Skyline, one of the few escape routes from town. Since-deleted and independently verified YouTube footage shows burned-out cars with skeletons inside.

I was on assignment for *Time*, photographing the aftermath of the deadliest and most destructive wildfire in California history. Barely a year after the Tubbs Fire ripped through Santa Rosa, the ignominious record was already shattered a few hours away. I felt numb. There was no joy in this story. This wasn't a fire. It was a body recovery operation and disaster area. I'd just spent a week covering the Woolsey Fire nonstop and was utterly exhausted.

This was the worst-case scenario we all feared the most—me, firefighters, emergency planners, anyone who'd been paying attention to wildfires, climate change, drought, and forestry management in

California the last few years. It felt like a bad dream and I wanted to wake up. But I owed it to the firefighters and stakeholders I'd spent years documenting to push through this and make pictures. I could deal with the fallout later. If I wanted to be a fire photographer, this was part of the story.

I couldn't pack up and ignore it just because I was still in shock from the Woolsey Fire. I drove up to Paradise after taking a day off from the Woolsey Fire, camping in the Eastern Sierra. It was a strange twenty-four hours between two fires. If the Woolsey Fire was everything I'd prepared for on fire behavior and staying ahead of a major Santa Ana wind fire siege, then the Camp Fire was what I'd try to mentally prepare for in the aftermath. I'd not fully processed the Tubbs Fire aftermath, or even that of the Valley Fire in 2015. Add in the hundreds of individual homes destroyed in smaller blazes over the years, and this was the tragic pinnacle of loss.

VIEW TO TRAGEDY

I drove into the burn area via the Feather River Gorge from the mountains, starting where the defective PG&E power line sparked the blaze, and followed the path of the fire into Paradise. I went around bends above the steep Feather River Gorge and stopped to photograph a burned-out truck overlooking miles of destruction. I passed National Guard Humvees running ID checkpoints outside the fire, then secondary sheriff checkpoints to access the destruction zone. It was still hot, dry, and windy, and the gorge acted as a giant bellows to move the fire onto the butte where Paradise was, with limited evacuation options downhill. As I observed the topography and weather, I imagined the fire barreling through at a deadly clip.

I arrived at the base camp for SAR teams, which was separated from the main fire camp. Hundreds of volunteers from county teams huddled in groups and hushed tones, as a veterinarian checked on the cadaver and search dogs. These people were barely being paid, or not

being paid at all. They were used to looking for individuals lost in the woods, not hundreds of missing and potentially dead people. The parking lot for staging was a shuttered bowling alley next to a hotel. The scene felt postapocalyptic. I embedded with the El Dorado County SAR and joined them as they searched. El Dorado SAR volunteer member Marijke Ellert, a farrier (horseshoe specialist), who I photographed later said of the process:

"You go to a house, you check to see if there are cars in the driveway because that's going to give you a clue as to whether or not somebody might have still been in the house. And so you go in, you see there's cars in the driveway, you check the cars, then you go in the house and try to find a high probability area where there might be a victim. Beds were a big one, bathtubs, shower stalls—and just go through each of those places and hopefully not find anything."

This is why the team flagged the handicapped bathtubs. Paradise was also a town with many retirees due to its rural nature and lower cost of living. So when the fire hit, many disabled people weren't able to quickly leave, and they formed the bulk of victims.[46]

As the team carried on looking through homes, we heard a dull whine. Off in the distance downhill from the house, in a muddy creek bottom, was an orange tabby cat, disheveled, covered in mud, with a severely injured and burned leg. Marijke and her colleagues chased the cat through the woods, and eventually wrangled it. The cat cried out in pain, scratching and biting, scared of the rescuers. Eventually, they were able to bring the cat to the road, and a volunteer humane society driver was able to take it to the vet. We weren't sure what happened to the cat— it probably needed to have its leg amputated. It was badly burned and infected, eights days after being out there without much food or water.

Driving through town, the scene was all loss. A burned-out church, a pile of twisted metal and smoke, aside from the baptismal pool, which was made of tile. A scorched business on the main street was gone, but a carved wooden bear sign that said, "Welcome to Bearadise," was somehow still standing. A stark reminder of how capricious fire can be during an urban firestorm. Everyday life was gone; there was no life.

Continuing in town, I came across both homes and cars taped off with POLICE LINE DO NOT CROSS tape stretched across the area. These were active crime scenes where the Butte County Sheriff found bodies. The cause of the fire was still under investigation, so each body recovery site was part of the crime scene. I eventually left town to find a tiny bit of fire still burning out in the woods. I found USFS hotshots and Cal Fire crews with bulldozers working the last few parts of uncontained fire line. I scouted down a road to see a smidge of backing fire, the last active part of the Camp Fire. What had been a deadly behemoth was now a small blaze. It was cruel and ironic that these burning shrubs and a single torching tree symbolized so much damage.

On the last day of the fire, I attended the morning briefing at the Butte County fairgrounds in Chico and listened to legendary Cal Fire FBAN (Fire Behavior Analyst) Tim Chavez speak about fuel conditions on the fireground. While rains were expected in the coming days, it was almost Thanksgiving and fuels were parched from months of no rain. Chavez said: "The fuels are the driest they've ever been." The message was the fire could flare up at any time and was still dangerous. That explained why the Camp Fire burned so fast on the first day. Dry fuel, wind, and slope.

As I started to make my way out of the fire, the Walmart parking lot in Chico was full of evacuees—the latest climate refugees in California. Dozens of vehicles and trailers formed an ad hoc camp of newly houseless residents with nowhere else to go. It was gut-wrenching. As the sun set and a full moon came up, I drove past more burned cars on my way up to the fire. It was two days before Thanksgiving, and time to head home. On the drive back it started raining over the Camp Fire, and the season mercifully came to a close. I was grateful for my physical health and safety, but my heart and emotional state were shattered.

FALLOUT

If I could face them
If I could make amends with all my shadows
I'd bow my head and welcome them
But I feel it burning
Like when the winter wind
Stops my breathing

It was six in the morning in December, a month after the Woolsey and Camp Fires, as I sat splayed out, crying in the back of a Lyft headed to LAX. I tried to keep it stealthy so the driver wouldn't notice. I had the cover of predawn darkness and the hum of the 105 freeway to shelter me as I sat in self-imposed emotional hiding.

In the stop-and-go traffic, I read *The Lorax* by Dr. Seuss in the half-awake state of early morning travel. To me, *The Lorax* is an allegory for our current climate crisis. I was on my way to Montana for snow, cold, and all things *not* wildfire related. It was only two weeks after coming home from the Woolsey Fire and the aftermath of the Camp Fire in Paradise. I'd spent a week photographing the end of the Woolsey Fire and the last days of the Camp Fire.

My therapist had said that my emotional reckoning would be delayed and come in waves when I least expected it. The wave that hit

me in the back of that car was a surprise, and the seemingly innocuous words of Dr. Seuss were the trigger that sent the water crashing over me.

In the midst of wiping away tears and trying not to sniffle loudly, I felt for the future of the planet and its people. I thought of the changing climate, the dead in Paradise, the dead in Malibu, the wildland firefighters we lost in 2018 and years before. I wept for the forest ecosystems altered, for future generations, and for the sum of anguish and vicarious trauma I'd seen on the fire line. From demoralized fire crews to families watching their homes burn down to dead pets on the sidewalk, it all came in a deluge.

I wish we had emotional storm drains to let the trauma rush out neatly. If there was a way of controlling and walling off these feelings, a way to be in control of when and where we process them. And in facing those specters a clean voyage out to sea and off my conscience. But the reality is messy, and the mud- and silt-laden water gets all over the place, and when it recedes, the trauma leaves behind a permanent watermark on your soul.

The camera is not a shield. The high watermark left behind reminds you of what you witnessed, went through, and it should be left there as a testament to your strength and resilience. Feeling pain, shame, survivor's guilt, is nothing to be afraid of or to apologize for. It's admitting our mortality and vulnerability in a very open and honest way. And owning that is powerful.

Thankfully, the stigma attached to emotional trauma and PTSD in the fire world is fast fading away, and I hope that trend continues. Every firefighter or civilian who shares their story of trauma, on their own time and terms, is another voice destigmatizing healthy attention to our mental and emotional well-being.

While the trauma of the Woolsey and Camp Fires was acute, the cumulative effects of seeing dozens of destructive wildfires prior to the 2018 season made my own reckoning that much harder. My breakdown in the Lyft was simply when the emotions finally came out. I allowed myself a chance to start grieving. The destruction and stratified trauma came due. The years of fire after fire from Granite Mountain to

Paradise heaped on. The anger, anxiety, and lashing out started as soon as I drove home from the Camp Fire, however.

REALITY ADJUSTMENT

I got home the day before Thanksgiving from the Camp Fire. I tried to drive all the way through but couldn't make it, my eyelids drooping at the nonstop onslaught of opposing headlights. I crashed at a cheap motel off Interstate 5, somewhere in the Central Valley. The next morning, I grabbed coffee from a roadside Starbucks, and the store was packed to the gills with holiday travelers. I was overwhelmed in an instant, angry almost, at the coffee shop being so crowded. I grumpily waded my way through to the pickup counter, grabbed my stuff, and got the hell out of there. "Damn, screw all these people!" I was cranky for no reason, or so I thought. I made it home that afternoon, grateful to be safe but thoroughly exhausted, both physically and mentally.

That night at family dinner, I started talking to my sister, who was seated next to me, about the burned cat at the Camp Fire. My family was repulsed by the graphic description. I didn't even realize that maybe it wasn't an appropriate dinner table conversation. It simply didn't cross my mind. My sister was understandably upset. I was still completely "switched on" and in fire mode. I didn't even realize. It felt unreal being back in coastal Orange County in a nice home that was still standing with electricity and clear skies and normalcy after the shit I'd just seen. "Nobody will ever understand unless they were there," I thought.

After dinner my brother and sister and I went to a bar that was packed for Thanksgiving. I saw the line and had to go home, completely overloaded and anxious. I couldn't even stand outside to make small talk with old friends in line. I left and was in bed by 10:00 p.m. I couldn't switch my mind off, and I was breaking into fits of coughing. At some point I drifted off into a deep slumber but awoke Thanksgiving Day still feeling listless and fatigued.

My family went out to Thanksgiving dinner at a local country

club. The family dynamic, combined with holiday niceties, was something I was not prepared to handle. The fires were still very much in the news and on the national consciousness. Between the president's Paradise visit and ongoing media coverage, it was a topic of discussion at the table and among people stopping by to chat. Amidst the luxury and privilege, I was sitting there feeling anxious and overwhelmed. I hadn't even talked to anyone yet, and I hoped I was invisible. The smell of smoke still clung to my sinuses.

A family friend came up to the table. During the course of the conversation, he turned to me and said, "Bull market for fires, huh?" All I could muster was a fake smile as images of burned cats, smoldering homes, and Camp Fire refugees getting rained on in the Walmart parking lot danced around in my head. I could've lunged across the table and stabbed him with a butter knife if I hadn't been feeling so broken inside. The opulence of the setting added to my feeling of being adrift.

For the next week after Thanksgiving, I stayed in my room with the curtains drawn and the lights out. I got up to workout and eat, and spent some time doing follow-up writing and interviews, but I was primarily lounging in bed and depressed. I needed to shut off the world and embrace the darkness and silence. Stimulus of any kind was too much. Texts, phone calls, plans: I just couldn't do it. Trying to schedule anything was overwhelming.

As I spent the days resting, I eventually saw my therapist. During the course of our conversation, I realized that my cup of emotional trauma, so to speak, had overfilled. The cumulative effect of photographing destructive wildfires for six years had caught up with me. It had begun to spill over in 2017 during and after the Wine Country Fire Siege and Thomas Fires, but the quiet winter gave me *some* distance and recovery from that. However, the trauma was still there, unresolved.

Every house I watched burn down, every dead animal, every warped pile of steel and puddle of melted aluminum that had been a car, caught up to me. The evacuations, frantic radio calls, civilians in parking lots sleeping in their cars, the nightmares of burning to death—it all came to a head.

With the Woolsey and the Camp Fires, it was like spraying a hose of water into an already full bucket, there was nowhere for it to go but spilling out over the edges. In the weeks and months after November 2018, I realized I was seeing a glimpse of what first responders experience daily. For wildland firefighters, those effects were particularly acute after the 2017 and 2018 seasons. What I dealt with paled in comparison. The silver lining is it gave me a glimpse, however small, into what first responders regularly encounter by keeping the rest of us safe.

THE FIRST RESPONDERS

Scott Upton was the North Ops Chief for Cal Fire, who grew up in the town of Paradise, and lost his childhood home to the Camp Fire, feels similarly about successive trauma as a first responder.

"Things like that traffic incident, the structure fire responding to Paradise, it's a culmination of things. And it just, you know, there's a certain—at a certain point you get where you're emotional, the capacity is filled and you have to take a step back. It's just PTSD." That traffic accident could be a particularly bad accident one responds to, or just the piling up of hundreds over the years.

Chief Upton is a thirty-plus-year veteran of Cal Fire, and retired shortly after the Camp Fire leveled his hometown. As North Ops chief he reported directly to Ken Pimlott, Chief of Cal Fire through December of 2018. Chief Upton was responsible for the northern swath of California that was the responsibility of Cal Fire during the 2017 and 2018 fire sieges.

The retirement timing coincided with the end of California Governor Jerry Brown's term and that of Chief Ken Pimlott, but the timing also seems appropriate for both men to have handed the reins off to the next generation of young firefighters. When I sat down with Scott and his wife Janet Upton, a former Cal Fire chief PIO, they were enjoying travel to baseball spring training in Arizona and going to Giants games. But you could see the recent fire seasons weighed heavily on them.

These were their roots being pulled up, their family and friends' homes being evacuated and destroyed.

With this in mind, Scott said of his fellow firefighters, "I'm worried a lot about the mental health of our people. I mean, it's just a struggle if you can imagine seeing people burn up in their cars. I mean, having to push cars out of the way with your pickup, so you can get other people out. It's like war."

I remember listening to the radio traffic the morning of the Camp Fire and hearing orders being given to use bulldozers to clear burned cars off the southerly evacuation routes from Paradise. It was harrowing enough just listening to it; being there is another level of nearly inconceivable terror, even for the most hardened firefighter. It was like Gino said in his morning text the November day it started: "tragedy."

One simply does not return home. Paradise looked like a warzone, and for most residents, there was no home left. When I was in town a week after the fire front burned through, hundreds of cars still lined the roads and empty lots in town were filled with wrecked vehicles towed out of the way and left for removal.[47]

In the face of colliding personal and professional trauma, the capacity for even the most toughened firefighters to accommodate it is overwhelmed. Scott Upton lost his childhood home in Paradise. First responders across the state lost their homes in a slew of blazes too. Add in previous long fire seasons and it's just too much.

The candidness of firefighters like Janet and Scott Upton and the need to process the overwhelming psychological weight of these fires have caused a much-needed shift in the fire service's thinking on mental health awareness and encouragement of wellness, at least in California.

Scott sums it up: "It seems that there's been a shift in acknowledging some of the things that are seen on the job . . . It's more acceptable for bosses to be able to say, 'Yeah, you need to go get some help or they need to get some help themselves.'"

These conversations are increasingly out in the open, and it's part of an important effort to destigmatize mental health issues and increase awareness on a broader societal level. If we hurt our shoulder, we go to

the doctor and rehab it. If our minds and souls are traumatized, why wouldn't we prescribe what's needed to heal? Those who risk their lives daily should never have to feel shame for asking for help.

During a 2019 wildfire conference in San Bernardino, former Cal Fire Riverside chief John Hawkins echoed the sentiment. Chief Hawkins had just retired and was giving an impromptu speech that was as much a retirement celebration as a poignant reflection on a model firefighting career. He was open about seeking counseling for the trauma he'd witnessed in his fifty-year fire career, from young firefighter to incident commander at the 2003 Cedar Fire, to being the one to knock on the door of the home of a fallen firefighter to tell their family.[48] It was heartening to see such a respected public servant and adept leader speak to an audience of influential chiefs, peers, and rank-and-file firefighters of such a need for mental health awareness. He finished his presentation to a standing ovation. It was clear the hundreds of attendees recognized this and, coming from such a respected figure, was humbling to witness. As an outsider looking in, it was a small yet watershed moment that we are headed in the right direction.

As a society we owe it to first responders to support them. A silver lining to the tragedy is it forces trauma, compassion fatigue, climate anxiety, and ultimately PTSD to the forefront of the national conversation around climate issues.

ON THE FRONTLINE

Kings River Hotshot Steven Flores, who faced tough firefighting conditions and intense emotional fallout from working at the same fire for nearly a month during two separate fatalities, experienced acute anxiety and stress on the frontlines. Of the Ferguson Fire he said, "That fire was fun and exciting, but I think the stress level was close to when we found out about Granite Mountain." Granite Mountain is compared to 9/11 by wildland firefighters in terms of how much it shocked the wildfire

world. The crew was working with the specter of two of their colleagues dead at the Ferguson. Having my own safety issues with snags, I cannot begin to imagine the danger of hiking deep into the burn area among them. Flores said at the fire (Note: A "forty-two inch pondo" refers to a three-and-a-half-foot wide ponderosa pine.):

"I was almost a statistic from a tree I was falling. I remember I was on my back cut on a tree that was probably about a forty-two-inch pondo and when it started to go, and a limb fell right next to me on my escape route from the tree. That spooked me big time."

Combine tough terrain, the weight of a local fire in your backyard, the deaths of two firefighters, and your own close calls, and the stress adds up. It's not just one factor that causes overload. It's the constant stress of incidents day in and day out. Imagine if two of your coworkers died in a month. They knew your friends, and they died under similar working conditions that you were in. Then one day at work, the same thing happens to you, but you just got lucky. How does that weigh on your own sense of mortality?

A GRASSROOTS MOVEMENT

During the summer of 2020, there was an open letter written to the USFS about wildland firefighters' long-term mental and physical health. The Grassroots Wildland Firefighters Committee is the effort of current and former wildland firefighters to advocate for themselves in the US Forest Service and other federally funded agencies for better pay, mental health, and career support.[49] They forced the issue of lower federal pay and benefits into the open. Wildland firefighters for decades fought for this support, but more extreme fire seasons wrought by climate change have created a critical inflection point.

The main contention point is that US Forest Service wildland firefighters are actually classified as "forestry technicians," an outdated term, and not "firefighters." While official federal sources often refer to forestry techs as "first responders" or "firefighters," their pay and

benefits reflect neither. Crew fatalities and suicides from depression and PTSD are also primary concerns. With brutal fire seasons, it's a cauldron of problems bubbling over.

Wildland firefighters often work a full year's worth of hours in just a handful of months. It's not uncommon to work fifteen hundred hours in four to five months, which equates to approximately sixteen-hour days, with a quick forty-eight hours off. Seasonal employees with the Forest Service and other federal agencies earn a year's worth of pay in just months, but it has further effects.

Luke Mayfield, a wildfire veteran, and former hotshot says: "After a yearly work total in five to six months, and people are done, burned out. They need to recuperate. They need to rehab. They need to be a family member, a husband. They need to see their family, their friends."

Aaron Humphrey was the superintendent of the El Dorado Hotshots in Placerville, California. I spent time with him on the fire line. In an open letter he penned on leaving the Forest Service in 2019, Humphrey addressed the emotional and mental health effects that stack up: "The longer you do this job, especially being a hotshot (or IMT member) ensures you will be involved in or will be affected by fatalities or serious injuries. The amount of shifts, miles driven and hiked under burning trees and rolling rocks."

This piles up, season after season, incident after incident. After being at the Ferguson Fire postfatality and being at the Thomas Fire the same day a firefighter fatality occurred, I felt the eerie echoes of Aaron's words about being maxed out all too clearly. "The more you take on without realizing all of the impacts each incident has the longer you stay in the redline. Each incident adding up."[50]

Aaron is talking about one's emotional tank being full. We get to a certain point and it just overflows, and sometimes that overflow takes the form of coping in various ways. Aaron survived a burnover at a fire and oversaw a crew of twenty firefighters. Those are heavy burdens to hold and continue to perform under. With worsening wildfires, firefighters with many years of experience simply didn't have enough left in the emotional gas tank to process the fires in a healthy way. And

this is no fault of their own, as we see this happening across the first responder world.

"Then our fire seasons really started throwing havoc and destruction at us. For me the LNU fires then the big Napa fires really added a new level I wouldn't come back from fully."

There it is. The 2017 fire seasons and beyond threw us into a new era of megafires. The destruction, death, scale. One fire I didn't photograph was the 2018 Carr Fire in Redding, which killed firefighters and civilians as a fire tornado developed with EF3 strength winds of over 136 miles per hour.[51] [52] One of El Dorado's crew bosses, and Aaron's successor as superintendent, Ben Strahan, told me of the Carr Fire: "After the Carr Fire, I for sure wanted to stop doing this job. You know, you kind of look at your life and go man, all this risk and exposure and trying to make sure everybody's doing the right thing so they don't get hurt. And you start, you start contemplating, man. I don't know if I'm getting compensated enough to be doing this. Like what am I doing out here? And so you start to question your life . . ."

We can't have our first responders worrying about pay and benefits. They are asked to do so much, the least we can do in return is take care of them. Seeing this fallout time and time again postfire, regardless of the department, shows that this is an issue that civilians affected by wildfire need to take seriously. It affects all of us.

But there's hope. Mental health continues to be destigmatized in first-responder culture, as Chief Hawkins bravely helped to do, and we are seeing movements to take care of wildland firefighters. Ben went through dark moments with Aaron, and I shared some of those fires with the crew at the Atlas and Thomas Fires. So when they share the feeling of being there, I can understand. Perhaps not fully, but I feel it.

"Through those really dark, crazy moments, if you have a good support system and you have the tools to be able to process what is going and what has happened to you, can have tremendous growth and come up on the other side a better person."

Ben outlines the key point of support and tools to move forward. If we don't allow first responders to process trauma, which includes time

off, mental health resources like therapists and counselors, then that emotional trauma piles up and pours out in unhealthy ways. And those intense moments where your life is on the line, you can create close bonds with the crew and make individuals stronger and more resilient, but the support network needs to be there. Without support, we see PTSD, higher divorce rates, increased suicides, and substance abuse. And just as concerning is the effect these fires also have on civilians and those connected to or touched by wildfire.

TWENTY-FIVE

RIPPLE EFFECTS

THE FALLOUT RIPPLES OUTWARD

Stress during climate catastrophes spills over to civilians, support personnel, and journalists. Virtually anyone who experiences a large and destructive wildfire is affected. This includes search and rescue (SAR) team members, law enforcement evacuating civilians, and specialized media that cover wildfires. Fire impacts everyone involved. Even those who are nearby and evacuated without loss are affected by smoke, loss of income, and kids missing school. There are second- and third-order effects that ripple through and rip into a community.

On the El Dorado County SAR team, volunteers like Marijke Ellert answered the call to search for human remains in Paradise. She was part of a team gridding houses that I photographed. The crew was used to looking for lost hikers in the woods and helping with individual technical rescues in remote areas. While they trained for earthquake disaster recovery, the scale of destruction in Paradise was something entirely different. In order to focus on work, Marijke said that you have to "switch off the part of your brain that sort of lets everything in and you just focus on what you're doing, and everything just becomes methodical and you just go through the steps."

This is consistent with firefighters and photographers too—you

focus on the task at hand in the present moment. You keep yourself busy, and when you're not working, you're eating, resting, or rehabbing gear. With long days, there isn't time to think about the emotional trauma you're witnessing, and you push that back for later. Except after the incident, you're thrust back into regular life, and it's easy to bury those emotions if you don't give yourself time and space to process. Marijke said: "The post-traumatic stress for myself was just how difficult the breathing was there. I mean, I can't even, like, I don't even like putting a respirator on for work now because it takes me back to being there, and you know, obviously there were things that you saw that were so much worse than, you know, smoky air, but it just, it's, it's that culmination of everything."

Days of wearing a respirator to protect yourself from toxic chemicals, day after day, house after house of searching: it's not one specific event that causes trauma. It's multiple traumas over time, one house after another, another victim, another dead pet. Trauma is cumulative when not processed. And even when it is, one still needs to be aware of the immediate and long-term effects on mental health. I made a photo of Marijke searching a home where she paused amid the rubble, respirator on. In her El Dorado SAR helmet and white coveralls, you could see the impact of the scene in her eyes. It was a quiet and poignant moment. All of these SAR team members were volunteers, witnessing the same thing as full-time first responders. Marijke said: "I think some of the stuff that was most difficult for our team was the animals because you know, they're innocent and so many were trapped and had nowhere to go."

The scene where Marijke was carrying out the injured orange cat with her fellow volunteers broke my heart. It was one of the toughest moments at the Camp Fire. After a week of Woolsey Fire destruction and wildfire aftermath, on top of the Ferguson Fire losses and the 2017 season megablazes, it was the straw that broke the camel's back. It was a point at which my ability to process vicarious trauma from documenting the scenes started to break down. Marijke said: "Paradise was terrible, and it was awful and I hope to never have to deal with

something like that again. But if it did, I would go in a heartbeat. One hundred percent, I would go."

Despite the impacts, Marijke brought a selfless attitude to public service, but not everyone involved at the fire did so, and it made things worse. In the days after the team demobilized, former President Trump toured the area, shortly after suggesting firefighters "rake the forest" on Twitter. It added insult to injury, and it was clear to me who the real public servants were—and it wasn't the president. A SoCal-based fire captain said of the president's response: "I was on the Camp Fire when Trump visited. I could not have been more disappointed in him." I'd met the firefighter at the Ferguson while hiking on a steep smoky portion of fire line putting out embers and spots.

The administration disrespected civilian victims, firefighters, and SAR team members after 2018 too. In August 2020, a former senior DHS official confirmed what many Californians already knew that the president, "told us to stop giving money to people whose houses had burned down from a wildfire because he was so rageful that people in the state of California didn't support him . . ." In the months after the Camp Fire, President Trump also tweeted on November 3, 2019: "Every year, as the fire's rage & California burns, it is the same thing—and then he comes to the Federal Government for $$$. No More." Fact check: Until 2019, California sent more money to the federal government than it received in aid, in prior years receiving as little back as seventy-eight cents on the dollar.[53]

What was "no more" supposed to mean? It was a tacit admission that he was punishing California for not voting for him in the Electoral College during the 2016 election. Fast forward to January 9, 2020, where he said: "Billions of dollars are sent to the State of California for Forest fires that, with proper Forrest Management, would never happen. Unless they get their act together, which is unlikely. I have ordered FEMA to send no more money."

It is clear the president didn't know much about wildfires, was committing human rights violations against his own citizens (the right to housing), and didn't know how to spell. This was hardly surprising

after years of divisive, racist, and climate-denying rhetoric, but it felt personal. To walk through ruins of fire where people had died and then to say that was heartless. I needed to process that righteous frustration after the Camp Fire.

CIVILIANS

For Masao Barrows, the wildfire evacuee from the Woolsey Fire, the fallout also lasted well beyond the fire's containment. Imagine being roused from bed in the middle of the night, with your house on fire. After waking in the dead of the night, Masao said: "I felt helpless and the only thing I was able to do was get ahold of my daughter and her mom and warn them . . . I hope I never have to deal with this again, you know, ever again."

After surviving the fire and fleeing only with his keys in his pajamas, Masao began to navigate the complex patchwork of local, state, and federal aid for financial impact from the fire. His trailer with his tools was destroyed. As a carpenter, this hit his business hard. Then his landlord asked them to move out less than two months after the trauma.

"I had to move out by Christmas Day, which was extremely tough for me because I wasn't prepared and I had to find a place and I had to get storage, so it was extra, extra tough, especially with the Borderline shooting that just happened."

Masao experienced acute trauma, lost thousands of dollars in carpentry tools, and then was forced to move. As a Thousand Oaks resident, the Borderline Bar and Grill shooting was also weighing heavily on him. "The fire really took a lot out of me," he said. "It just kicked me down into the dirt . . . This scar is still there."

Masao recounted how whenever he'd get a report of a fire, or even see smoke, it would bring back memories for him. He reacted quickly in light of what he'd just experienced. He went on to share, "This fire was like a storm and it was scary. I mean I'm a tough guy, but this one was different."

Fire is an equalizer in this way. Fire can knock you down and catch you off guard. When we spoke months after the fire, Masao was back at work, staying busy as a contractor and doing carpentry work. But he ended up not filing a FEMA claim for his tools and had to replace them all out of pocket. It pains me that his business was hit so hard, through no fault of his own.

Masao's story and experience was repeated thousands of times over in November of 2018 and beyond. Civilians awoke in the middle of the night, their houses on fire. Losing everything or part of their business, never to be made whole by the combination of insurance, Cal OES grants, SBA loans, and FEMA grants. One wonders how much impact the Trump administration's attitude toward California had on fire victims' ability to receive help. Hours after Masao's dramatic escape from his home, more residents in the path of the Woolsey Fire would be traumatized as they fled for their lives.

JORDAN POPE

Eight hours after Masao fled his home, I stood on Upper Trancas Canyon Road with Malibu resident Sara Daoud and her then-boyfriend, Jordan Pope, after they evacuated their home. I met with Jordan at a cafe in Anaheim Hills to discuss our shared experience after the fire. That cafe was also just down the street from the Canyon I Fire in 2017.

Jordan was a psychology student and offered a poignant, philosophical perspective on the Woolsey Fire. He explained that he was hospitalized and treated for smoke inhalation affecting his pulmonary system. This is a consistent issue with fires in CA. The reduced air quality becomes hazardous for sensitive groups with asthma and other respiratory conditions that are exacerbated by poor air quality. In 2020, Stanford researchers said the extreme wildfires may have contributed to the premature deaths of over one thousand civilians that year.[54]

Jordan and Sara eventually went their separate ways after the blaze and broke up. While Jordan doesn't solely attribute the fire to the

breakup, he said the "additional stresses on the relationship" impacted the success of their dating.

This was a similar observation to wildland firefighters I'd spoken with over the years. While fire and the trauma from it may not be the sole reason for relationship troubles, it can be a catalyst that causes the dissolution of marriages and dating. Then there are the family impacts and day-to-day life issues.

Jordan eventually took time to process what he'd seen and moved to Utah to finish school. He credits the fire with changing the direction of his life, and in some ways for the better. Both Masao and Jordan were displaced due to the Woolsey Fire and ended up moving. Could we consider these people climate refugees, even if only temporarily? When we look at those who lost houses in Paradise, many residents left the area permanently.

For example, the average renter paid approximately $2,500 a month in rent in Los Angeles County in November 2018, when the national average was closer to $1,250 nationwide.[55] How many non-homeowner residents had $5,000 cash laying around after a disaster, while waiting for renter's insurance (if they even had it), to move? Let alone replace their belongings and get back on their feet.

IT AFFECTS MEDIA TOO

My friend, multidisciplinary artist Jeff Frost, spent six fire seasons documenting wildfires via time-lapse for his film, *California on Fire*. He says of the effect of blazes on him: "On the human end it just seemed like, you know, I saw many mansions burn down, many middle-class homes, many lower-class homes, like trailer parks. And it just seems like, you know, fire respects no religion, no prayer, no class . . . Fire doesn't give a fuck what you think."

Jeff perfectly summed up with his own colorful language how fire does what fire wants. Over the summers I covered fire, the blazes marched along their own path, taking whatever houses were in the way.

Rigorous debate exists in the fire and journalism world about allocation of fire resources and the politics of protecting wealthier, higher-value neighborhoods, and it does have some merit to it. *However*, in the case of the Camp, Woolsey, and other fires, resources were stretched thin. Entire neighborhoods simply couldn't get a large enough response due to the fire's speed.

At smaller fires, the opposite can happen. The responses can be so massive and robust that losses were mostly down to home placement and defensible space. But there's also a middle ground where firefighters need to triage homes, and in my personal experience, it's more about the defensibility and ability to save the home, versus its potential value. Regardless of the home being impacted, witnessing and photographing that loss affected Jeff, and it affected me similarly.

I would have the same waves of frustration Jeff experienced after fires. Small things would set me off. My fuse became short and narrow. A slow driver, a website not loading, or the mail being delivered late. It was like the Dr. Seuss book setting me off in the Lyft on the way to LAX before sunrise. At fires Jeff said: "I'd find myself at fires driving through these hellscapes with houses burning down. And it just didn't register at all emotionally. I just completely flat-lined or I would blast the stereo and be like, this is all right."

As Jeff explained this during one of our many post-fire season chats, I was struck by the similarities between his experience and that of Marijke. They were both focused on their jobs, one doing recovery work post fire, the other documenting the active flames. But they both dug into the work and encountered the fallout afterward.

Jeff and I both encountered compassion fatigue during and after the fires too. It was part of the coping mechanism.

"The beginnings of PTSD, which is what compassion fatigue is, is definitely not as serious as full-blown PTSD . . . [but] even that can completely cripple you in terms of depression."

Jeff was right. As humans in the twenty-four-hour news cycle, our minds did not develop to handle the influx of daily news in these modern times, amidst all the intense trauma we witnessed firsthand.

It's overwhelming for the mind to process. It explains why making the burned cat comment to my sister at family dinner in the aftermath of the Camp Fire was so lacking in empathy, which was unusual for me. It was compassion fatigue. I had to remove myself from the feelings in the short term at fires to focus on my photographic work.

After the 2018 season, part of my own catharsis for processing the wildfire vicarious trauma was getting on the road, working through my emotions while exploring the backroads of the West, and just living life. Getting back to the basics like I did in 2016 when I was trying to find balance after chasing fires intensely. Part of that was a pilgrimage to pay my respects and learn where major wildfire burnovers happened across the American West.

THE PULASKI PILGRIMAGE, OR GHOSTS IN THE GULCH

In June, I took a boat out to Mann Gulch and hiked to the ridgetop where a group of smoke jumpers lost their lives seventy years ago. Walking their last footsteps decades later gave me an appreciation for the conditions they faced. At best Mann Gulch is inhospitable, with steep ridges, minimal tree cover to shelter from the hot and dry Montana summer sun, loaded with ticks in the gullies, and whipped by ridgetop winds on either side. A deer kill on the trail made me grateful for my bear spray, and the intermittent clouds lessened the heat. Vultures perched on a dead tree on the boat ride in. The scene was grim.

What is lacking when it comes to a comfortable hike is made up for by the view and solitude of the wilderness area. If it weren't for the weathered stone crosses on the hill, marking where the men fell one by one as they scrambled to the ridgetop, you'd never know the smoke-jumpers tried to race for their lives in a struggle most would lose. I followed the same path they did, trying to beat the clock in "the race," as Norman Maclean put it in *Young Men and Fire*. I lost.

Despite being in decent shape, I huffed and puffed my way up the ridge but couldn't hack it. I probably would've been overtaken by fire

in 1949, just a few hundred feet from safety over the sheltered side of the ridge. Each cross marked where the men had fallen. Passing each one I felt a sense of place and history, a solo hike tempered by the ghosts of fatal wildfires past. Each gust of wind carried with it a whisper from those departed souls.

Once I made it to the top, I took in the vista of the Gates of the Mountains Wilderness. I could see down to the Missouri River, over to Helena, and off into rugged and wild country. The trail itself was a simple footpath, with tall grass revealing the minimal foot traffic. I saw nobody for four hours.

Walking the trail back to the beach, I contemplated the historic fire behavior and lessons we've learned (or not) since then. Burned tree trunks from recent fires dotted the trail, a reminder that Mann Gulch is a place to visit but where we cannot stay.

Waiting at the river, a tour boat came by with a loudspeaker blaring about Mann Gulch, snapping me back to human interaction. Summer tourists leisurely took in the trailhead of the Gulch from the water, shielded from the actual site by the rocky and steep hills inside the river canyon, separated from feeling the full weight of the place.

The tour cruise departed, and I sat on the bank taking in the ospreys soaring above the vertical cliffs across the river. No sooner had I put my pack down to water up, the boatman appeared to take me down the river back to civilization.

I bid a silent farewell to Mann Gulch and the souls that haunt its hillside.

THE PULASKI PILGRIMAGE

The pilgrimage to the Pulaski Tunnel was nearly the opposite of the one to Mann Gulch a few days later. Leaving Missoula in the late afternoon, I headed west on the interstate into the Rocky Mountains, leaving Montana amid a summer thunderstorm. I made my way into the Idaho panhandle as the altitude got higher and the sky grew darker. By dusk it

was pouring rain and the temperature had dropped twenty-five degrees. The rain was relentless, and I was grateful to arrive in Wallace, Idaho late in the evening just as the water stopped falling.

Coming into town, I was strung out from the long drive. Compounding the strange feeling was the town itself, seemingly lost in a time warp from one hundred years ago. Brick buildings dotted the main streets, and neon signs for motels and bars were reflected in puddles on every corner. A sign for the bordello museum advertised tours during the day. Mist hung over the mountains surrounding the town in the narrow valley as the deep blue of late dusk faded into black. It reminded me of the mountains of West Virginia.

I felt transported back into the early twentieth century. Minus the weather, it could've been the town that fateful summer night during 1910, hours before the Big Blowup began. I walked into one of three bars in town and ran into the local historian and her friend visiting from Avery, a town of twenty-five people.

The Big Blowup Fires from August 1910 were conflagrations across Idaho and Montana and are considered the genesis of the modern US Forest Service. The standard fire-tool, the Pulaski, was named after ranger Ed Pulaski who saved half of his crew from certain death in a doomed tunnel outside of Wallace, Idaho. Five men perished from oxygen deprivation and smoke inhalation as the fire burned over the tunnel entrance, and legend has it that Pulaski forced the ragtag crew to shelter in the tunnel at gunpoint. The entire crew passed out when the fire front blew over and burned the mountain town of Wallace mostly to the ground a few miles away. Thirty-nine men would survive to hike out of the tunnel. An estimated three million acres were burned during the Big Blowup as a series of fires wracked the dry Northern Rockies forest. And now 110 years later, I was standing on a street corner in downtown Wallace just a few miles from that tunnel.

The trailhead to the Pulaski Tunnel was crowded compared to Mann Gulch. There was one spot in the parking lot and early morning hikers were already coming off the trail as I got my pack together. It was humid, misty, and drizzling rain. Instead of the barren hillside in

the hot sun, the trail was shaded with heavy vegetation, mossy rocks, and a creek full of fresh snowmelt with fairly high water. I ran into at least a dozen other hikers on the trail, a far cry from the solitude of Mann Gulch.

The trail was well-groomed and maintained, with wooden footbridges, explanatory signs, and mile markers. Tall trees festooned the hillsides on either side of the canyon, and dead and down trees, fallen down the ridges, crossed over the creek. Jagged boulders covered in moss and ferns adorned the trailside, fed by runoff.

The rain switched on and off as I hiked the gentle incline to the tunnel. The density of the fuels was apparent, in addition to many ladder fuels. Trees had since grown back in the 109 years since the Big Blowup. The creek was full of early summer snowmelt. As the trail switchbacked along the creek, it grew cooler and even more humid, as the canyon narrowed, and the sky became gray.

I arrived at the overlook to the Pulaski Tunnel, which was largely inaccessible across the swollen creek. I climbed down the embankment for a closer view and considered crossing the stream. Feeling the ice-cold water combined with my non-waterproof shoes nixed the idea. Still, there I was, twenty feet from the Pulaski Tunnel, hallowed ground in the world of wildfire. Here, five men would perish but the rest would survive as the fire burned over them a century prior.

Wildland firefighting was also markedly different during the Big Blowup and the Mann Gulch Fire. In 1949 the Forest Service was a sizable entity with smokejumpers, early hotshot crews, and forest rangers scattered across the states. In 1910 the Forest Service was but a nascent glimmer of its future self, employing rough-and-tumble, out-of-work men pulled from the bars and streets of the Idaho Panhandle and Western Montana.

One was a professional firefighting force, the other a ragtag band of day laborers pressed into service. But some men in both fires would encounter a similar fate, killed by the flames or smoke of a raging wildfire in a steep canyon not far from civilization, in tragedies that would shape modern wildland firefighting.

As I stood across the water looking into the tunnel, I imagined the scene a century ago: massive trees shaking the earth as they fell, rolling down the hillsides and crashing over the headframe; rocks and pebbles tumbling as soil once held by deep roots was loosened by the treefall.

There are beams in place today, installed by a local artist to approximate the burned-out mineshaft entrance from the time of the fire. Despite the artificial rebuild, I felt the presence of Pulaski and his men. I thought of the ones who made it out, permanently injured and traumatized. Pulaski himself was reportedly never the same, physically or emotionally, after the fire. And, finally, those who involuntarily went to sleep under the oxygen-depleted gases of the fire, never to awaken.

We were separated by time, but not by place or sentiment. We played different roles but shared the common bond of having stared out at a pyrocumulus, in primal awe at the spectacle of nature. I wonder what Pulaski would think of climate change?

Standing across the tunnel with my camera, it started raining again. I scrambled up the saturated and muddy embankment to climb back up to the trail, reaching for branches to pull myself up as I struggled up the steep slope. Once back at the top, I said goodbye to the souls of the long-departed fireman and started down the trail back to Wallace and the cemetery where some were buried.

The Wallace Cemetery is north of the interstate viaduct on a plot of hilly land shaded by pine trees. On my weekday visit, the cemetery was empty. The gravestone markers of Pulaski's men stood among a larger marker to the Pulaski Tunnel. The clouds were clearing overhead above the weathered tombstones. Pines swayed in the breeze, the wind carrying the spirits of these fallen firemen from long ago. I stood alone in the cemetery, a mix of eerie solitude and nostalgia. Today, their names may be largely forgotten to history, but on this day they were not.

I left the cemetery, turned onto the interstate viaduct, and accelerated to seventy miles per hour, my truck rattling and groaning under the weight of being packed full.

FIRESTORMS OF THE FUTURE

OCTOBER, 2019:
CRASHING WAVES OF ORANGE

The Kincade Fire burned faster than firefighters could keep up with. I had the same challenge photographing the blaze. As the flames danced in the hills above the Alexander Valley, another north wind event, like one that started the fire, was forecast. I caught the last flight into Sacramento, renting a red 4×4 pickup. More wind on an existing fire was bad. I was ready for a firestorm but hoped for the best.

Around midnight I stood on a ranch hillside where Mando Perez and a few other guys from the El Dorado Hotshots were working structure protection. Already exhausted, I was downing cold Panda Express takeout as the first gusts of wind started to kick up in the hills. Within minutes, as predicted by the National Weather Service, the gusts continued to increase and soon there was a wave of fire cresting the ridge a few miles up the mountain. The fire was moving toward Highway 128 through the fabled Alexander Valley wine-growing region of Sonoma, and I decided to move down into the flatland. The fire was screaming downhill and headed straight for vineyards, wineries, and homes. The road was cut off minutes later by fire and downed trees, and remained cut off until the next morning.

The first wave of fire crashed into foothill homes and vineyards just like the Woolsey Fire had careened into Malibu the fall before. The cool October night warmed as the hot and dry wind shook the grapevines with ash-laden air. It was like the Tubbs and Woolsey Fire had an evil progeny as the winds continued to howl. Gusts of eighty-two miles per hour were reported on nearby Mount Saint Helena,[56] solidly in the Category 1 Hurricane–force wind bracket. No wonder the fire burned so fast downhill.

The wind sent embers spotting ahead nearly a mile from the main fire. Bottle Rock Winery caught fire, and by the time I realized how far south the Kincade Fire had run, it was two miles into more trees and homes farther south. Bottle Rock was an inferno, so hot I couldn't get close to the building. Chalk Hill Road, a narrow foothill lane that ran from Windsor up to Highway 128 in the Alexander Valley, was still impassable. A fellow fire photographer drove his Dodge Sprinter van up Highway 128, and ran over a large fallen branch, damaging his front axle. Luckily, we had cell reception, and seeing his frantic texts, I drove farther down than I wanted and plucked him off the highway shoulder. He'd limped his damaged van to a safe spot and I was able to extract him. He rode alongside me in the pickup shooting video and photo until the next morning.

It was unreal watching the fire burn through and seeing the chaos of how fast it moved. The Kincade Fire wasn't one that could have been stopped. It was one that you needed to get out of the way of and not die. If you were able to get everyone out of harm's way and save most of the homes, that was a victory. The county of Sonoma had evacuated hundreds of thousands of people and public safety power shut-offs (PSPS) affected millions in the Bay Area. The Kincade Fire left few untouched in the North Bay and wine country region in Northern California.

I chased crews doing structure defense on wineries and mansions and modest homes alike all night, trying to save what they could in a battle against embers. Like the Canyon I and II Fires, the issue wasn't always the fire front. It was the innumerable embers from burning vegetation and larger fuels left in the wake of the fire. Just a few of them would ignite a home. I spent the evening photographing the

dark outlines of firefighters silhouetted against the orange glow of flame. The extreme wind event was indicative of widening goalposts for climate extremes. The wind ferocity combined with exceptionally dry fuels became less of an outlier. A marginal increase in wind, lower humidity, and slightly dryer fuels could turn a fire from a fast moving one to a dangerously moving one.

In the predawn hours filled with smoke and confusion, I slept in my truck with the videographer in the passenger seat. We napped for ninety minutes until the sun rose, blood-orange light straining through the haze. Exploring Chalk Hill, dozens of homes were burned. Crews tried to save what they could. I was speechless at how far the fire had moved overnight.

DAY 2

After resting during the day, the Kincade Fire continued its fiery march south, impacting the city of Windsor. Driving through evacuated smoke-filled neighborhoods, dozens of fire engines sped between houses trying to save structures as embers hit outbuildings and vegetation threatened entire cul-de-sacs. The fire was burning dirty, spotting across fuels and reigniting interior pockets, causing flare-ups as the winds kicked up. It was blue-chip wildland firefighting, cutting handline and using tools like axes and pikes to tear down burning fuels away from homes. It was a battle filled with ash and foam. Firefighters were exhausted, pulling twenty-four-hour shifts after driving in from around the state. Windsor was also Kent Porter's hometown, and his own family was evacuated.

Proving that fire was a small world, I ran into a friend from the gym back home who was also five hundred miles north on a California Governor's Office of Emergency Services neon yellow fire engine. Local governments staff these engines when they are needed for mutual aid. *At least the cavalry is here*, I thought to myself.

After firefighters saved homes with some outbuilding loss, I waded through foam and mud, which had splattered onto a wheelchair, mattress,

and other items removed from a burning shed. Hiking along a greenbelt through an abandoned playground, a Sonoma County Sheriff's cruiser drove by, blaring a hi-lo two-tone siren. It sounded like a European ambulance, a high whine and boop, in a BEE-BOOP cadence, echoing over the monkey bars and swing set. They'd installed the speakers for emergency evacuations after the Tubbs Fire. And here we were, almost exactly two years later, in a suspended state of reality in an otherwise quaint upper-middle-class suburb, looking like the apocalypse. It was quiet moments like these that rammed home the immediacy of the climate crisis. This was a community in the middle of town. Nobody was safe from fire.

I took a break to file images on deadline for the *Washington Post*. During a quick nap, my radio and phone chattered and rang about the fire blowing up again near Windsor. This time in the exclusive Mayacama Country Club area. The road was blocked to media, but I was able to catch a ride in. Fighting fire again in his backyard, Gino was in the midst of the firefight. Pulling up to the checkpoint, I threw my fire pack and helmet in the back seat, jumped in, and we were speeding off before I even had the door closed.

We drove uphill and were surrounded by fire in seconds.

Head-high flames moved fast through the grass while oak trees torched. Down the street a house caught on fire, and we drove up to check on it, trying to kick in the garage door to move any cars out of harm's way. They were locked and the house burned to the ground.

We spent the evening supervising fire engines guarding various homes engaged on structure defense. The fight went house to house. While homes were lost, the defensible space, modern building codes, and many fire engines ensured the losses weren't worse. One home had the composite deck on fire, with brush underneath. Fire crews literally dismantled the deck as the smoke detectors incessantly beeped in acrid and toxic smoke. While the homeowners needed a new deck, their house was still standing. A victory during a challenging fire.

So here I was, in another firestorm riding alongside Gino. I was grateful for both his friendship and wildfire mentorship. Without his generosity

of time and spirit, half of the powerful action photos from *Terra Flamma* never would've happened. Gino said to me, "Stu, I'm deciding whether you're good luck or bad luck!" He went on to say that I was always with him during the shitstorms, but that we always came out safe with a story to tell and homes saved. Perhaps I was a little bit of both as we skirted the fire's edge.

The fire flared fifty feet in the air as an oak tree and manzanita ignited behind a fire engine on the road into the housing development. I reflexively pressed the camera to my face, quickly composed, and mashed down on the shutter button. The frame showed the scale of the fire and terrain. The next day it was front page of the *Washington Post*. Soon after making the photo, the relative humidity finally increased, the north winds died down, and the explosion of fire in the Mayacama area laid down for the night.

It had been a wild twenty-four hours.

The Kincade Fire was indicative of our new climate reality. The reality is that future fires will be explosive, deadly, and move faster than any sort of containment can happen. All you can do is get people out of the way. Quality of life is impacted, regular routines upended for weeks amid evacuations and smoke and repeated wildfire trauma.

The Kincade Fire was a harbinger of the future, but the future came sooner than I expected.

THE FUTURE IS NOW

AUGUST 19, 2020

I reluctantly and anxiously entered the Bozeman Airport for the first direct flight I could book into the Bay Area midpandemic. In the ninety-degree summer heat, I dragged one hundred and fifty pounds of camera and fire gear, my glasses fogging from my KN95 mask. I fidgeted with my glasses to form a better air seal on my freshly shaven face. It would allow better protection both on the flight and when I had to don my P100 half-face respirator for photographing the homes that would be

burning later that night. I debated driving the sixteen hours straight but decided that the risk of flying made sense. It was between two points with lower per capita caseloads and adequate testing/tracing. I felt it was safer than driving exhausted after a thousand miles of interstate. I'd voluntarily self-isolate upon my return to Montana to finish this book and get rapid-tested after landing.

In the days prior, a massive lightning storm with more than 10,000 ground strikes had hit thousands of square miles in California sparking over 350 fires and overwhelming initial attack resources. As I sat in my writing perch to pen this final chapter, the future happened before I could write about it. Rather than talk about what might happen in our wildfire future, I would have a front-row seat.

A record-setting heat wave caused rolling blackouts for the first time in nearly twenty years in CA—the first time since the early 2000s energy crisis. Sites in the Bay Area nearest to the fires had nearly the worst air quality in the world, with the AQI around Santa Cruz exceeding 300, or extremely unhealthy levels. I measured a few of them myself with a handheld air quality meter around Lake Oroville that exceeded an AQI of 600. NASA satellite imagery showed a hurricane off of Baja, Mexico, swirling slowly north, and smoke from the hundreds of fires drifting south into the Pacific Ocean, blanketing the state in smoke. It was a picture of climate change on a global scale.

From a thousand air miles away, a haze of smoke sat over the Gallatin Valley as the jet gained altitude, likely drift smoke from fires in Idaho. The entire American West was affected by wildfire smoke, from the Bay Area to the Northern Rockies. A wildfire in Colorado grew to be the largest in state history while I was in the air, and evacuations were ongoing at blazes in Washington state. National Interagency Fire Center (NIFC), the national nerve center of wildland fire coordination in the US, went to PL5 or Planning Level 5, meaning there was high resource demand across the country, and fire units were running low. It was the highest alert level in their system.

Because of the COVID-19 pandemic, traditional evacuation centers were not fully open. In Sonoma County, a dispatcher told me

that locations were campgrounds, county parks, and parking lots. Evacuees were to sleep in their cars. Heap on the trauma of a pandemic, the economic fallout and uncertainty, then add fleeing your home only to sleep in your car in a parking lot, and one can imagine the heartbreak. For Napa and Sonoma County residents, this was a horrifying repeat of what they'd done in 2017 and 2019. Santa Cruz was also suffering.

From the window, the first time I'd been on a plane since "the before times" (prepandemic), I watched towering cumulus and anvil head clouds float over the mountains and plains, a beautiful display of dry lightning and late-summer thunderstorms. But that same system brought lightning, and it's related to the system that caused the fires in NorCal. I had a front row to the smoke and weather that caused the fires in the Bay Area. Below ten thousand feet was a smoky inversion layer stretching hundreds of miles, affecting air quality for millions.

The fuels were ripping by mid-August, even in the absence of strong winds. Weather scientist and meteorologist Daniel Swain said the fires were creating their own weather. Peeved at leaving my summer writing retreat, I remembered that fire called the shots, not me. While writing this chapter on a lake in Montana and giving my dog swimming lessons, I knew the next morning I'd be California bound for fire.

Fire does whatever the hell it wants.

On the ground, firefighters ran out of engines, personnel, and aircraft to effectively attack the fires. At the Hennessey Fire, part of the LNU Lightning Complex, between Vacaville and Lake Berryessa, firefighters abandoned fighting the blaze to focus on "immediate life safety threats" and getting civilians out of harm's way. All night, radio traffic indicated trapped civilians, and there were reports of burn victims at the fire in Santa Cruz. It was a repeat of the Tubbs, Woolsey, and Camp Fires. Except it wasn't fall; it was the middle of August. Ultimately, civilians would die at both fires and hundreds of structures would burn. Cal Fire had twelve thousand firefighters deployed, and it still wasn't enough. Firefighters came in on their days off to help, and even California state parks used a fire-qualified wildlife biologist to help out in Armstrong Redwoods State Natural Reserve.

The day I left for the fires, I got a text from Gino, now at a local fire protection district in Sonoma County. I'd asked him whether it was something I should cover. He said: "You should be coming to Sonoma County. [The fire is] going to take entire fucking towns off the map again." Gino is one of the most level-headed people I know—his candor communicated an urgency I'd seldom seen from him. He went on to say:

"These fires will burn for weeks . . . This is a catastrophe."

Photographer Kent Porter echoed the same concerns. I asked him how bad the fires were on a scale of one to ten. He replied, "Twelve." His truck engine had also caught fire after embers entered the engine compartment. It was damaged, so his truck was disabled and left in the fire area.

It was time to load up and roll. I hadn't set foot in California for nearly three months, hiding in Montana to write my fire book and shelter in place. The NorCal Lightning Siege of 2020 was shaping up to be a monster. Shit was real, and I wasn't on the fireground yet.

BOOTS ON THE GROUND

On final approach into SFO, I counted thirteen—yes, *thirteen*—distinct pyrocumulus columns over the Northern California region. Drift smoke extended all the way to Montana. Stepping off the plane, I asked the pilot if he'd ever seen anything like it, and he replied in an Australian accent: "Not in this country!" He must've been flying at some point during Australia's record-breaking fires earlier in the year. Now it was California's turn, again.

The most challenging part of the 2020 NorCal Lightning Fire Siege was figuring which fire was doing what, and what was under threat. It's challenging enough to maintain situational awareness for one single fire, let alone a fire with multiple fronts, let alone over twenty major fires. There were easily forty-plus active flaming fronts to track. Flames were everywhere and radio chatter was indecipherable at half the fires.

I relied on firefighter and Twitter updates, plus my own on-the-ground observations to make access. Fire agencies tracked the fires through dispatch centers, computer programs, and aircraft in the air mapping the flames with infrared sensors. I had to focus on just one fire and take it piece by piece. The Walbridge Fire was threatening Healdsburg, so that was my priority for the evening.

SMOKE IN THE VINEYARD, REVISITED

The Walbridge Fire was the western side of the LNU Lightning Complex, burning in terrain similar to the Tubbs and Nuns Fires of 2017, and the Kincade Fire of 2019. I was vaguely familiar with the area from fires past and was able to link up with Gino and other firefighters on structure protection patrol. The fire was established in a drainage and burning in a remote area, so it was slower long-exposure images to round out the evening. Off a road between the 101 freeway and vineyards, I pointed my camera to the flames and heavens for the thousandth time, composed a frame, clicked the shutter, and boom! Vineyards, fire, and Milky Way. It was smoke in the vineyard, once again.

I'd also wised up on pacing for these multiday, multifire events. Getting a good's night rest when the action was at a lull was key. Fresh air and a real bed felt like a luxury, but they were necessities to chase fire for a whole week. Traveling, driving, making pictures, negotiating photo assignments, staying aware of safety, and not getting hit by falling trees or breathing in horrible smoky air—it added up. Rest was just as important as driving safe or creating compelling images. The first day at the fire would be a full one.

Gino was embedded near the Russian River town of Guerneville, helping with structure protection in Armstrong Redwoods State Natural Reserve, and guarding thousand-year-old redwoods themselves. The park hadn't burned since shortly after World War I, about one hundred years of built-up fuels. It was a challenging place to fight fire with minimal resources.

There were no additional fire engines available during the day. It was just Gino, the park supervisor, a wildlife biologist with fire qualifications, and a second firefighter. This was a skeleton crew, thrown together to protect a park residence and a National Historic Landmark, a historic pottery barn. Gino wasn't even on duty that day. He was volunteering because firefighters were in such short supply. It was the backyard of his fire district, and he felt compelled to help his colleagues and community.

Gino and the wildlife biologist single-handedly engaged in a low-key firing operation after cutting handline to clear fuels around the park residence, which was an older wooden building on a hill with a large deck. It was a vulnerable WUI building but worth saving. The motley crew did the same for the pottery barn, firing out in tall grasses and using a road to tie in the fire line. Gino said to me, "Stu, you can always add more fire, but you can't take it away." Like a haircut, go light the first time, and you can always take off more the next go-round. It was a dance of Gino's drip torch and delicate placement of intentional fire on the ground. It was strategic to deprive the main fire of fuel. It was like a real-life wildfire behavior class at an actual incident. I made photos while trying to soak in the knowledge of the moment.

On our way out of the park, we stopped in the smoky grove of ancient redwood trees, orange light filtering through, the crackle of Gino's radio, and the warm, dry breeze coming through the ravine. I stepped out in my Nomex and PPE, face glistening in sweat, to reach out and touch a tree, the namesake of Armstrong Redwoods. These giants, there for thousands of years, stood strong against the fire. They were deeply rooted into the earth and their thick bark had protected them from many fires before. And it would do so again; the trees would survive and endure.

I needed a moment to channel some of their energy. I too would need to stand strong and rooted, in the face of criticism for speaking out about climate change, social justice, and an uncertain future for an American democracy under siege by antiscience ignorance.

That moment in the grove, like being alone in smoky El Capitan

Meadow at the Ferguson Fire, was what the Japanese call a "forest bath"—a moment in nature to recharge. I was grateful for it amid the destruction and would need that moment of calm for the next set of fire line events.

The granddaughter of a resident evacuated at the fire asked me to check on their remote house far up Wallace Creek Road, a WUI nightmare in a canyon in the middle of the burn area. Gino was game so we went along the road where we'd met the night before, except now there was more fire and a house had burned. I stopped in the afternoon light to make photos of the smoldering remains of a once-beautiful home. It was on top of a steep hill, with little defensible space: one way in, and one way out. Gino and I looked at each other and shook our heads. There wasn't much that could've been done for this particular home. It had been built for failure in the event of megafire.

Continuing up to Big Ridge Road, which would drop us to Wallace Creek, we decided to check on the house where I'd met Gino the night before. As we drew closer, downed trees blocked our path. Gino stepped out with a chainsaw to cut the trees apart, and I played sawyer, bucking logs and branches and moving them out of the way. Nearing the home on Big Ridge, the trees were totally burned, indicating an intense ground and crown fire, and the chances of the house surviving became "fifty-fifty," as Gino put it. We encountered more downed trees and power poles on our way in. It was a slog to get through in the fading dusk light, but Gino was determined to see if the house had made it. As we drove through a saddle by the house, we saw a burned truck, tractor, and outbuilding. "No no no . . ." Gino muttered.

I saw the despair in his eyes as the realization dawned on both of us that this large and beautiful country home was probably gone. As we came up the hill, we saw one standing guest cottage, then the half-crumbled chimney of the main house. Gino and I both let out expletives. I hopped out to make photos, and to give him a minute while he called other firefighters to inform them of the loss and get on the radio. The pool was untouched, with sunscreen, empty beer cans, and a straw hat sitting there. The occupants had left in a hurry.

The house was gone, the pool covered in ash, floaty toys drifting in the ash and burned leaves. It was another scene of loss. Gino said, "I don't like losing, Stu." I didn't blame him for being upset, when losing meant someone's home burned down. I felt his disappointment, too, that same sinking feeling in the pit of my stomach. It was just a building, but it was also someone's home. But they did the best they could. Cal Fire had over ninety-five percent of their firefighters committed. There simply weren't enough firefighters, at one of the largest fire agencies in the US, to handle these megafires. Cal Fire said that to adequately staff all the fires burning in the state, they'd need ten times the firefighters currently engaged.[57]

We kept pushing down the hill, trying to get to the other house I needed to check on. We dropped another dozen trees and checked on another house that had burned down, this time a fire marshal's home. The irony was too much to think about. Gino's truck and chainsaw were low on gas, and we came across a sixteen-inch-diameter pine that was too large to cut with our little saw. We admitted defeat and turned around the same way we'd come in.

We never did make it to the house on Wallace Creek.

REFLECTION

AUGUST, 2020:

What do we call a fire siege fueled by historic fire suppression, WUI development, and climate change that we can't even fight? Is it a wildfire? Or is it some sort of inferno we just need to run from? The only way we address this, and slow down more fires like this, is to better fund prescribed burning, have stricter building codes, and discourage building in vulnerable WUI areas. The federal government also needs to work on decarbonization and decisive climate action. Two hurricanes hit the Gulf, and Iowa got hit by a major storm. As the 2021 fire season ramps up, we are in our driest water years on record in California since records were started in the late 1800s.

"This is real and happening now," I mused while driving around the ruins of trailer parks, cemeteries, and a storage facility on Lake Berryessa at the Hennessey Fire.

That evening, thick smoke settled into Santa Rosa and the surrounding region. The awful air quality made the fire inescapable, permeating my clothes, rooms, car seats, the food. Fire was everywhere and forced us to confront it. Somewhere between the mask-wearing—both for smoke and pandemic—was a moment of reckoning that there was no going back to normal. The only normal was to expect extreme wildfire behavior. There was no hiding from or denying climate change now.

At the end of the day, I drove past the Journey's End Mobile Home Park for a second time after the Tubbs Fire. It had been bulldozed and was now a gravel and concrete field with weeds growing lazily over the rubble. The skeletons of some palm trees also bore testament to the flames that had burned through three years prior. The ghosts of fires present and past piled up, bodies, homes, hopes and dreams. There would be more battles in the West, but for now it was time to rest.

On a foggy and smoky beach in San Francisco debriefing after the siege, *San Francisco Chronicle* wildfire journalist Lizzie Johnson said of us, "We are in it now; there is no going back." We'd seen the same kind of hellscapes over the years and bore the same burden of having witnessed and reported on it. Like Kent, Gino, and Jeff, she understood.

I packed my weathered, leather fire boots, dirty Nomex, worn cameras caked in grime, and scuffed helmet away for the next fire and the trip home. I was ready for whatever came next, ready to step into the inferno.

EPILOGUE:
DESERT BREEZE

As you come up the switchbacks of Highway 89 descending out of the low-slung Sonoran Desert in Western Arizona, known as the "Arizona Outback," you come upon the Bradshaw Mountains rising abruptly to the east. As you gradually ascend on the straight line, two-lane blacktop toward Congress and Wickenburg, the road rises out of the bajada onto a series of switchbacks quickly bringing you up to four thousand feet to the town of Yarnell. "Where the Desert Breeze Meets the Mountain Air," the sign beckons as it greets you upon entering the small town where people retire to get away from it all and value their privacy. Yarnell is actually closer to me than many of the fires in Northern California I've rolled.

On the way up to Highway 89 is a viewpoint looking over the desert floor. It's often windy as thermal belts and pressure systems collide between the taller mountains around Prescott to the east and the series of desert valleys, bajadas, and ranges stretching west to the Pacific Ocean more than three hundred miles away.

It was here that the Yarnell Fire occurred on June 30, 2013—the blaze that took nineteen lives from the Granite Mountain Hotshots.

I'd driven through the town in 2014 and 2015, on my way to explore

Prescott and attend the Arizona Wildland Incident Management Academy. This time was different. Here I was in 2020, writing a book, and going to hike the trail that had been created leading to the site of the Granite Mountain Hotshots deployment and fatal entrapment.

It was a long hike of moderate difficulty, but I was not alone. Walking with me was Amanda Marsh, wife of crew superintendent Eric Marsh, on her second hike into the site. It was almost seven years later, but I suspected this pilgrimage would be emotionally heavy. Desert rocks, wind, unrelenting sun. Maybe I would feel what it was like in those last few hours, reading the topography, fuels, wind shifts, the unforgiving nature of this steep and rocky terrain that so often bedevils firefighters with flashy pinyon-juniper and manzanita fuels from Los Angeles to Los Alamos.

We met in the crisp, late-winter morning of Prescott, a chilly thirty-eight degrees at sunrise with snow still on the ground. We carpooled and took the back way out of town through Skull Valley to avoid the tortuous switchbacks of Highway 89, the same route Granite Mountain would've likely taken into Yarnell when doing their initial attack on the fire in 2013. Their buggy wouldn't have liked the switchbacks either.

The morning light belied the fact that Amanda would be returning to the spot where her husband, Eric, and eighteen other men died almost seven years ago. I hadn't slept well the night before. Lying in the motel thinking about the day and what brought me here, I broke down a couple of times, overwhelmed with a combination of emotion, the weight of the last one hundred fires, Amanda's trust in me to share this moment, and general exhaustion. Since the park had been built, I'd wanted to hike and pay my respects, take a moment to see the entrapment site, and complete the pilgrimage to the fatal fire locations. It was just a hike, but it was so much more.

We drove along the rural places between Yarnell and Prescott, talking about our shared background of having grown up in Southern California, Amanda in Chino in the Inland Empire and myself in Newport Beach. We talked about some of the good work the Eric Marsh Foundation was doing, and some of the challenges of losing

your husband in what still is a very public tragedy. I was interested in the time after the tragedy, the grief and days of simply surviving. And now after many years, living with the loss in your heart, while slowly building room to expand life and soul beyond the scope of that loss. It was difficult for me to say the right words, to be sensitive and respectful, but also to talk about hard topics.

But Amanda did that for me, in her way of understanding what I was trying to get across without me having to really finish my thoughts. She knew. Amanda is a people person, and very much interested in how human beings interact with each other. I was particularly interested in how Amanda decided to create the Eric Marsh Foundation. I wanted to learn about its work helping firefighters who had PTSD or were injured, or the families of those killed in the line of duty, and how that related to her own processing of grief and loss.

THE HIKE

The switchbacks are steep, rising twelve hundred feet from the trailhead on Highway 89, going up as the highway and your pickup truck become small, the winding dry washes of the Sonoran Desert below in the flatland, the granite peaks punctuated by brush behind you. A short way down the trail a metal plaque of Eric Marsh is fixed into the stone, a dot matrix portrait of him and a paragraph talking about his life and love for fire. Every six hundred feet there's a marker for each fallen firefighter in order of seniority. Chris Mackenzie, Travis Turbyfill, Jesse Steed—the list goes on. Every name is etched into aluminum, fixed into stone, laid along the trail to remember.

They provide a moment to rest, and to reflect, as you make your way up in elevation. Each plaque has a small stone, or a beaded cross hanging on the corner, or simply a baseball cap. Dried flowers at the base, small mementos meant to take stone and metal and personify the soul behind the combination of raw elements.

Once we reached the top of the switchbacks and the end of the

plaques, the trail leveled off onto a ridge with an incredible view. Shortly after mounting a second ridge, you can see the entrapment site from afar.

We paused atop the ridge looking down into the bowl, near a shaded rest area and backcountry type board covered in stickers, hats, and shirts of the dozens if not hundreds of fire crews from all over the world that had stopped to make the hike, learn, and pay their mutual respects. It's a living memory board where some stickers have been faded by the desert sun, and other mementos fresher and newer, not yet yellowed and faded by the unrelenting UV rays of the desert. A memorial to what was lost and the passage of time.

The last set of switchbacks drops you into a bowl where the entrapment occurred. A set of nineteen stone baskets held together with wire surrounds the site, and it protects the nineteen metal crosses that mark where the men fell. Each stone cairn is connected to the other by a chain, symbolizing the teamwork between each member of the crew. More hats, shirts, photos, and trinkets decorate each stone basket.

We made our way closer to the deployment site and I was silent, approaching the area with a mixture of mild anxiety and reverence. Here was a place I'd held in my mind for years, and there I was with Amanda going to visit for the first time. It was heavy, but I focused on the present moment and being there, talking in detail, making notes, and photographing the site. I leaned into the work to give my feelings a break.

It was surreal being there with Amanda to memorialize where their lives ended trying to save the town of Yarnell and the subdivision of Glen Ilah. Amanda said: "They put the crosses where their heads were," as the best approximation of where the marker of a fire front swept over their shelters, radios crackling. "There's Eric." Amanda pointed to the cross marking where her husband deployed his fire shelter. I squinted in the midday light even with my sunglasses on, and I saw his name alongside the other eighteen men who perished there.

We sat down on a bench to rest and eat our snacks, chatting about the processing of grief over time. A crew from Avondale, Arizona had hiked in behind us and gently approached Amanda, asking: "Excuse

me, but are you Amanda Marsh?" She confirmed and soon the dozen or so men with the wildland division were shaking her hand and introducing themselves. The crew does an annual hike out and had come to pay their respects. I can only imagine their surprise that Amanda was at the bottom of the trail with me.

It was odd because I thought there'd be more emotion involved during the moment in my visit to the deployment site, but I was too focused on the hike and present moment and speaking with Amanda and letting her tell her story to be swayed by what I may have felt inside. I took time to grieve for myself after the hike in the hotel room.

Walking into the clearing of the fatality site, we stood silent.

We reflected more on the crosses, Amanda sharing details of each person, maybe a nickname, a story about the family.

THE PASSAGE OF TIME

The brush has grown back over the skeletons of manzanita, the memorial plaques have started to weather in the sunlight, and the memorial parking lot is usually full during the spring desert season, even on weekdays. Fire crews from Phoenix and retirees from Nebraska make the hike, bringing in people from all walks of life to pay their respects. The time has gone on, I've grown older, Amanda has remarried and is starting to travel more, but the crosses sit there as silent sentinels all day and all night. And when the last hiker walks out at dusk, and night casts a shadow over the desert, the stars come out.

Or maybe it's a moon-filled night, gently illuminating the crosses with a blue glow. Or perhaps there's a storm moving through, the desert cloaking the deployment site in darkness that only those who've seen the desert without light can see in their minds. Those nineteen crosses are still there in the closed-off deployment zone, frozen metal and snow in the winter and metal so hot in the summer's desert rays it would burn your hand.

The crosses sit there, in repose, with a lone American flag at

half-staff, lit overnight by a solar panel. It reminds me of the grief and trauma those who lose a loved one in fires see. The memory is always there, ever-present. You visit it, as do others with a public tragedy. And in the night, when you are alone, those memories and trauma stay with you. Sometimes it's subtle like that dull glow of the moon. Sometimes it's brutal, the darkness of clouds obscuring even starlight, plunging you into despair.

And sometimes there's just enough light to get you through the night, but if you sit in that and embrace the smallest amount of light, and give it time, you'll look up and see millions upon millions of stars looking over the graves of those men who passed away trying to save the town of Yarnell. While their bodies may no longer be present, their soul and memory live on in the hearts of their loved ones, and the minds of those left to carry on their legacy in fire. There is light, and it may take time for our eyes to adjust in the darkness, but it is there. It takes time, self-love, patience, and just getting through, day by day.

FAREWELL

Hiking out at the last plaque, I slowed down when we were almost to the parking lot and looked back to make sure Amanda wasn't too far behind, and for a second, she extended her hand out to touch the photo of Eric printed on the metal memorial plaque affixed into the stone, the first one going into the hike and the last one going out. Just as a hotshot crew superintendent is the first in and last out at a fire, so was Eric in his memorial along his final hike.

I asked Amanda if she wanted to stop or if she'd like a few minutes to herself without me. She said, "Nope, I'm okay," and carried on to the parking lot. But in that last moment, that flash of a hand, I saw the grief that never leaves, but also the strength and slow healing that years bring.

Her hand brushed the plaque bearing the photo of Eric, and lifted off.

ACKNOWLEDGMENTS

Writing and editing a book about wildfire amidst California's largest wildfire season on record, political instability, and a global pandemic was a challenge. Staying focused and conjuring memories of eight years of wildfire as the world literally and figuratively burned required the tremendous guiding hand of manuscript draft editor Andrew Madigan. Not sure I would've been able to pace myself without his assistance. He kept me to task. Thanks also to Michael Signorelli for your incisive comments and constructive suggestions. Your guidance was invaluable.

I owe an immense debt of gratitude to everyone on this list. From editors, to agents, to wildland firefighters, to family, to climate scientists, to Twitter friends and fellow wildfire photographers, you all made this possible. Just like wildfire cannot be fought by one person, neither can a book be written as one. It takes an entire team, a village if you will. And this list spans the gamut.

First and foremost, I am grateful to every firefighter and civilian that allowed me to photograph them on the toughest and worst days of their lives. It was an honor and I look forward to doing your stories justice in this text and beyond.

To my literary agent, Jen Chen Tran, who believed in my photography and writing, championing the book project and idea from concept, to pitch, to manuscript draft. Your unwavering support and heartfelt

concern about wildfires and the environment is inspiring. Thank you to Bradford Literary as a whole for bringing me on.

To the publisher Blackstone, for also finding urgency and importance in the story of wildfire. My heart feels heavy each time I think about how the very publisher of this book, their employees, and families have been forever impacted by fire. To Vikki Warner, who steadfastly supported the work, helped to guide my direction, and accommodate my writings during a tough time in all our lives with a pandemic, and for giving me the license and space to create and tell the story.

To my friend Karen Happel, who introduced me to Jen and Bradford Literary, thank you for also thinking my story worthy.

To my parents, Marion and Roger Palley, who supported my education and foundation to always learn, to inquire, and to seek truth. They provided me with the resources to embark on this project, and to take on risk many creatives starting their career cannot. Thank you.

To my dear friend Kyle Ramer, who took my dog on many occasions last minute so I could chase fire. I always felt calm knowing my pup was being well cared for while I was eating smoke.

To Lalo Romo, who first brought me into USFS training and helped to sponsor me for AD work in the Forest Service to get my first red card and get hand crew experience for my perspective.

Scott Gorman, Dalton Hotshot Superintendent, who let me photograph the crew at fires time and time again.

To the chiefs and PIOS of the Cleveland National Forest and the Angeles National Forest, for providing me annual training, and to the US Forest Service and National Interagency Fire Center for providing me with assignment opportunities to directly embed with fire incidents to document history for the public.

Ah, Gino DeGraffenreid. The amount of fire you and I have seen across this state. Fire sieges, firing operations, from the sidewalks of subdivisions and shotgun in your pickup. This book and these stories wouldn't be complete without the mentorship and advice and access you've given me along the way. It's people like you that make telling these stories worth it. I am always in your debt. And grateful to call

you a friend. You and your colleagues have saved hundreds of homes. The homeowners may never meet you face to face, but I hope they can appreciate your work in this book. The public owes you infinite thanks.

To Amanda Marsh, you are an inspiration. Your strength, grace, and fortitude inspire me. There's not a day on wildfires that goes by where I don't think about Granite Mountain. Your willingness to share the hike into the deployment site is humbling. Thank you for sharing your journey so the public and the fire world may benefit. It's an honor to call you a friend, and I hope this work can help do justice to their memory, and the future of the wildfire world and the public's understanding and appreciation of it.

To Ben Strahan, thanks for saving me when the fire whirl reached out during the firing operation at the Thomas Fire in December 2017. I owe you one. And thanks for your time amidst a busy rookie season as the ElDo supe to interview for the book. I am glad you and the crew made it through 2020 and look forward to seeing you back out on the line.

To Aaron Humphrey. You are a hero. You've done so much to help the fire world, the ElDo crew during your tenure as supe, and then still continue to serve the community today in your new role. I'm glad you are with family now and wish you all the best as time goes on. May your sacrifice and that of your family over the years be an inflection point for bettering the fire service in the future. Both you and Ben have saved many homes in the woods, and I will always remember that.

Scott and Janet Upton, thank you for allowing me into your home and sharing your stories of years of dedication to public service. I am proud that you are still involved in the fire world even in retirement. And I am grateful for your vulnerability to share the impacts to firefighters after major sieges.

Ken Pimlott, thank you for meeting with me toward the beginning of this project, and sharing your wisdom and perspective from running one of the largest fire departments in the country. Your humility, expertise, and leadership left this state better off, and your legacy continues to help save property. I hope you are enjoying a well-earned new season in your life after Cal Fire.

Jordan Flores, thank you for letting me photograph you and the crew on the fire line after tragedy, and for sharing what that meant to you.

Luke Mayfield, thank you for speaking with me about challenges for firefighters going forward and how we can help them. Thank you for a career serving the public, fighting fire, and making sacrifices to serve. It is an honor to help share the message.

Marijke Ellert, you too are a hero. You helped provide closure and clarity for Camp Fire victims' families and helped to save a cat. Your bravery and heart shone through during the SAR times at the fire and afterward when we spoke. Thank you for your time, and for your willingness to go back out there in the aftermath of the 2020 Bear Fire. I hope the public always remembers your service.

To the climate scientists who research and tell the data and logic side of wildfire and climate change. Research, analysis, fieldwork. Your decades of focus and professionalism helped give me the foundation to explain fire in layperson's terms to the public. Now more than ever, in an era that denies basic science, your work is so important. Myself and society are grateful. Never give up sharing the truth, furthering knowledge, and speaking out for science-based policy and rational thought.

LeRoy Westerling, thank you for speaking with me about the future of wildfires and for your work on the national climate assessment. Your advocacy for the truth is important.

Thank you, Rich Thompson, for your many tidbits of weather info and assessment. You helped me know when the fire weather was coming and provided insight to make nuanced decisions on coverage. It's been an honor to learn from you, and to have worked directly with you at fires.

Daniel Swain, I hang onto every word you write. Your work has helped me to better understand fire, climate change, weather, and how it's all connected. Keep being a public communicator, researcher, and scientist getting the word out.

Neil Lareau, thank you for your multitude of research that's helped my understanding of fire, and for contributing to how we understand fire.

And a big thank you to "Science Twitter" in general for educating

me on background info and support, and always willing to lend a helping hand for details and questions.

Masao Barrows, in your moment of trauma, you allowed me to document it. And your graciousness and kindness in the aftermath humbled me. Because of your courage to share, millions have seen your image evacuating from the Woolsey Fire. Thank you.

Jordan Pope, thank you as well for allowing me to photograph you and Sara during a tough day at the crescendo of the Woolsey Fire. Your time and generosity of spirit are wonderful.

Lisa Montiero, thank you for educating me about what Sierra homeowners have, and continue to go through.

To the many unnamed people who let me photograph what might have been the toughest or most traumatic days of their lives, when they lost everything, a loved one, a pet. Not a day goes by where I don't think about it. You are all courageous, survivors, and will persevere.

To my creative and media friends, you rode along, caravanned, provided support, intelligence, and logistics help. We are a motley crew that loves to argue and are independent, but at the end of the day we all have each other's backs. It's the closest thing to a fire crew we will ever have out there.

Lizzie Johnson, your dedication to reporting wildfire is second to none. One of the few people who understands what it's like documenting fire and experiencing its effects. Thank you for dedicating yourself to this field.

To my dear friend and photographer Ryan Babroff, who has chased dozens of fires with me across the state in all manners of hellacious conditions. Without your support and information, this project wouldn't be complete. The radio calls, tips, and introductions you've given are critical. Thank you.

To Kent Porter, who is a photography mentor to me with limitless heart and talent. He sets the bar for the visual storyteller I strive to be. Another one of the few people who knows what it's like. I still owe you some beers, man. Maybe after the freaking pandemic.

To Jeff Frost, battle buddy at many a fire. We've been through a lot

of smoke, ash, drama, destruction, and creation. Thank you for your friendship and support during the project and writing, on good days and bad. Your insight and perspective helped carry me through. And your kindness and creative Swiss Army knife mind is always fun to see in motion. Every time we say we're done, fire has other ideas.

To Patrick Fallon, one of my oldest photographer friends, who I chased my first real wildfire with. I can always depend on you for an accountability buddy on the fire line.

To John Schreiber, who keeps me in the loop from the air with information and makes sure I don't get hurt from afar.

ENDNOTES

Chapter 2: High Fire Hazard Severity Area

1 Arango, Tim, "Behind Most Wildfires, a Person and a Spark: 'We Bring Fire with Us'," *New York Times*, August 20, 2018, https://www.nytimes.com/2018/08/20/us/california-wildfires-human-causes-arson.html.

2 Los Angeles County, and LACoFD, After Action Review of the Woolsey Fire Incident (2019), pg 6.

3 "Sayre Fire Map," *Los Angeles Times*, November 15, 2008, https://www.latimes.com/local/la-me-sayrefire-googlemap-htmlstory.html.

4 Research shows that the Santiago Fire may have been a complex of multiple fires burning at once. Rather than one large fire, Santa Ana winds help to push a multitude of fires across Southern California. Historians still debate the issue to this day.

5 Elliott, Jeff, "The 1964 Hanly Fire," Santa Rosa History, September 11, 2019, http://santarosahistory.com/wordpress/2019/09/the-1964-hanly-fire.

6 Arango, Tim, "Behind Most Wildfires, a Person and a Spark: 'We Bring Fire with Us'," *New York Times*, August 20, 2018, https://www.nytimes.com/2018/08/20/us/california-wildfires-human-causes-arson.html.

Chapter 3: Access to Wildfires, Training, Staying Safe

7 Vartabedian, Marc, "The Photographers Who Walk Into the California Fires," *Wall Street Journal*, November 3, 2019, https://www.wsj.com/articles/the-photographers-who-walk-into-the-california-fires-11572784201.

Chapter 5: Initial Attack at the Mountain Fire

8 Gabbert, Bill, "Night Flying Helicopter Used on the Mountain Fire," Fire Aviation, July 21, 2013, https://fireaviation.com/2013/07/21/night-flying-helicopter-used-on-the-mountain-fire/.

9 Associated Press, "Mountain Fire: Homeowner Sued for $25 Million over 2013 Wildfire," Southern California Public Radio, July 15, 2016, https://www.scpr.org/news/2016/07/15/62638/mountain-fire-homeowner-sued-for-25-million-over-2/.

Chapter 6: It's the Climate

10 "Climate Change: Global Temperature," NOAA Climate.gov, March 15, 2021, https://www.climate.gov/news-features/understanding-climate/climate-change-global-temperature.

11 Swain, Daniel L., Baird Langenbrunner, J. David Neelin, and Alex Hall, "Increasing Precipitation Volatility in Twenty-First-Century California," *Nature Climate Change* 8 (April 23, 2018), https://www.nature.com/articles/s41558-018-0140-y.

12 Davies, Bethan, "Ice Core Basics," AntarcticGlaciers.org, June 22, 2020, http://www.antarcticglaciers.org/glaciers-and-climate/ice-cores/ice-core-basics/.

13 Parrenin, F., V. Masson-Delmotte, P. Köhler, D. Raynaud, D. Paillard, J. Schwander, C. Barbante, A. Landais, A. Wegner, and J. Jouzel, "Synchronous Change of Atmospheric CO_2 and Antarctic Temperature during the Last Deglacial Warming," *Science* (March 1, 2013), https://science.sciencemag.org/content/339/6123/1060.full.

14 Westerling, Anthony L., Daniel R. Cayan, Timothy J. Brown, Beth L. Hall, and Laurence G. Riddle, "Climate, Santa Ana Winds and Autumn Wildfires in Southern California," *Eos* 85, no. 31 (August 3, 2004), https://agupubs.onlinelibrary.wiley.com/doi/abs/10.1029/2004EO310001.

15 Palley, Stuart, Interview with LeRoy Westerling, Personal, August 13, 2019.

16 Cal Fire, "Top 20 Largest California Wildfires," California Department of Forestry and Fire Protection, August 2020.

17 Palley, Stuart, Interview with Cal Fire Chief Ken Pimlott, Personal, March 25, 2013.

18 Hasemyer, David, "Fossil Fuels on Trial: Where the Major Climate Change Lawsuits Stand Today," Inside Climate News, January 17, 2020, https://insideclimatenews.org/news/17012020/climate-change-fossil-fuel-company-lawsuits-timeline-exxon-children-california-cities-attorney-general/.

19 Funk, Cary, and Meg Hefferon, "U.S. Public Views on Climate and Energy," Pew Research Center Science & Society, November 25, 2019, https://www.pewresearch.org/science/2019/11/25/u-s-public-views-on-climate-and-energy/.

20 "Temperatures: Addressing Global Warming," Climate Action Tracker, accessed September 12, 2020, https://climateactiontracker.org/global/temperatures/.

21 Voiland, Adam, "California's Nightmare Fire Season Continues," NASA Earth Observatory, October 1, 2020, https://earthobservatory.nasa.gov/images/147363/californias-nightmare-fire-season-continues.

22 Stone, Madeleine, "A Heat Wave Thawed Siberia's Tundra. Now, It's on Fire.," *National Geographic,* July 6, 2020, https://www.nationalgeographic.com/science/2020/07/heat-wave-thawed-siberia-now-on-fire/.

23 Grandoni, Dino, "The Energy 202: California's Fires Are Putting a Huge Amount of Carbon Dioxide into the Air," *Washington Post*, September 17, 2020, https://www.washingtonpost.com/politics/2020/09/17/energy-202-california-fires-are-putting-huge-amount-carbon-dioxide-into-air/.

24 Byer, Renée C., "It's Her Job to Test Paradise's Water. Here's What She's Finding," *Sacramento Bee*, April 17, 2019, https://www.sacbee.com/news/local/environment/article229397934.html.

25 "Carbon Dioxide Concentration," NASA, September 17, 2020, https://climate.nasa.gov/vital-signs/carbon-dioxide/.

26 Schwartz, John, and Lisa Friedman, "The 'Straightforward' Link between Climate and California's Fires," *New York Times*, September 9, 2020, https://www.nytimes.com/2020/09/09/climate/nyt-climate-newsletter-california-wildfires.html.

27 Popovich, Nadja, Livia Albeckripka, and Kendra Pierre-Louis, "The Trump Administration Is Reversing Nearly 100 Environmental Rules. Here's the Full List.," *New York Times*, October 15, 2020, https://www.nytimes.com/interactive/2020/climate/trump-environment-rollbacks-list.html.

28 Groom, Nichola, "Analysis: Trump's Wrong—California Does More to Manage Forests than Feds," *Times of San Diego* (September 23, 2020), https://timesofsandiego.com/politics/2020/09/23/analysis-trumps-wrong-california-does-more-to-manage-forests-than-federal-government/.

Chapter 7: Megafire

29 Jenkins, Michael J., Elizabeth Hebertson, Wesley Page, and C. Arik Jorgensen, "Bark Beetles, Fuels, Fires and Implications for Forest Management in the Intermountain West," *Forest Ecology and Management*, https://www.sciencedirect.com/science/article/pii/S037811270700713X.

Chapter 9: Reality Check

30 NIFC, "Fatalities By Year," NIFC.gov, 2018, https://www.nifc.gov/safety/safety_documents/Fatalities-by-Year.pdf.

31 Palley, Stuart, NPS Law Enforcement Officer Interview, Personal, August 2018.

Chapter 10: The Campaign Fires of Lake County

32 Hanak, Ellen, Jeffrey Mount, and Caitrin Chappelle, "California's Latest Drought," Public Policy Institute of California, July, 2016, https://www.ppic.org/wp-content/uploads/JTF_DroughtJTF.pdf.

33 Faunt, Claudia, Michelle Sneed, Jon Traum, and Justin Brandt, "Water Availability and Land Subsidence in the Central Valley, California, USA," USGS.gov, November 2015, https://ca.water.usgs.gov/pubs/2015/FauntEtAl2015.pdf.

34 "National Climate Report—Annual 2015 Average Temperature Anomalies," National Climatic Data Center (NOAA), accessed 2020, https://www.ncdc.noaa.gov/sotc/national/201513/supplemental/page-1.

35 Preisler, Haiganoush K., Nancy E. Grulke, Zachary Heath, and Sheri L. Smith, "Analysis and Out-Year Forecast of Beetle, Borer, and Drought-Induced Tree Mortality in California," *Forest Ecology and Management* (May 29, 2017), https://www.sciencedirect.com/science/article/pii/S0378112717304772.

36 Jenkins, Michael J., Elizabeth Hebertson, Wesley Page, and C. Arik Jorgensen, "Bark Beetles, Fuels, Fires and Implications for Forest Management in the Intermountain West," *Forest Ecology and Management*, https://www.sciencedirect.com/science/article/pii/S037811270700713X.

37 Universität Bonn, "Fire Beetles May Revolutionize Early-Warning Systems for Forest Fires," ScienceDaily, May 23, 2012, https://www.sciencedaily.com/releases/2012/05/120523102148.htm.

38 "Quick Facts, Lake County, California," Quick Facts, Lake County, California (2019).

Chapter 12: No Light

39 Melting temperature range of aluminum, observation based on my best estimate.

Chapter 14: Fatigue Sets In

40 "Typical Home Value Southern California," Typical Home Value for Southern California Counties Since 1996, accessed 2020, http://www.laalmanac.com/economy/ec37c.php.

Chapter 18: The Great Western Firebreak

41 Palley, Stuart, Conversation with Rich Thompson, Personal, August 11, 2020.

Chapter 19: Fire in the Valley

42 Johnson, Lizzie, "Bulldozer Slipped 3 Times before Firefighter's Fatal Plunge near Yosemite," *San Francisco Chronicle*, August 2, 2018, https://www.sfchronicle.com/california-wildfires/article/Bulldozer-slipped-3-times-before-firefighter-s-13128007.php.

Chapter 21: The Big One, Woolsey Fire Part 1

43 Palley, Stuart, Interview with Fire Photographer Ryan Babroff, Personal, May 15, 2020.

Chapter 22: I Of the Storm

44 I had meant Point Dume, but in my sleep deprivation got the wrong spot.

45 Arnsten, Amy F. T., "Stress Signalling Pathways That Impair Prefrontal Cortex Structure and Function," *Nature Reviews Neuroscience* 10 (June 2009), https://www.ncbi.nlm.nih.gov/pmc/articles/PMC2907136/.

Chapter 23: Paradise Lost

46 Skiba, Katherine, "Paradise Camp Fire Survivors Remember the Wildfire," AARP, October 15, 2019, https://www.aarp.org/politics-society/history/info-2019/paradise-camp-fire-anniversary.html.

Chapter 24: Fallout

47 Miller, Hope, "Camp Fire Evacuees Can Check the Status of Their Cars," KCRA, November 13, 2018, https://www.kcra.com/article/camp-fire-evacuees-can-check-the-status-of-their-cars/25061190.

48 Hawkins, John, "Southern California Association of Foresters and Fire Wardens 2018 Annual Conference," *Southern California Association of Foresters and Fire Wardens 2018 Annual Conference* (May 2, 2019).

49 "The Grassroots Wildland Firefighters Committee," The Grassroots Wildland Firefighters Committee, *The Anchor Point Podcast*, 2020, https://anchorpointpodcast.com/grassroots-wildland-firefighters.

50 Humphrey, Aaron, "Mental Health and Being a Hotshot," Wildland Fire Leadership, March 31, 2020, http://wildlandfireleadership.blogspot.com/2020/03/mental-health-and-being-hotshot.html.

51 Johnson, Lizzie, "150 Minutes of Hell," *San Francisco Chronicle*, December 5, 2018, https://projects.sfchronicle.com/2018/carr-fire-tornado/.

52 Lareau, N. P., N. J. Nauslar, and J. T. Abatzoglou, "The Carr Fire Vortex: A Case of Pyrotornadogenesis?," *Geophysical Research Letters* 45, no. 23 (March 2018), https://doi.org/10.1029/2018gl080667.

Chapter 25: Ripple Effects

53 Wildermuth, John, "California No Longer Pays More to Washington than It Gets Back, Study Finds," *San Francisco Chronicle*, May 3, 2020, https://www.sfchronicle.com/politics/article/California-no-longer-pays-more-to-Washington-than-15243861.php.

54 Burke, Marshall, "Indirect Mortality from Recent Wildfires in CA," G-Feed, September 11, 2020, http://www.g-feed.com/2020/09/indirect-mortality-from-recent.html.

55 "Los Angeles, CA Rental Market Trends," RENTCafé (Yardi Matrix data), accessed 2020, https://www.rentcafe.com/average-rent-market-trends/us/ca/los-angeles/.

Chapter 27: Firestorms of the Future

56 Leonard, Diana, "California Forecasters Saw the 'Devil Wind' Storm Coming. It's the Worst-Case Scenario for Wildfires," *Washington Post*, October 27, 2019, https://www.washingtonpost.com/weather/2019/10/27/california-forecasters-saw-devil-wind-storm-coming-its-worst-case-scenario-wildfires/.

57 Associated Press, "As 560 Wildfires Burn in California, Overwhelmed Firefighters Receive Aid from 10 States," *USA Today*, August 22, 2020, https://www.usatoday.com/story/news/nation/2020/08/22/california-wildfires-firefighters-receive-aid-10-states/3418583001/.

BIBLIOGRAPHY

Arango, Tim. "Behind Most Wildfires, a Person and a Spark: 'We Bring Fire with Us'." *New York Times*. August 20, 2018. https://www.nytimes.com/2018/08/20/us/california-wildfires-human-causes-arson.html.

Arnsten, Amy F. T. "Stress Signalling Pathways That Impair Prefrontal Cortex Structure and Function." *Nature Reviews Neuroscience* 10 (June 2009). https://www.ncbi.nlm.nih.gov/pmc/articles/PMC2907136/.

Associated Press. "As 560 Wildfires Burn in California, Overwhelmed Firefighters Receive Aid from 10 States." *USA Today*. August 22, 2020. https://www.usatoday.com/story/news/nation/2020/08/22/california-wildfires-firefighters-receive-aid-10-states/3418583001/.

Burke, Marshall. "Indirect Mortality from Recent Wildfires in CA." G-Feed. September 11, 2020. http://www.g-feed.com/2020/09/indirect-mortality-from-recent.html.

Byer, Renée C. "It's Her Job to Test Paradise's Water. Here's What She's Finding." *Sacramento Bee*. April 17, 2019. https://www.sacbee.com/news/local/environment/article229397934.html.

Brigandi, Phil. "1889 Fire." OC Historyland. Phil Brigandi. Accessed
 2020. https://www.ochistoryland.com/1889fire.

"National Climate Report—Annual 2015 Average Temperature
 Anomalies." National Climatic Data Center (NOAA). Acccssed
 2020. https://www.ncdc.noaa.gov/sotc/national/201513/
 supplemental/page-1.

"Climate Change: Global Temperature." NOAA Climate.gov.
 March 15, 2021. https://www.climate.gov/news-features/
 understanding-climate/climate-change-global-
 temperature.

"Temperatures: Addressing Global Warming." Climate
 Action Tracker. Accessed September 12, 2020. https://
 climateactiontracker.org/global/temperatures/.

Teie, William C. *Firefighter's Handbook on Wildland Firefighting:
 Strategy, Tactics and Safety*. Stillwater, OK: Fire Protection
 Publications, 2018.

Davies, Bethan. "Ice Core Basics." AntarcticGlaciers.org. June 22,
 2020. http://www.antarcticglaciers.org/glaciers-and-climate/
 ice-cores/ice-core-basics/.

Davis, Mike. *Ecology of Fear: Los Angeles and the Imagination of
 Disaster*. New York: Vintage Books, 1999.

Egan, Timothy. *The Big Burn: Teddy Roosevelt and the Fire That Saved
 America*. Boston: Houghton Mifflin Harcourt, 2009.

Elliott, Jeff. "The 1964 Hanly Fire." Santa Rosa History. September
 11, 2019. http://santarosahistory.com/wordpress/2019/09/
 the-1964-hanly-fire.

Faunt, Claudia, Michelle Sneed, Jon Traum, and Justin Brandt. "Water Availability and Land Subsidence in the Central Valley, California, USA." USGS.gov. November 2015. https://ca.water.usgs.gov/pubs/2015/FauntEtAl2015.pdf.

Cal Fire. "Top 20 Largest California Wildfires." California Department of Forestry and Fire Protection. August 2020.

Folger, Tim. "The Cuyahoga River Caught Fire 50 Years Ago. It Inspired a Movement." *National Geographic.* June 21, 2019. https://www.nationalgeographic.com/environment/2019/06/the-cuyahoga-river-caught-fire-it-inspired-a-movement/.

Funk, Cary, and Meg Hefferon. "U.S. Public Views on Climate and Energy." Pew Research Center Science & Society. November 25, 2019. https://www.pewresearch.org/science/2019/11/25/u-s-public-views-on-climate-and-energy/.

Gabbert, Bill. "Night Flying Helicopter Used on the Mountain Fire." Fire Aviation. July 21, 2013. https://fireaviation.com/2013/07/21/night-flying-helicopter-used-on-the-mountain-fire/.

Grandoni, Dino. "The Energy 202: California's Fires Are Putting a Huge Amount of Carbon Dioxide into the Air." *Washington Post.* September 17, 2020. https://www.washingtonpost.com/politics/2020/09/17/energy-202-california-fires-are-putting-huge-amount-carbon-dioxide-into-air/.

"The Grassroots Wildland Firefighters Committee." The Grassroots Wildland Firefighters Committee. *The Anchor Point Podcast.* 2020. https://anchorpointpodcast.com/grassroots-wildland-firefighters.

Groom, Nichola. "Analysis: Trump's Wrong—California Does More to Manage Forests than Feds." *Times of San Diego*. September 23, 2020. https://timesofsandiego.com/politics/2020/09/23/analysis-trumps-wrong-california-does-more-to-manage-forests-than-federal-government/.

Hanak, Ellen, Jeffrey Mount, and Caitrin Chappelle. "California's Latest Drought." Public Policy Institute of California. July 2016. https://www.ppic.org/wp-content/uploads/JTF_DroughtJTF.pdf.

Humphrey, Aaron. "Mental Health and Being a Hotshot." Wildland Fire Leadership. March 31, 2020. http://wildlandfireleadership.blogspot.com/2020/03/mental-health-and-being-hotshot.html.

Jenkins, Michael J., Elizabeth Hebertson, Wesley Page, and C. Arik Jorgensen. "Bark Beetles, Fuels, Fires and Implications for Forest Management in the Intermountain West." *Forest Ecology and Management*. https://www.sciencedirect.com/science/article/pii/S037811270700713X.

Johnson, Lizzie. "150 Minutes of Hell." *San Francisco Chronicle*. December 5, 2018. https://projects.sfchronicle.com/2018/carr-fire-tornado/.

"Bulldozer Slipped 3 Times before Firefighter's Fatal Plunge near Yosemite." *San Francisco Chronicle*. August 2, 2018. https://www.sfchronicle.com/california-wildfires/article/Bulldozer-slipped-3-times-before-firefighter-s-13128007.php.

Johnson, Lizzie. *Paradise: One Town's Struggle to Survive an American Wildfire*. New York: Crown Publishing Group, 2021.

Kay, Charles E. "Native Burning in Western North America: Implications for Hardwood Forest Management." USDA US Forest Service. Accessed 2020. https://www.fs.fed.us/ne/newtown_square/publications/technical_reports/pdfs/2000/274%20papers/kay274.pdf.

Kodas, Michael. *Megafire: The Race to Extinguish a Deadly Epidemic of Flame.* Boston: Houghton Mifflin Harcourt, 2017.

Lareau, N. P., N. J. Nauslar, and J. T. Abatzoglou. "The Carr Fire Vortex: A Case of Pyrotornadogenesis?" *Geophysical Research Letters* 45, no. 23 (November 2018). https://doi.org/10.1029/2018gl080667.

Leonard, Diana. "California Forecasters Saw the 'Devil Wind' Storm Coming. It's the Worst-Case Scenario for Wildfires." *Washington Post.* October 27, 2019. https://www.washingtonpost.com/weather/2019/10/27/california-forecasters-saw-devil-wind-storm-coming-its-worst-case-scenario-wildfires/.

Lindsey, Rebecca, and LuAnn Dahlman. "Climate Change: Global Temperature." NOAA Climate.gov. March 15, 2021. https://www.climate.gov/news-features/understanding-climate/climate-change-global-temperature.

Los Angeles County, and LACoFD, After Action Review of the Woolsey Fire Incident (2019), pg 6.

Maclean, John N. *Fire on the Mountain: The True Story of the South Canyon Fire.* New York: Harper Perennial, 2009.

Maclean, Norman. *Young Men and Fire.* Chicago: University of Chicago Press, 1992.

NIFC, "Fatalities By Year," NIFC.gov, 2018, https://www.nifc.gov/safety/safety_documents/Fatalities-by-Year.pdf.

"National Climate Report—Annual 2015 Average Temperature Anomalies." National Climatic Data Center (NOAA). Accessed 2020. https://www.ncdc.noaa.gov/sotc/national/201513/supplemental/page-1.

Palley, Stuart. NPS Law Enforcement Officer Interview. Personal. August 2018.

Palley, Stuart. *Terra Flamma: Wildfires at Night.* Atglen, PA: Schiffer Publishing, Ltd., 2018.

Parrenin, F., V. Masson-Delmotte, P. Köhler, D. Raynaud, D. Paillard, J. Schwander, C. Barbante, A. Landais, A. Wegner, and J. Jouzel. "Synchronous Change of Atmospheric CO_2 and Antarctic Temperature during the Last Deglacial Warming." *Science* (March 1, 2013). https://science.sciencemag.org/content/339/6123/1060.full.

Popovich, Nadja, Livia Albeckripka, and Kendra Pierre-Louis. "The Trump Administration Is Reversing Nearly 100 Environmental Rules. Here's the Full List." *New York Times.* October 15, 2020. https://www.nytimes.com/interactive/2020/climate/trump-environment-rollbacks-list.html.

Preisler, Haiganoush K., Nancy E. Grulke, Zachary Heath, and Sheri L. Smith. "Analysis and Out-Year Forecast of Beetle, Borer, and Drought-Induced Tree Mortality in California." *Forest Ecology and Management* (May 29, 2017). https://www.sciencedirect.com/science/article/pii/S0378112717304772.

Pyne, Stephen J. *Between Two Fires: A Fire History of Contemporary America*. Tucson: University of Arizona Press, 2015.

Pyne, Stephen J. *Fire in America: A Cultural History of Wildland and Rural Fire*. Seattle: University of Washington Press, 1997.

Santos, Fernanda. *The Fire Line: The Story of the Granite Mountain Hotshots*. New York: Flatiron Books, 2016.

Schwartz, John, and Lisa Friedman, "The 'Straightforward' Link between Climate and California's Fires." *New York Times*. September 9, 2020. https://www.nytimes.com/2020/09/09/climate/nyt-climate-newsletter-california-wildfires.html.

Skiba, Katherine. "One Year Ago: California's Deadliest Wildfire Ravaged Town of Paradise." AARP. October 15, 2019. https://www.aarp.org/politics-society/history/info-2019/paradise-camp-fire-anniversary.html.

Stone, Madeleine. "A Heat Wave Thawed Siberia's Tundra. Now, It's on Fire." *National Geographic*. July 6, 2020. https://www.nationalgeographic.com/science/2020/07/heat-wave-thawed-siberia-now-on-fire/.

Swain, Daniel L., Baird Langenbrunner, J. David Neelin, and Alex Hall. "Increasing Precipitation Volatility in Twenty-First-Century California." *Nature Climate Change* 8 (April 23, 2018). https://www.nature.com/articles/s41558-018-0140-y.

Universität Bonn. "Fire Beetles May Revolutionize Early-Warning Systems for Forest Fires." ScienceDaily. May 23, 2012. https://www.sciencedaily.com/releases/2012/05/120523102148.htm.

Vartabedian, Marc. "The Photographers Who Walk Into the
 California Fires." *Wall Street Journal*. November 3, 2019.
 https://www.wsj.com/articles/the-photographers-who-walk-
 into-the-california-fires-11572784201.

Voiland, Adam. "California's Nightmare Fire Season
 Continues." NASA Earth Observatory, October 1,
 2020. https://earthobservatory.nasa.gov/images/147363/
 californias-nightmare-fire-season-continues.

Westerling, Anthony L., Daniel R. Cayan, Timothy J. Brown, Beth
 L. Hall, and Laurence G. Riddle. "Climate, Santa Ana Winds
 and Autumn Wildfires in Southern California." *Eos* 85, no. 31
 (August 3, 2004). https://agupubs.onlinelibrary.wiley.com/doi/
 abs/10.1029/2004EO310001.

GLOSSARY

Air Attack—Aircraft that flies overhead of a fire and guides firefighting aircraft and lead planes.

Buggy—Small bus on heavy duty truck chassis used to transport hotshot crew, hand crews, and inmate crews to a fire line. Usually two buggies per crew.

CA 409.5—California law, sub section C, that allows "credentialed" media into areas off limits to the public for newsworthy coverage at various types of disasters, exclusions for active crime scenes and first responder safety.

File—In verb form: the process of uploading digital images to a laptop in the field, then quickly editing a selection of images, adding captions, and remotely sending them to a news desk or client from the fire line. Can be done on deadline or as needed for breaking news. For slower stories, it's done at the end of the day or when there is downtime.

FML—Fuel Moisture Level

Hand Tool—Rakes, shovels, axes used by firefighters to cut fire line to bare mineral earth.

IA—Initial Attack

ICP—Incident Command Post

ICS—Incident Command System

IMT—Incident Management Team

Inversion Layer—Smoke that settles in over a fire, usually overnight, that moderates fire behavior. Especially present in valleys, can "burn off" as the day gets hotter. When the inversion lifts fire activity typically increases.

IWI—Incident Within Incident

LAL—Lightning Activity Level

Ops—Operations

PIG (Probability of Ignition)—The percentage probability that a given piece of fuel will ignite when presented with an ember, etc.

PIO—Public Information Officer

PPE—Personal Protective Equipment

Pulaski—A combo axe and hoe used by wildland firefighters, named after firefighter Ed Pulaski (circa 1910).

Relative Humidity—The relative amount of moisture in the atmosphere. The lower the percentage, the more critical fire weather conditions are. The critical percentage varies on region.

SLR/DSLR—Digital Single Lens Reflex camera, the gold standard for professional digital cameras. Now being superseded by mirrorless cameras.

Viewfinder—Mirror box or digital display on a camera that a photographer holds their eye up to in order to compose an image before pressing the shutter button and making an image.

WUI—Wildland Urban Interface